great painters
of the world

3237 Great Painters of the World
This edition published in 1999 by CLB

Copyright © 1993 Quadrillion Publishing Ltd,
Godalming, Surrey, England GU7 1XW

Distributed in the USA by
Quadrillion Publishing Inc,
230 Fifth Avenue, New York, NY 10001

Printed and bound in Italy

ISBN 1-84100-309-3

Jean-François Guillou

great painters
of the world

CLB

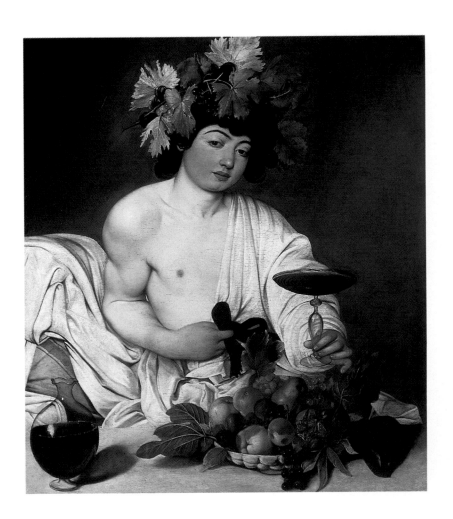

Caravaggio
Young Bacchus
Oil on canvas
Florence, Ufizzi Gallery

CONTENTS

From Giotto to Picasso : the age of man

The 14th century was a century of paradox. Marred by the Black Death in 1348 and the Hundred Years' War, but transfigured by the rediscovery of the heritage of antiquity, it presents a contradictory picture of renewal and disorder. It was a transitional period, not dissimilar to our own, where it seemed that something had to die to make way for something new. In the span of six centuries between then and now men wanted to believe in their own power: the power to subdue nature and make the human dimension its norm.

This belief, the essence of humanism, runs right through this long period, giving it its unity. Between the Middle Ages marked by man's submission to the obscure forces of nature and the age of technology which dawned in the 19th century — the building of the Eiffel Tower could be said both to symbolize it and serve as its birth certificate — there was the age of man: a period of improbable hope illustrated by the enigmatic figure of the great Leonardo da Vinci. Man no longer belonged among things, a creature among creatures. He had become the center of a world which — in his eyes — only his existence justified.

Applying Protagoras's saying that "man is the measure of all things" to themselves, artists and scientists nurtured the ambition of equalling creation. When it came to engraving an epitaph on Raphael's tomb Cardinal Bembo had no qualms about writing: "Here lies Raphael who made Nature fear during his life that it would be mastered by him, and in his death that it would die with him." Beyond the circumstances to which the words relate, this can be read as the declaration of a real program.

The origins of this "renaissance" or "rebirth" have been interpreted in a variety of ways. Seen by some as resulting from the Franciscan renewal in the 13th century, and by others as the consequence of the rediscovery of Greek and Latin texts, it also betrays the influence of French Gothic, then at its height north of the Alps. It is not really important to establish which of these elements was the determining one. In point of fact the Renaissance resulted from the coming together of a whole range of favorable factors — among which the prosperity of the countryside in the 12th century, and from the 13th century on the relaunching of the flow of money and the strengthening of communal autonomy, especially in North Italy, must also be included.

Whatever the truth may be, the cause in this case matters less than the effect, i.e. the renaissance of the arts. And among the arts painting unquestionably takes pride of place, quite simply because no other art has succeeded so well in leaving its imprint on our imaginary world. No other art has more successfully retranscribed the stages of this long interlude during which men

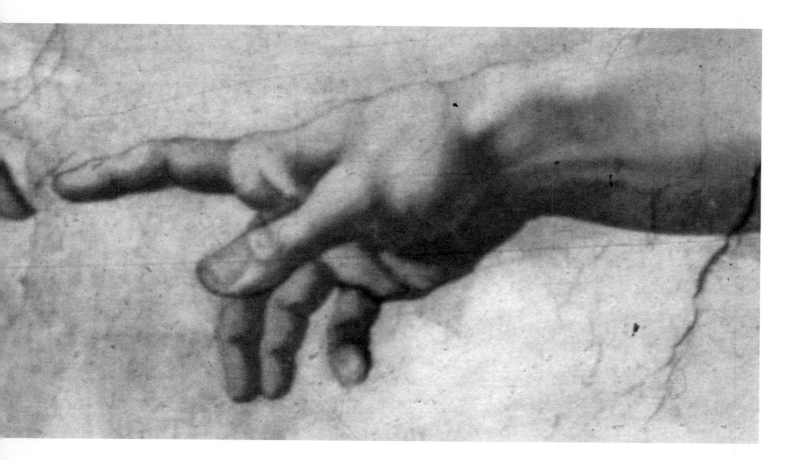

believed they were capable of insuring their mastery of the world, and in so doing insuring the happiness of mankind. From the pre-Renaissance hesitations to the "classical" mastery of the quattrocento, from Baroque exaltation to Romantic torment, artists were inspired by a single certainty: that man was at the center of world and nature was his cradle. "The poet is a seer," Victor Hugo wrote in *Contemplations*. His mission was to guide other men toward happiness. The artist unveils, reveals. He shows the goal and invents the way.

In this connection painters have veered between two poles: respecting the norm and expressing subjectivity. Thus 15th-century harmony is counter-balanced by 16th-century Mannerism; French Classicism by 17th-century Baroque, or late 18th-century Neoclassicism by Romanticism and the Impressionism of the 19th century. Painters such as Leonardo da Vinci, Raphael or David are generally classed as belonging to the former trend, while others such as El Greco, Goya or even Delacroix are placed in the second category. But this dichotomy, however useful it may be, is artificial. In their work all artists have drawn on both poles. And it is the tension that each and every one of them has managed to engender between these two extreme options that constitutes his talent and essential originality.

Another fracture line and one that is no doubt more relevant is that dividing those believing in Platonic idealism and those advocating Aristotelian mimesis. For the former (Raphael, Poussin, David, Ingres ...) nature does no more than afford an always imperfect reflection of an ideal which they have set themselves the mission of making visually perceptible. The model (man or nature) has to be remodeled in accordance with the canons of classical beauty. Under this definition beauty becomes universal. The second group on the other hand is less concerned with seeking truth than probability, less concerned with the idea than with the thing or the truth of the instant. For them perfection does not exist outside nature. It is potentially inscribed in nature and that is where it must be sought. The Flemish painters, French 19th-century Realists and – to a lesser extent – the Impressionists adhere to the latter current of thought.

Nonetheless, beyond their divergencies the two schools had a shared ethic. Esthetics was a moral code. Humanity in its imperfection was seen as perfectible, with art offering itself as the favored instrument whereby harmony could be achieved. This is undoubtedly the idea that gave this long period its coherence. Understood in this way, the Renaissance extends to the dawn of the 20th century. It expired under our very noses along with innocence, somewhere between the Chemin des Dames in the First World War and the extermination camps of the Second.

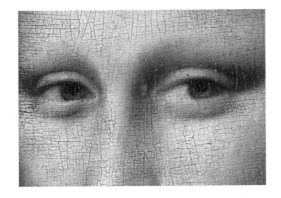

8

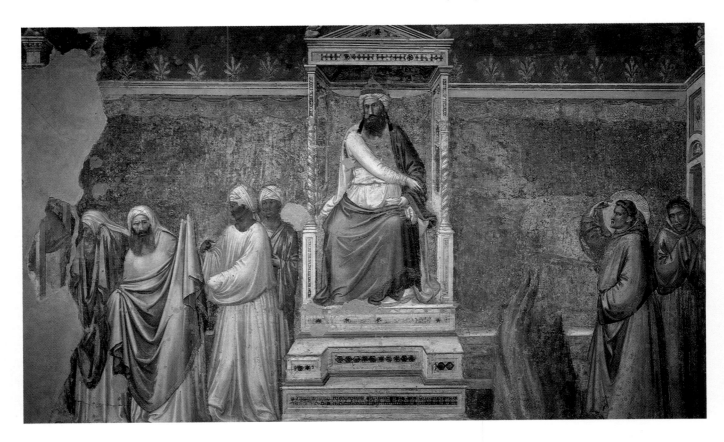

A painter of emotion

Dante in his *Purgatorio*, then Vasari two centuries later in his *Lives*, celebrated Giotto as the founder of modern painting. Dante was his friend, and Vasari was a Tuscan. Without disputing Giotto's genius later historians have qualified Vasari's theory. In the innovative realism with which he represented figures Giotto broke with the Byzantine tradition and foreshadowed the Renaissance. But the crucial contribution made by two of his predecessors, his master Cimabuë (c.1240 – after 1302) and the Roman Pietro Cavallini (c.1250–c.1330), cannot be discounted.

Giotto's genius lay in very rapidly assimilating their teaching, and taking innovation a step further by introducing new subjects into painting. A new taste foreshadowing humanism then revolutionized Italian art, with greater importance being attached to nature and the expression of human feelings, which had been banished from painting for several centuries by the hieratic character of Byzantine art.

This new sensibility which Dante defended in literature doubtless originated in the preaching of St. Francis of Assisi at the beginning of the 13th century. The extraordinary growth of his order and the power of its message made a strong impact on Tuscan artists. A return to the simplicity of the Gospels, divestment, a feeling for nature and mankind, all defining characteristics of the Franciscan ideal, could equally well be applied to Giotto's painting.

The new passion which he paints is a passion for life, a human passion. Rejecting the idea of expressing a fixed, codified passion, his painting is faithful to the message of St. Francis and goes back to early Christianity, a religion based on personal experience. For Giotto was of humble birth, and retained the simplicity and practical sense of the people. Emotion arises not from an idea, but from a situation. The immediate requirement was to rekindle the power of the story, and in order to do that the characters had to be animated and given a semblance of reality. This new scenography, aimed at engendering within the viewer the same type of emotion as he would have experienced had he been present at the actual event, derived its power to convince from life. Gold grounds gave way to architectural or natural backgrounds which placed the scene in a historical context. Giotto's people have ceased to be icons, they are real flesh and blood. This new approach was first used in the narrative cycle *Scenes from the life of St. Francis* painted in the early 1300s. The group of 28 panels decorating the right-hand wall of the basilica of St. Francis in Assisi founded the Franciscan legend. The attribution of this series to Giotto, though it was questioned for a time by German art historians, seems now to be beyond doubt. But Giotto's talent came into full flower between 1305 and 1310 when he went to Padua to decorate the Scrovegni chapel in the Arena. This cycle of 38 panels, inspired by the Gospels in the canonical Scriptures and the apocryphal Gospel of St. James, is unanimously accepted as Giotto's finest achievement. Celebrating mankind and bringing a message of love and anxious compassion, the frescos were regarded by Dante himself as the equivalent in the plastic arts of his own poetic works.

Giotto
St Francis before the
Sultan of Egypt
Fresco
Florence, Church of Santa Croce, Bardi chapel

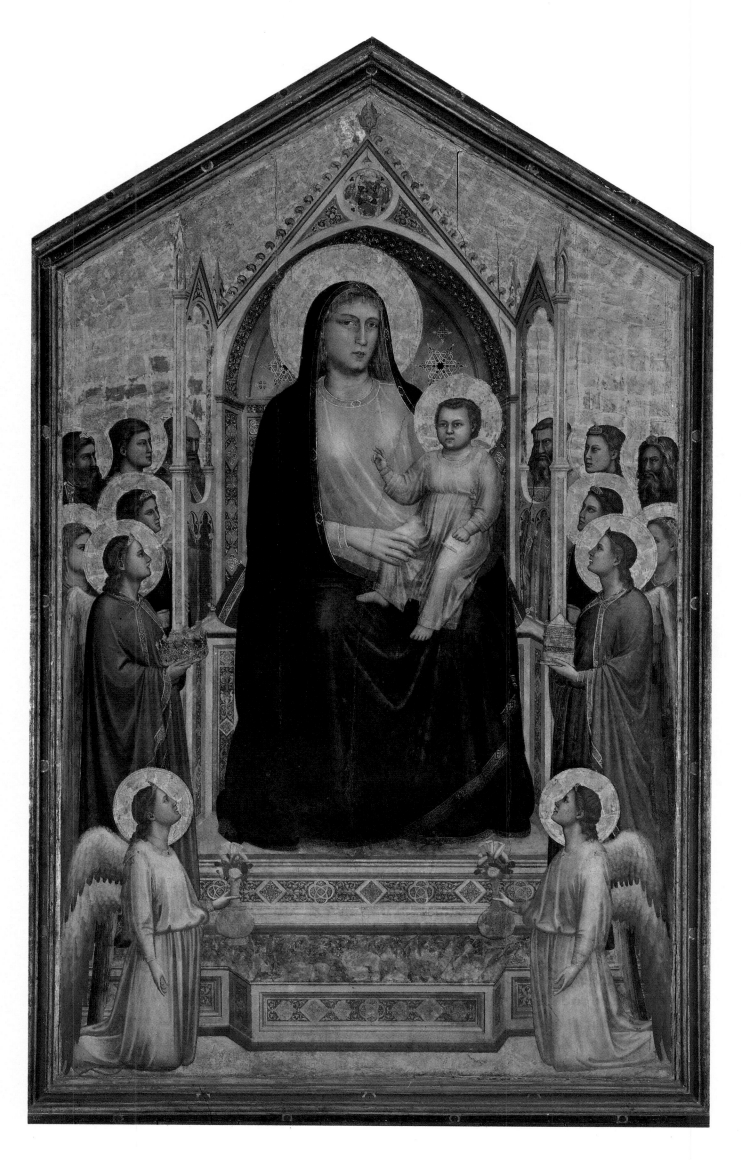

In a composition still bearing the hallmark of the Byzantine legacy but with the innovations derived from Gothic France showing through, the Madonna of Ognissanti displays an essentially human gravity. She is simultaneously the holy mother of God, a symbol of the universal, and a simple mortal, a physical body carrying within it the flesh of her flesh. Her gaze is inward-looking, yet directed toward an impalpable other world, reiterating the Christian enigma of the presence of the universal within the individual, of which St. Francis had provided a reminder.

Giotto
*Madonna in majesty with angels and saints
(or Madonna of Ognissanti)*
Tempera on wood
Florence, Uffizi Gallery

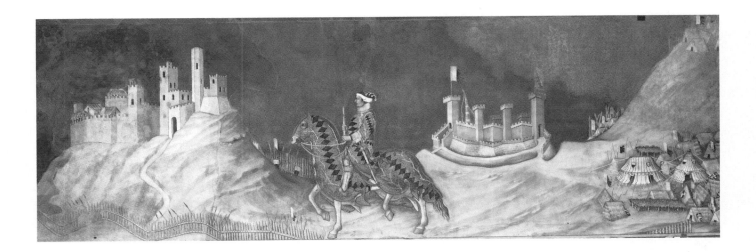

The Gothic influence

At a time when Italy was seemingly being reborn from its ashes and starting to dream again of its past greatness, it was oddly enough in France, a monarchy ruled by the Capetian dynasty, that it found the means of breaking free of Byzantine influence. Italy at that time was a mosaic. Every city was a self-ruling republic, jealous of its own independence, but they were all inspired by a single model: Rome. What was at stake was emancipation, firstly from Byzantium, which for a long time had been regarded as the sole heir to imperial greatness and which was now perceived as a rival, as Italy was irked at being dispossessed of its past, and then from the Church – though it had been diminished by the Pope's exile in Avignon, its temporal powers still chafed the free towns. The immense popularity of the Franciscan movement is indicative in this respect of how uncomfortable a fair number of Christians felt about the Church's increasing wealth.

Thus autonomy and rivalry were the watchwords: rivalry between one city and another, rivalry between the Italians and the Byzantines, and lastly rivalry between the republics and the papal States. This gives a thumbnail sketch of the political and intellectual climate in which early *trecento* artists had to evolve. When a free town gave a commission, it was with a view to celebrating its own glory.

In 1315 the governing authorities of Florence's neighbor, Siena, called on Simone Martini, a pupil of Duccio. His *Maestà*, inspired by a painting of the same subject by his master four years earlier, already reveals a French influence. Breaking with the Byzantine hieratic style which still governed the work of Duccio, Martini chose a realistic, narrative approach to painting.

This initial inclination was subsequently reinforced by a journey Martini undertook to Naples. There can be no doubt that the Angevin dynasty in Naples founded by Charles of Anjou, the brother of St. Louis (Louis IX of France), preserved close cultural links with Capetian France, then ruled by the sons of Philip the Fair.

Thus three influences in all came together in the work of Martini to combat the Byzantine heritage: Latin humanism, Franciscan humanism, and the chivalrous ideal of the courtly cycles. The first of these was associated with Petrarch, a friend of King Robert, and after 1339 an associate of Martini's in Avignon; King Robert himself was part of the second sphere of influence, while Robert's brother Louis, who renounced his claim to the throne to don a Franciscan gown, represented the third.

In his portrait of *Guidoriccio da Fogliano* Martini looked to antiquity for his inspiration. When Fogliano, a *condottiere* or military leader engaged at great expense by the city of Siena to maintain its territory and independence, is depicted on horseback proceeding as if at a military parade in front of the towns of Montemassi and Sassoforte which he would soon overcome by force of arms, our thoughts naturally turn to the equestrian statues of the Roman Emperors. In the *Annunciation* painted in 1333, on the other hand, the French influences – the Gothic and that of courtly literature – are uppermost.

Simone Martini
Guidoriccio da Fogliano
Fresco
Siena, Palazzo Comunale

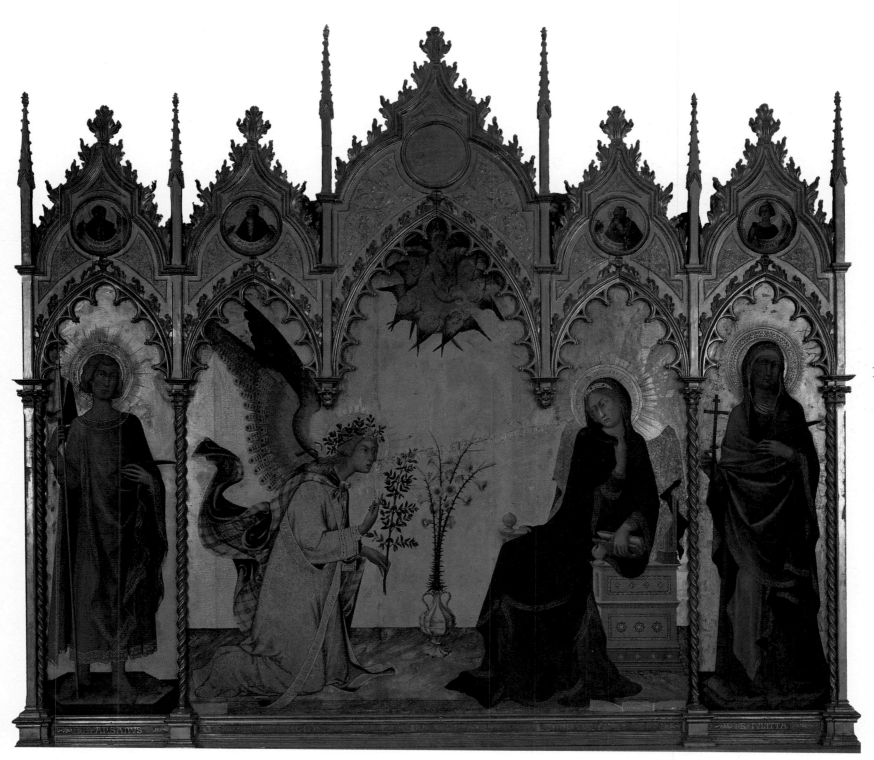

A sulky face, an irritated movement of withdrawal revealing disquiet, her hand half-closing the book – the woman surprised in her privacy by the angel is still an ordinary woman, unaware of her destiny. In this scene all the symbolism and preciousness of courtly literature are used to further the Marian cult which would be so far-reaching and powerful in Italy.

Simone Martini
Annunciation
Tempera on wood
Florence, Uffizi Gallery

14

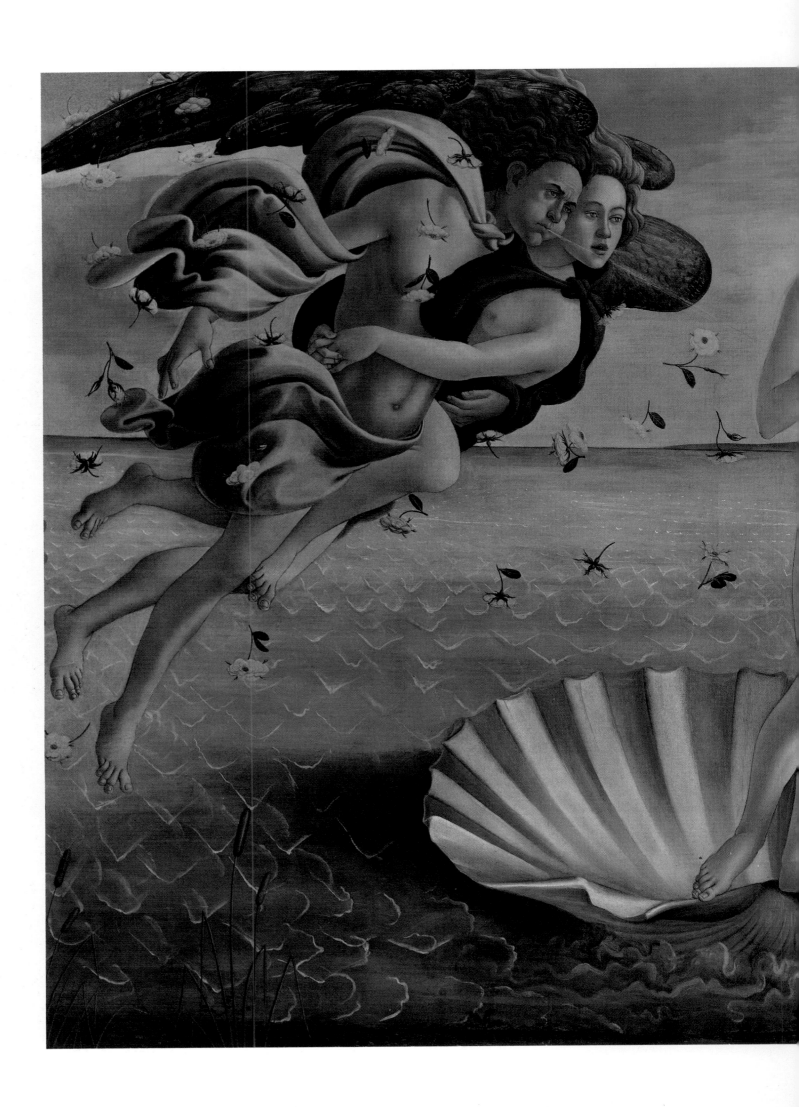

Sandro Botticelli
Birth of Venus
Tempera on wood
Florence, Uffizi Gallery

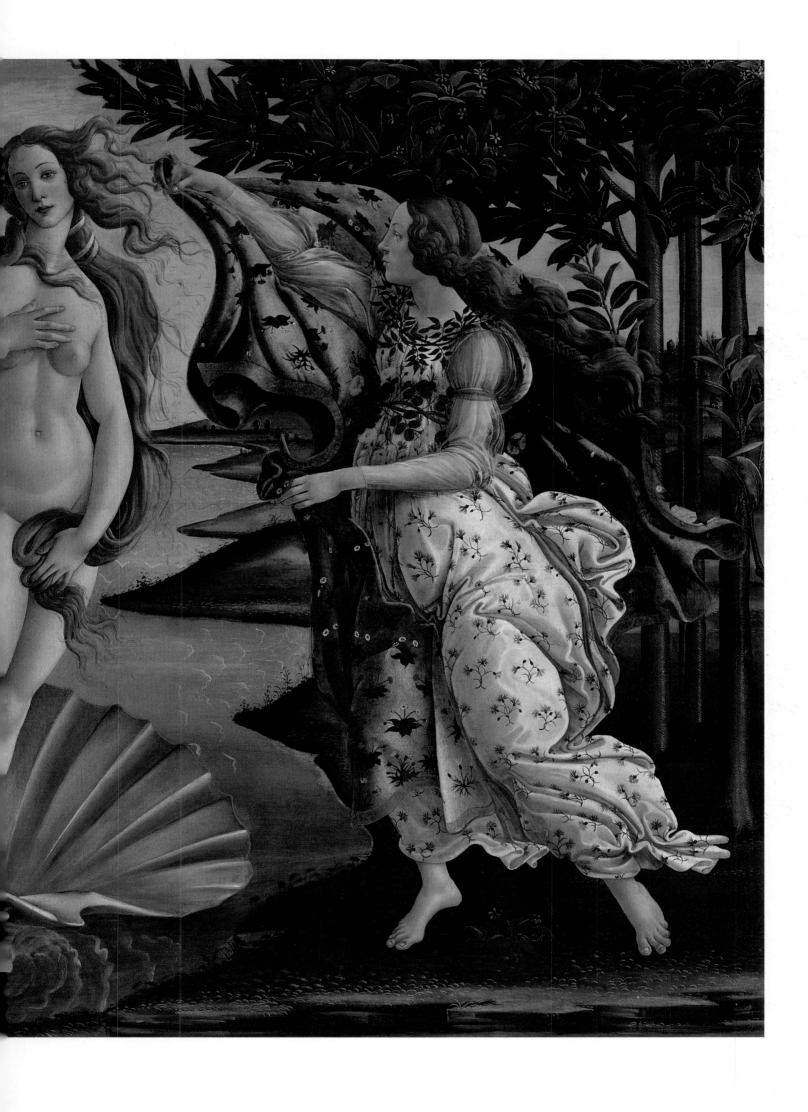

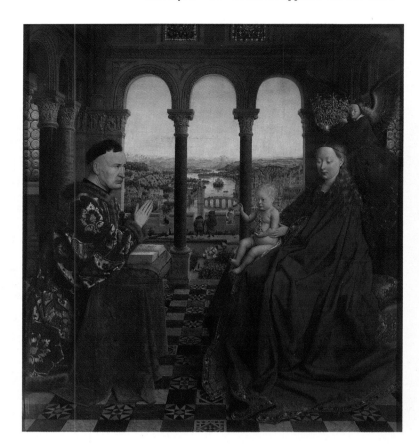

The eye as a mirror

The artistic renewal started in Tuscany at the beginning of the 14th century was brutally interrupted by the tremendous drama of the great plague in 1348. Modern historians reckon that the Black Death wiped out a third of the population of Europe. Northern Europe, which was less seriously affected by the plague, also suffered from the turmoil resulting from the conflict which set France and England at loggerheads for more than a century. In this troubled context Burgundy, which then owned the Low Countries, appeared as a haven of peace. There was a brilliant court at Dijon where the Duke of Burgundy, the brother of King Charles V of France, set out to surround himself with the greatest artists of his period – the majority of whom were Flemish.

Consequently, when Jan Van Eyck became available on the death of his master John of Bavaria in 1425 it was completely natural that he should be summoned by Philip the Good, Duke of Burgundy. The following year he and his brother started work on the polyptych of the *Mystic Lamb* for Ghent cathedral, and it was installed there on 6 May 1432. This interpretation of the Apocalypse with the redeeming Lamb as its central theme reveals a vision of mankind's destiny which, if not optimistic, is at least resolutely realistic and concrete, and in which mankind is not opposed to the divine, but aspires to draw nearer to divine perfection. In Van Eyck's work reality and nature are perceived not as the mark of man's fallen state, but as the manifestation and sign of a perfection which attentive scrutiny may

hope to reveal. For Van Eyck the ideal is not located in a world beyond which can be reached only by escaping into the imaginary. Van Eyck is not a visionary, but an observer. His eye registers in order to reconstitute, not to transform. And it is beyond doubt that no other eye before his had shown such keenness of vision. Perhaps that is why the figure of Eve in the polyptych of the *Mystic Lamb* shocked people so much, just as Manet's *Olympia* was to shock them later: Van Eyck did not paint a symbol, but a flesh-and-blood person. When realism is pushed as far as this the viewer is turned into a voyeur, as if Eve's sin became our own, and as if Van Eyck's eye, in operating with the objective neutrality of a mirror, actually disappeared, leaving us alone with his model.

The same basic attitude governs the composition of the *Madonna with Chancellor Rolin* painted c. 1435. In a reference to the three corners of the divine triangle (Father, Son and Holy Ghost), nature (landscape), mankind (the chancellor) and divinity (the Virgin) are positioned round the central figure of the Child, whose benedictory and uniting finger, extended by the bridge in the background, points in a redeeming gesture to the clasped hands of the Chancellor at prayer at the other end of an invisible parabola. This ternary organization is echoed by the three Romanesque arches, opening onto the gilded pallor of a mystical sky.

In his detailed contemplation of Creation Van Eyck celebrates the union of the creature with his Creator.

Jan Van Eyck
Madonna with Chancellor Rolin
Painting on wood
Paris, Louvre

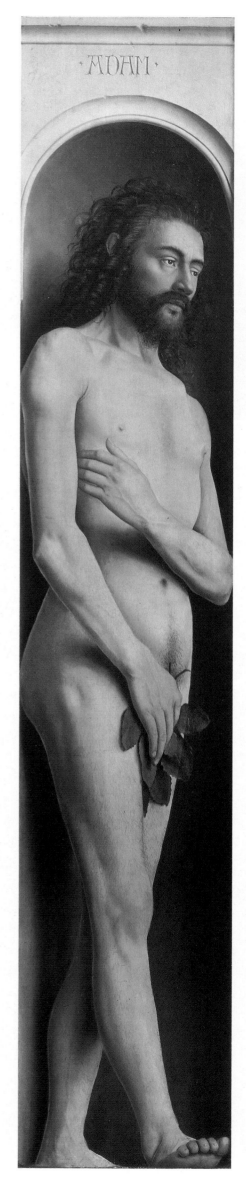
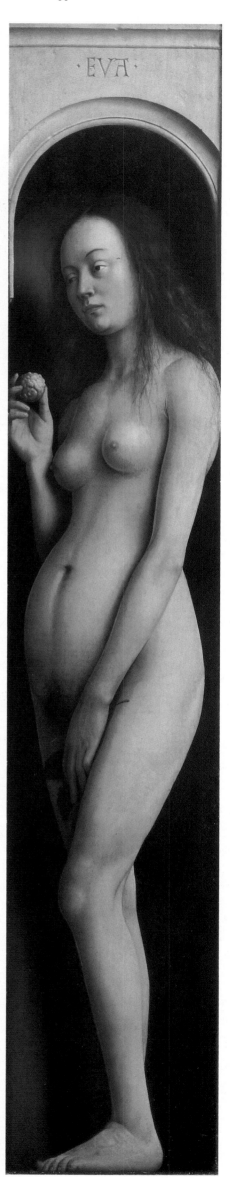

Eve, the opposite of Mary, the nocturnal aspect of the female nature, resembling a pale moon with her sides pulled down by the weight of sin. Cruelly real, as reality is cruel. Yet beautiful and attractive, a temptress and at the same time a woman without illusions, looking at the world with the melancholy gaze of someone who already knows too much, someone who has seen something that ought never to have been seen. A gaze weighed down by misfortunes yet to come. A stomach that is still smooth, but in which the stirring of all future mankind can be sensed. A superb, yet terrifying work.

Hubert and Jan Van Eyck
Adam, Eve
(detail from the polyptych The Mystic Lamb)
Painting on wood
Ghent, St Bavo cathedral

"Jan Van Eyck was here"

The eye is like a mirror, and the mirror like an eye – an eye watching over the clasped hands of husband and wife. In this secular, domestic scene we find the same solemnity combined with the same naturalness as in the portrait of Chancellor Rolin. The painter seizes an instant, and in that instant encapsulates every moment of a lifetime. In the portrait of *Giovanni Arnolfini and his wife* Van Eyck successfully reconciles the anecdotal and the ideal, as he had succeeded in reconciling realism and mysticism in his religious works. Again it is through a detailed, almost obsessive approach to appearances that he manages to go beyond them and suggest a different reality, this time of a moral order.

Van Eyck's style, which was undoubtedly new, led him gradually to break with the prevalent International Gothic fashion. Details and objects in his work gradually lost their decorative purpose and moved in the direction of verisimilitude. The magpie in the *Madonna with Chancellor Rolin* or the Arnolfinis' dog is neither a symbol nor an ornament; they are real, living creatures which contribute to the scene's verisimilitude. With this in view the artist rejected the stylization and fantasy characteristic of the International Gothic style, replacing them with a more searching, acute observation of what was real. That is why Van Eyck's art, though his genius was recognized immediately by his contemporaries, perhaps appeared austere and cold in comparison with what people were accustomed to seeing and admiring at the time.

The Swiss painter Konrad Witz, a follower of this new trend, settled in Basle in 1431. The same rigor in drawing and the same concern for reality can be found in his painting. In 1444 the Bishop of Geneva summoned him to the city and commissioned him to paint a retable for the cathedral, two wings of which have been preserved. The most famous scene is *The miraculous draught of fishes*, an episode taken from the Gospel according to St. John, in which Christ appeared to the apostles for the third time after the Resurrection on the shores of the Sea of Tiberias. But the interest of the painting lies elsewhere, in the background. Witz preferred not to imagine a shore in Galilee nor to overcome the difficulty by using an artificially contrived setting; so he chose simply to paint the lake which the townspeople of Geneva knew best, their own Lake Geneva. By ridding the depiction of an event from the Gospels of the decorative clutter normally surrounding it, Witz provided a realistic version of a miracle. The job of the background here is to restore the historical dimension to the event and so to the character of Christ. The message emanating from the work might be this: the god of the Christians who made himself a man among men is also a God among men, accessible to everyone, including the humblest. Depicting the possibility of a direct dialog between man and his Creator in this way was in tune with the Genevan way of seeing things, which Calvin would use as a prop a century later in developing his concept of the Reformation, based on a concrete, practical reading of the text of the Bible, just like the work of Witz.

Konrad Witz
The miraculous draught of fishes
Painting on wood
Geneva, Musée d'Art et d'Histoire

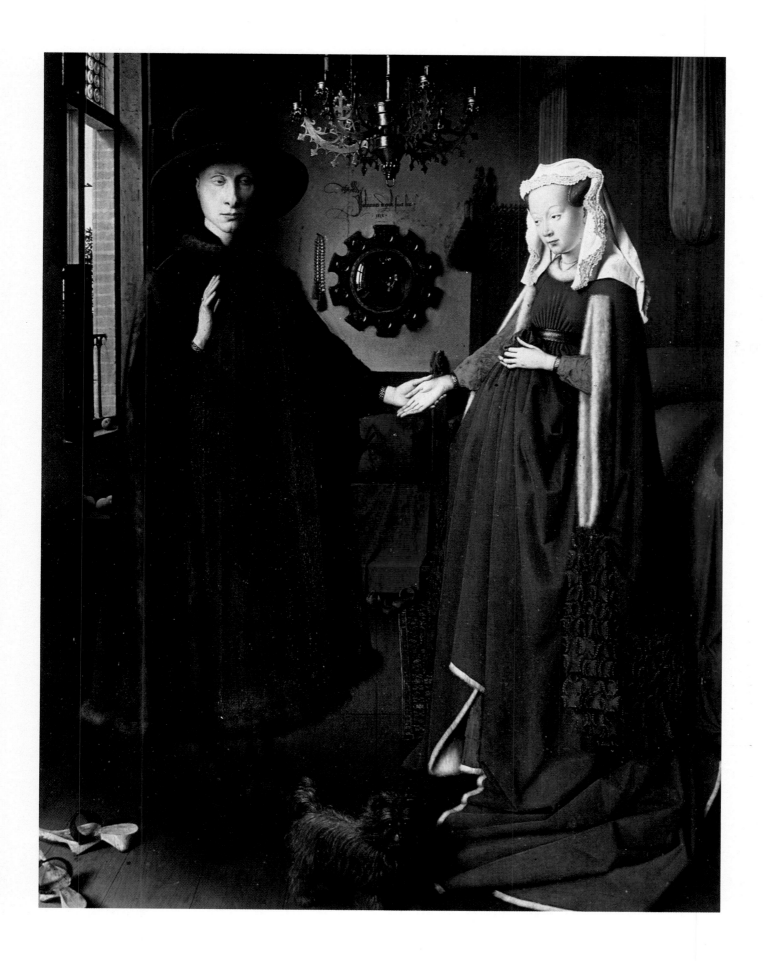

Jan Van Eyck
Giovanni Arnolfini and his wife
Painting on wood
London, National Gallery

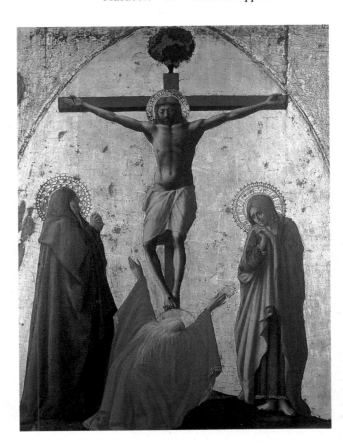

The invention of space

The International Gothic style which had gradually been superseded in the north by Flemish Realism was rivaled south of the Alps by a new trend which might sometimes be described as "heroic." There were three of these "modern" artists, as Vasari called them, the sculptor Donatello, the architect Brunelleschi and the painter Masaccio, all working in Florence.

Masaccio who was born in 1401 died at the very early age of 27, leaving only a limited number of works behind him, including frescoes in the church of Santa Maria Novella and in the Brancacci chapel of the church of Santa Maria del Carmine in Florence, painted between 1426 and 1427, shortly before his death. He was heir to Giotto in his realistic execution, the monumentality of his figures and his talent for expressing human drama, and at the same time anticipated Michelangelo in his extraordinary sense of perspective and setting.

In his *Crucifixion*, now in Naples, the perspective he employs goes beyond the simple illusion of a space internal to the work. The distortion he uses in portraying people demonstrates that in his composition he took account of how the picture would appear when it was hung, so that the viewer looking up from below would feel drawn into the scene. The perspective goes beyond the confines of the picture to fill the space covered by the viewer's gaze, and the illusion is so perfect that one has the impression of standing oneself at the foot of the Cross, so becoming an invisible participant in the drama, as if the miracle of perspective had trapped one's gaze.

Such mastery of illusion could not have resulted from improvisation. To obtain such effects Masaccio must have excluded excess and reined in his own subjectivity. It is undoubtedly in this respect that he differs most from Giotto who inspired him. Masaccio's painting is scientific and mathematical, based on applying the geometrical principles of perspective discovered by Brunelleschi. In contrast to Van Eyck, who worked empirically, copying detail after detail with the greatest of care, Masaccio opted for synthesis. He did not copy reality, he rethought it. He reinvented a virtual reality which paradoxically seems more true than a detailed reproduction of what is real. One might almost say that the more Masaccio uses artifice, the closer he comes to apparent truth, as if artifice, inspired from reality, replaced it with an image of itself that was truer than nature.

In addition to all this there was the increasingly important role played by light. Gradually turning away from bright colors and gold, from 1426 Masaccio's painting evolved toward a simplification of masses, which are modeled by a light that seems to emanate from the eyes of the beholder and which, using the play of light and dark, completes the illusion of volume with depth where there is in fact only surface.

However, the contribution made by Masaccio did not attract an immediate following, probably because his extreme austerity was not in tune with the prevailing mentality of 15th-century Florence. It had to wait to be rediscovered by Michelangelo in the following century – he then profited from it in a manner known to us all.

Tommaso Masaccio
Crucifixion
(part of the Pisa triptych)
Painting on wood
Naples, Capodimonte Gallery

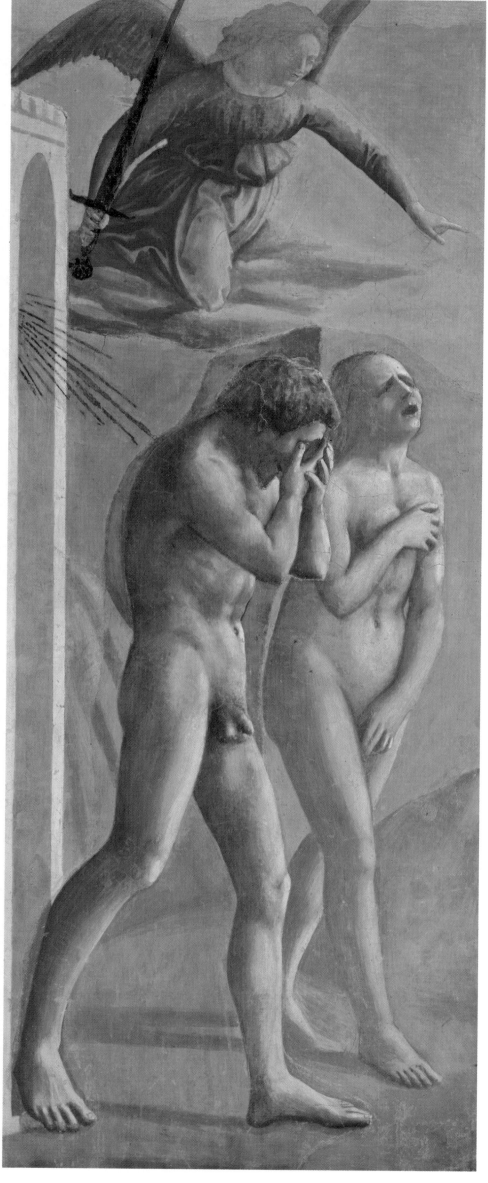

21

*The scene that underlies
man's tragic destiny, The
Expulsion from Paradise.
Expelled from happiness,
escaping from anger,
setting out along the road
of History. Avoiding the
risk of slipping into
naivety or over-emphasis,
Masaccio has chosen
simplicity and restraint,
striking just the right
note. The figures are not
two symbols, but flesh-
and-blood creatures who
are stealing away,
ashamed and unhappy.*

Tommaso Masaccio
*Expulsion of Adam and Eve
from Paradise*
Fresco
Florence, Church of Santa Maria del Carmine, Brancacci chapel

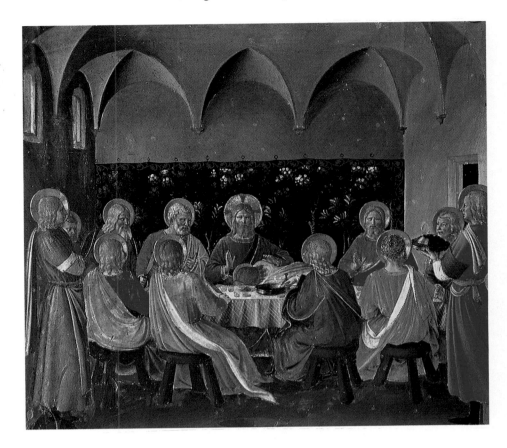

The purity of divestment

22

Fra Angelico took his vows in 1417. The Church, which was then riven by the Great Schism, was going through one of the most critical periods in its history. Fra Angelico, whose real name was Guido di Pietro, was only about twenty then, and virtually nothing is known of him during the fifteen years that followed, his first known work dating from 1432. Based on the way his earliest works are executed, however, it is reasonable to surmise that he was trained as an illuminator and miniaturist at the various Dominican monasteries where he lived.

Unlike a painter such as Masaccio, for whom the search for reality was an overriding imperative, Fra Angelico proved to be mainly concerned with the ethical dimension of his art, taking reality only as a basis for an idealized version of it which he used to teach a morality based on love and peace – in which respect he unquestionably resembled Giotto.

The idyllic, not to say unreal character of his compositions was very instrumental in distinguishing him from his contemporaries, and brought him great fame during his lifetime. His manner of painting has been described as suave, or people have written of naive painting. His candor and piety seem to set him apart as an artist, far removed from the learned calculations of the humanists. Nonetheless, quite apart from the fact that it is always dangerous to make inferences regarding an artist's character from

his esthetic choices as an artist, Fra Angelico was obviously aware of Masaccio's contribution to art. Light and volume occupy a central role in his work too. And space, bounded in the background by buildings or landscapes directly inspired by the Tuscan countryside of the *quattrocento*, is given a third dimension by placing the figures in depth in a way similar to that used by Masaccio.

In his paintings on wood, which are characterized by an almost excessive use of color and a pronounced liking for detail and anecdote derived from illumination, Fra Angelico was very close to the Gothic tradition, but he showed himself capable of extreme restraint when painting the frescoes for the monastery of San Marco in Florence. His painting, which was sensuous and precious when it was addressed to the world at large, here became austere and serious, as if called upon to incarnate the spirit of the place and become one with the walls. This ability to move so successfully from one register to another is surely the most notable feature of his talent.

As a mystical painter, Fra Angelico continued to work for his faith. The scenes he depicts are not of this world. They are visions or dreams. And the light that bathes them, unlike the frontal light used by Masaccio, seems to emanate from the people depicted, as if reminding us that light, even in the hands of the artist, is still a gift from God.

Fra Angelico
The Last Supper
(or Christ announcing his betrayal)
Scene from the Life of Christ and the Virgin
originally from the tabernacle of Santa Annunziata
Painting on wood
Florence, San Marco Museum

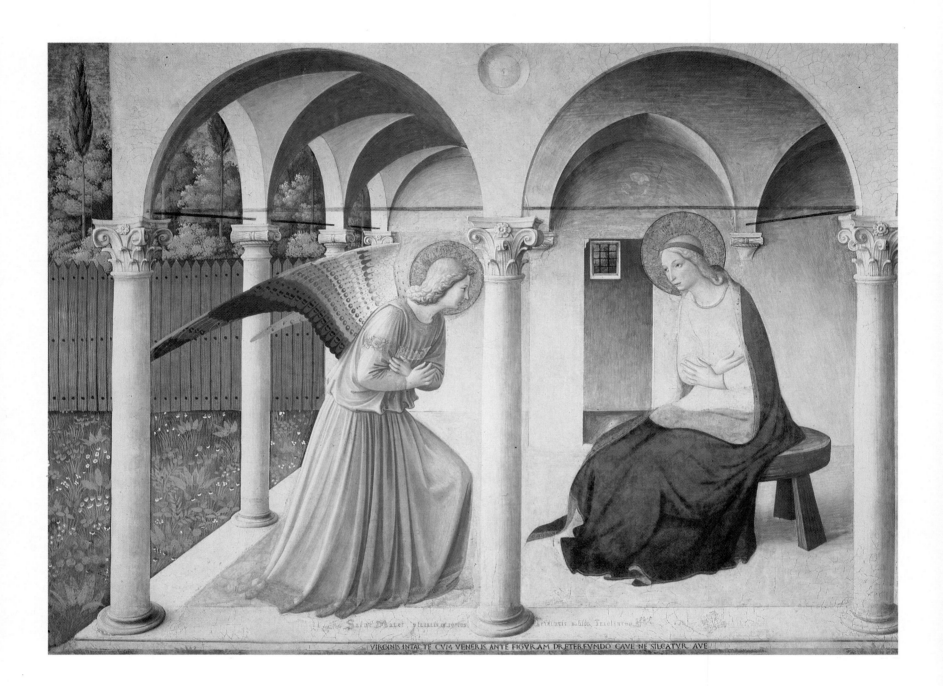

The volumes are simple, the shades austere, the faces serene. This is a painting that invites meditation, intended for an audience of monks, discreetly encouraging contemplation like a pale dream projected onto a wall by the tranquil imagination of a man who has withdrawn from the world. A work born of silence, applied to a naked, virgin surface.

Fra Angelico
Annunciation
Fresco
Florence, San Marco Museum

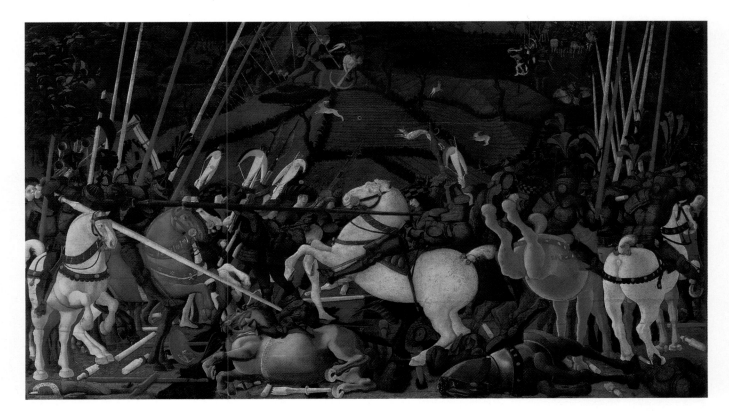

24 *The passion for perspective*

In contrast to Fra Angelico, who was gradually taken by his art toward simplicity, Paolo di Dono, known as Uccello, according to Vasari "did his utmost and wasted his time trying to resolve the problems of perspective." Uccello, a contemporary of Fra Angelico, was born and died in Florence. After training as a mosaicist he came to painting as someone interested in plasticity, and his choice of subject matter generally showed a bias toward animal or war themes.

In the frescoes for the Chiostro Verde at Santa Maria Novella painted between 1430 and 1445 he made the bold decision to limit his use of color to the general tonal range "terra verde" – hence the name given to the cloister. But it would be a mistake to interpret this choice as a deliberate desire for restraint: the modesty of the color is intended to emphasize the power of the composition and the rigor of the forms. Uccello approaches painting like a sculptor. His primary material is the line, and his obsession is movement. He does not paint to satisfy the soul, but to amaze the eye and stimulate the imagination.

When the Bartolini family commissioned a work from him in 1456 to celebrate Niccolo da Tolentino's victory over the Sienese forces, Uccello painted three panels known collectively as the *Battle of San Romano* which were set up in the hall of honor of the Medici Palace. The epic intention of these works gives them a character that is both archaic and modern: archaic in the aspects they retain from the Gothic tradition and the detailed art of the illuminator, and in the multiplicity of secondary episodes depicted in a stylized manner on the margins or in the background, but modern in the astonishing complexity of the construction of space, built on the straight lines of the lances and the curves of the horses' bodies; to underline the effect being sought the horses are sometimes represented with a foreshortening that is almost maniacal in its virtuosity.

A comparison between this battle scene and the portrait of Captain *Guidoriccio da Fogliano* painted by Simone Martini a century earlier is very revealing in this connection. While Martini suggests the clash of arms by absence and bareness, by the silence preceding the battle, Uccello sets out to show and describe it. Uccello prefers the art of detailed narration to Martini's elliptical art, as if he were trying to imply the presence of life through a profusion of movements.

No doubt he had embarked on a fruitful path, but by trying too hard to bow only to the laws of perspective Uccello favored the setting at the expense of the subject. For movement became frozen in the demanding straitjacket of flight lines which immobilized people who were too scientifically arranged, as if placed there only to serve the perspective, which had become the true subject of the work. To sum up, conventional criticism reproaches Uccello with not having tried to conceal the process whereby he created perspective, so giving prominence to artifice rather than to illusion, which is so dear to the public's heart.

Paolo di Dono, known as Uccello
The Battle of San Romano
Tempera on wood
Florence, Uffizi Gallery

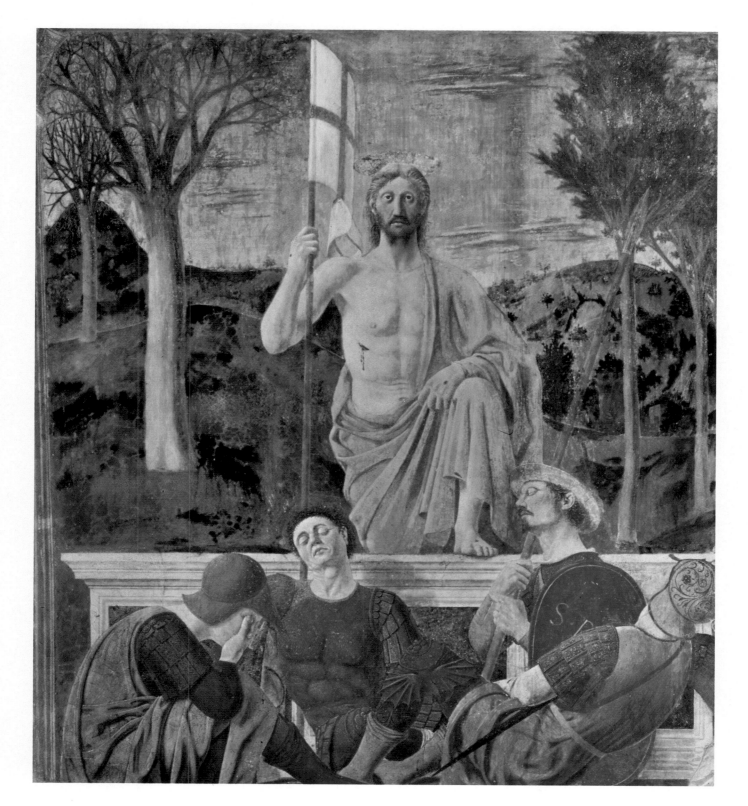

To show what nobody saw, between the instant and eternity, between here below and the world beyond, that is the crux of the matter. Here we have God, men and nature. Nature still dormant on the left, in the bareness of winter, but awakening on the right, revived by the message of Christ. A message of hope which has still not reached human consciousness, but which is already occupying men's dreams. The synthesis achieved here is masterly.

Piero della Francesca
The Resurrection
Fresco
Borgo San Sepolcro, Palazzo Comunale

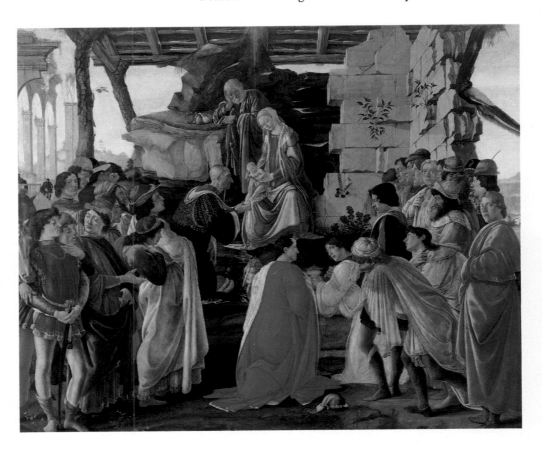

28

The tooler of arabesques

If Leonardo da Vinci had not existed Botticelli might have become the emblematic figure of the Renaissance; though in its execution his painting displays an unexpected reversion to the Gothic tradition, it is otherwise based on essentially humanist themes.

Sandro Botticelli, the son of a Florentine tanner, was apprenticed to a goldsmith in 1460 at the age of fifteen and later became a pupil of Filippo Lippi. Works in his early manner, including the *Virgin, Child and John the Baptist* (1470), still betray the influence of Lippi, Verrocchio and Pollaiuolo.

He achieved recognition at the age of thirty: the Medicis frequently commissioned work from him, and in 1481 he was invited to Rome to decorate the walls of the Sistine chapel, along with other Tuscan artists (*The trials and triumphs of Moses; The Temptation of Christ*). Apart from these religious commissions, the Medicis also called on him to decorate their villas, including the villa at Castello belonging to Lorenzo di Pierfrancesco, the cousin of Lorenzo the Magnificent, for which Botticelli painted the famous allegorical composition *Primavera* in 1478.

Botticelli's art displays a great sense of composition and narration supported by firmness of line and richness of detail. But unlike his contemporaries he had no qualms about breaking with the demands of realism and giving his imagination free rein. In the *Birth of Venus* and *Primavera*, an allegory of spring, he suggests depth merely by sticking a few trees against a background that is rather reminiscent of a tapestry, as if grace and rhythm were more important than the accuracy of the scene, just as in the body of Venus the elegance of the curve seems more important than anatomical correctness. Everything in his work appears to be subordinate to the arabesque and the undulating line. The way bodies intertwine is dictated primarily by the rhythmic demands of the composition. Neither likeness nor verisimilitude was Botticelli's objective, though he drew on reality for a complete repertory of forms which he exploited as a musician would use notes of music. This way of looking at things set him apart as an artist, with some people thinking he was unduly affected by Gothic influences.

Botticelli does not play on the same register as Masaccio; where the latter gives prominence to the power of relief and to monumentality, the former opts for line and lightness. Masaccio sculpts while Botticelli draws. He expresses himself with greater preciosity and naivety, to be sure, but also more decoratively.

According to Vasari, this excessive sophistication was the reason why Botticelli fell from favor at the end of his life; unable to break away from an outmoded style, he received ever fewer commissions and saw his studio being gradually shunned by patrons. His deliberately elaborate style attracted very few admirers after 1500 and the sparse information we have regarding the ten final years of his life suggests that he died in relative poverty. He was nonetheless the first artist to attach so much importance to movement.

Sandro Botticelli
Adoration of the Magi
Tempera on wood
Florence, Uffizi Gallery

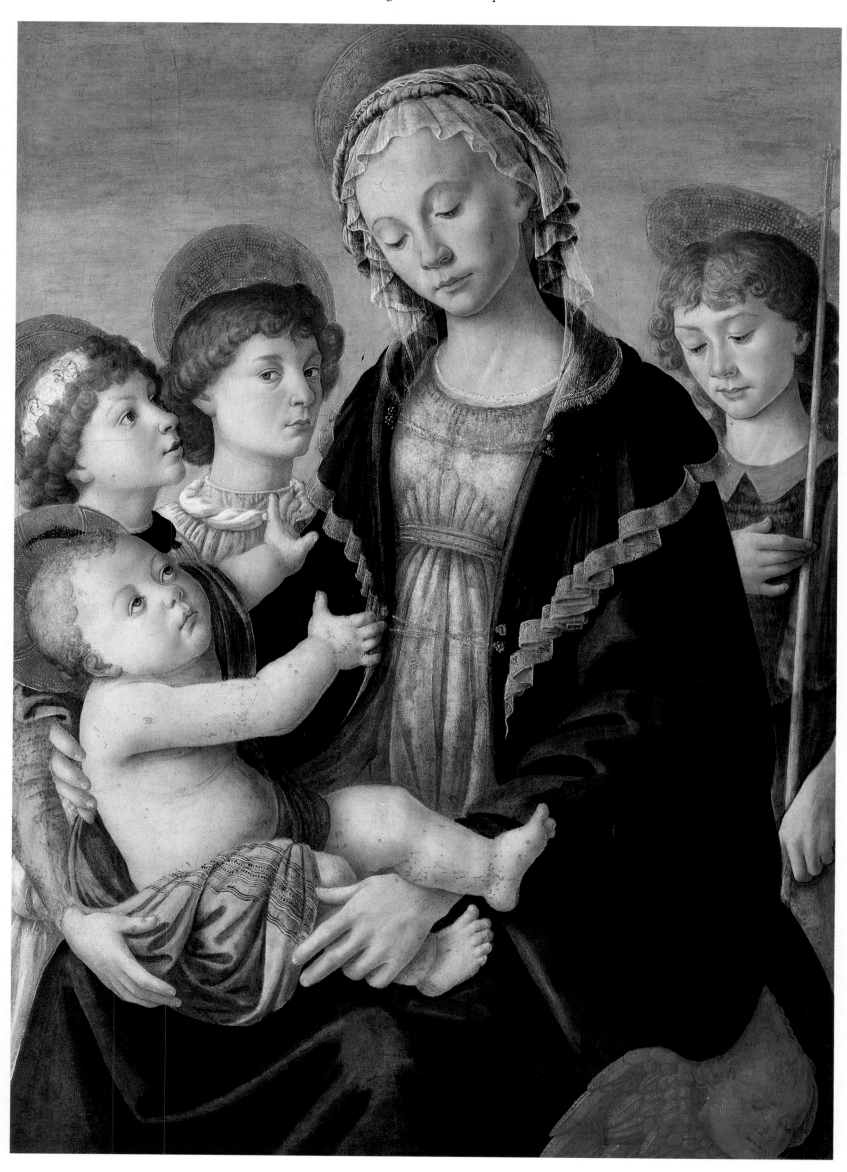

Sandro Botticelli
Virgin, Child and John the Baptist
Painting on wood
Florence, Accademia Gallery

The grace of antique myths

30

While most of Botticelli's paintings were religious works commissioned by brotherhood orders, it is through his mythological pictures that he occupies one of the foremost places in the history of painting. The influence of his protectors, the Medicis, in Florence had become paramount during the reign of Cosimo Medici (1389-1464). Cosimo's grandson Lorenzo the Magnificent carried on his work, taking the city to its cultural zenith. Himself a poet, a patron of the arts and a book-lover, he surrounded himself with the greatest Italian scholars and artists of his day, while at the same time working in the political field to strengthen Florence's position in relation to the other states in the Italian peninsula.

Pope Sixtus IV, worried by the power of Florence, secretly encouraged the Pazzi conspiracy in which Lorenzo's brother Giuliano met his death in 1478. In this context of violence and murderous intrigue, philosophical concerns might have seemed very unimportant. But the contradiction between their proclaimed humanism and the cynicism of political practice was only apparent. For this return to sources, the rebirth of antique culture, had political implications as well as esthetic ones. Though Florence was not Rome, it nonetheless laid claim to the heritage of Rome. After its exile in Avignon the previous century the papacy inevitably perceived this indirect claim as a challenge to its own preeminence in Italy. But, rather than opposing the burgeoning renaissance of the arts, the papacy was intelligent enough to turn it to its own

advantage and adopt the new humanist credo as its own. Viewed from this angle, Botticelli's arabesques take on a dimension that goes far beyond purely esthetic considerations. Of course it is by no means certain that Botticelli appreciated the full implications of this aspect of the work he was doing for the Medici family. For him the Neo-Platonism which was then in vogue in Florence was less a matter for debate than a vision of the world, accepted as such and used in the service of his personal esthetic.

For all that he had worked to propagate the humanist doctrine, Botticelli was extremely receptive to the preachings of Savonarola which set Florence alight from 1490. A vibrant advocate of Church reform, Savonarola was violently opposed to the Renaissance and the return to antiquity, which he saw as responsible for all Christianity's ills. Considered in this light the rehabilitation of antique myths seemed a moral and religious scandal, a public return to the pagan beliefs current in the empire before the reign of Constantine. Despite his devotion to the Medici family Botticelli was profoundly shaken by these criticisms.

After 1490 he abandoned mythological themes, devoting himself exclusively to religious works; some, like the *Calumny of Appelles* (1496) for example, were interpreted as defending Savonarola, who by then, threatened with excommunication, was already on the way to martyrdom, depriving Botticelli of his most precious sources of support.

Sandro Botticelli
Annunciation
Tempera on wood
Florence, Uffizi Gallery

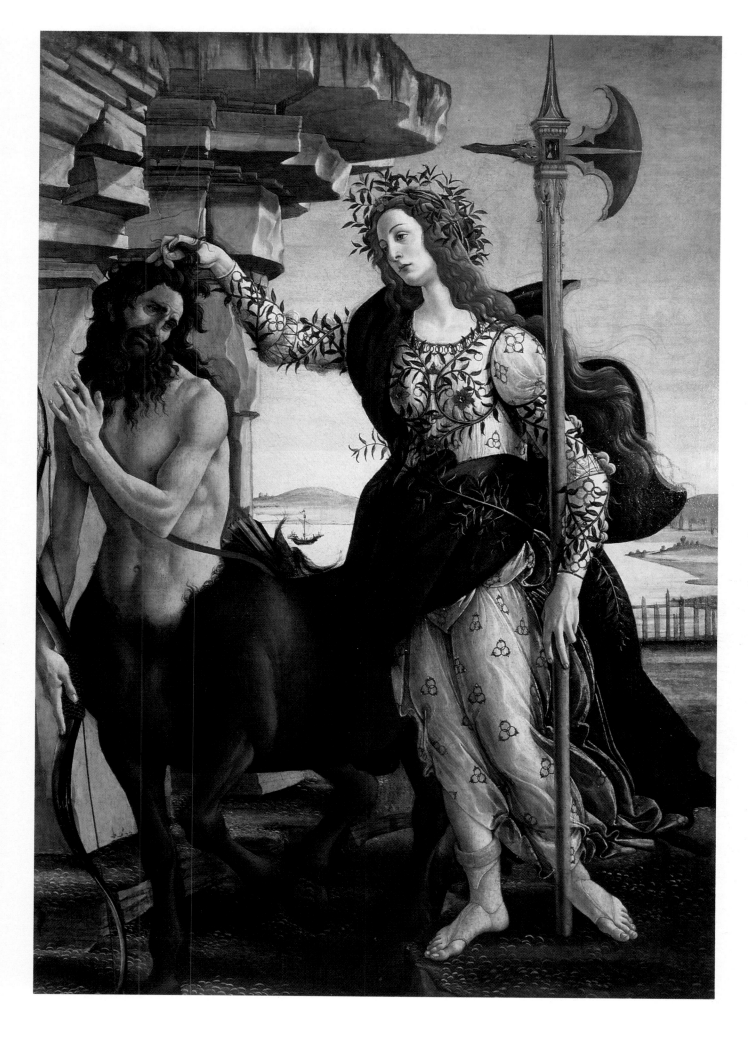

Wisdom subduing
ignorance, or beauty
subduing strength, or
possibly Florence (for
Pallas is also Flora)
reducing Rome to
impotence. However it may
be, the work is built on a
solid play of contrasts
between horizontals and
verticals, background and
foreground, light and
dark. But who gets the
upper hand in the fight?
Is Pallas restraining or
caressing the centaur?
And the ship that seems to
be sailing toward her
stomach, what is it if it is
not the shaft that unites?
Cupid is near at hand.

Sandro Botticelli
Pallas subduing a Centaur
Tempera on wood
Florence, Uffizi Gallery

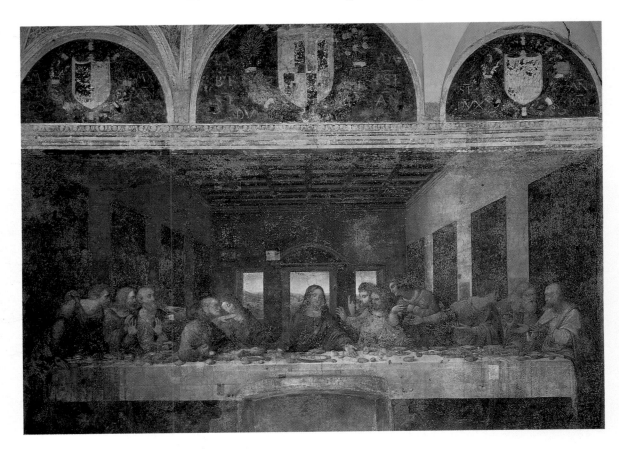

Art that brings knowledge of the world

Leonardo, who was born in 1452 at Vinci near Pistoia, entered Verrocchio's studio at the age of seventeen. When he was thirty, convinced of the greatness of his own genius, he left Florence for Milan, where he offered his services to Ludovico (Sforza) "the Moor." He remained there until 1499, when King Louis XII of France defeated his protector.

The great Leonardo was a humanist with eclectic and universal interests. Vasari described him as "variable and changeable which resulted in him learning many things, then casting them aside almost as soon as he had tackled them." Though close to the Neo-Platonic ideas current in Florence in the circle of Lorenzo de' Medici, he differed in showing a certain mistrust of purely intellectual theories. Empirical by temperament, he thought it was essential to test theory against nature. In short, systems were of worth in his eyes only as tools enabling man to understand reality. Primarily a researcher and keen on experiment, he regarded the arts and sciences as no more than a means of resolving and checking difficulties encountered in his efforts to understand the natural system.

This concept of art helps explain Leonardo's tendency to leave works he had embarked on unfinished: the *Adoration of the Kings* in Florence (1481), the *Battle of Anghiari* (lost) in the Palazzo Vecchio, the monument to Trivulzio in Milan, and the *Portrait of a musician* (Pinacoteca Ambrosiana, Milan) or again the *Benois Madonna* in the Hermitage, were never completed. Of course he did not do this out of pique or to snub those who had commissioned them, but quite simply because he was diverted by other projects, enthusiasms or patrons.

Moreover, painting was only one aspect of Leonardo's manifold activities. He was also a sculptor, an engineer, an architect, a town planner, a public health specialist, an expert in anatomy and no doubt much more. His activity, exuberant to say the least of it, eventually attracted criticism. The man who prided himself on his experiments and did not hesitate to declare that his scientific research was utilitarian in nature was reproached with some justification for letting himself be carried away in Utopian, materially impracticable projects. In short, he was accused of vanity.

Nonetheless, no sooner had he arrived in Venice in 1500 than he was again busy devising, on paper, military defense systems against the Turks. But he was only there briefly – after a long absence of eighteen years in April 1500 he returned to Florence, where he met his two younger rivals, Raphael and Michelangelo.

It was during this period that he painted the portrait of the *Mona Lisa*, the wife of the Florentine merchant Francesco del Giocondo, and the *Madonna and Child with St. Anne*, which he took with him to France when he was invited to Amboise by Francis I in 1516. Meanwhile two further spells in Milan (1506-7 and 1511-13) gave him the opportunity to work on several projects which, unfortunately, came to nothing, such as the equestrian monument of Marshal Trivulzio, commissioned from Leonardo in 1511.

Leonardo da Vinci
The Last Supper
Fresco
Milan, Church of Santa Maria delle Grazie

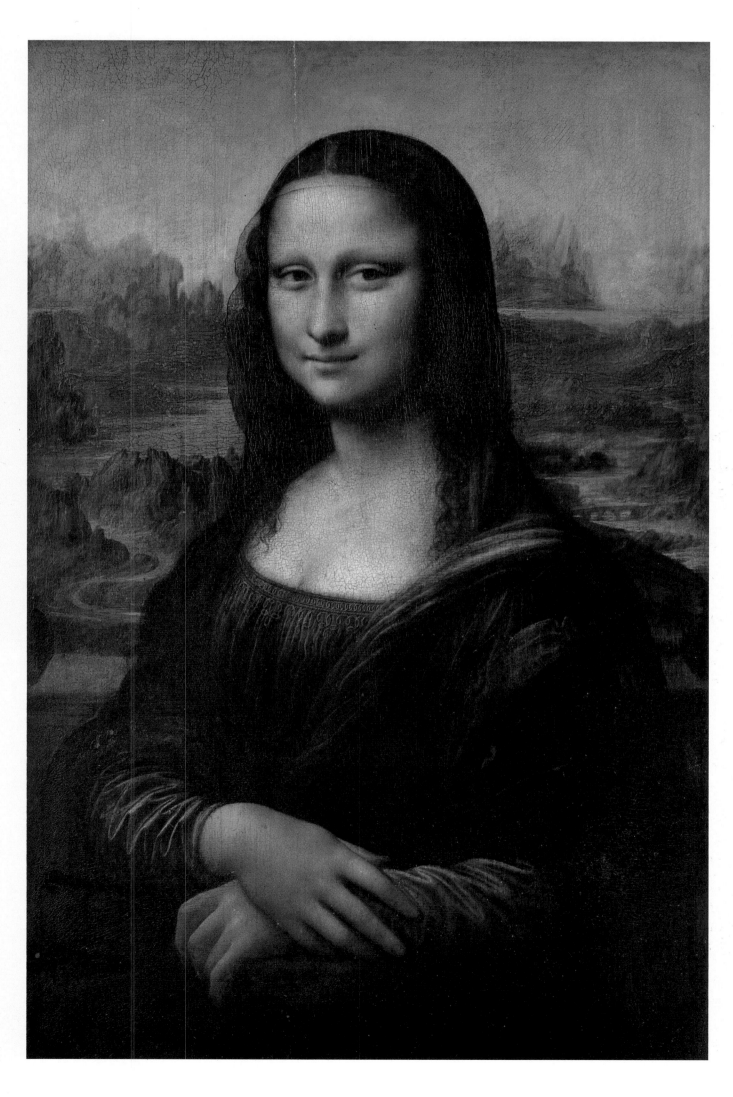

Leonardo da Vinci
Mona Lisa
Oil on wood
Paris, Louvre

34

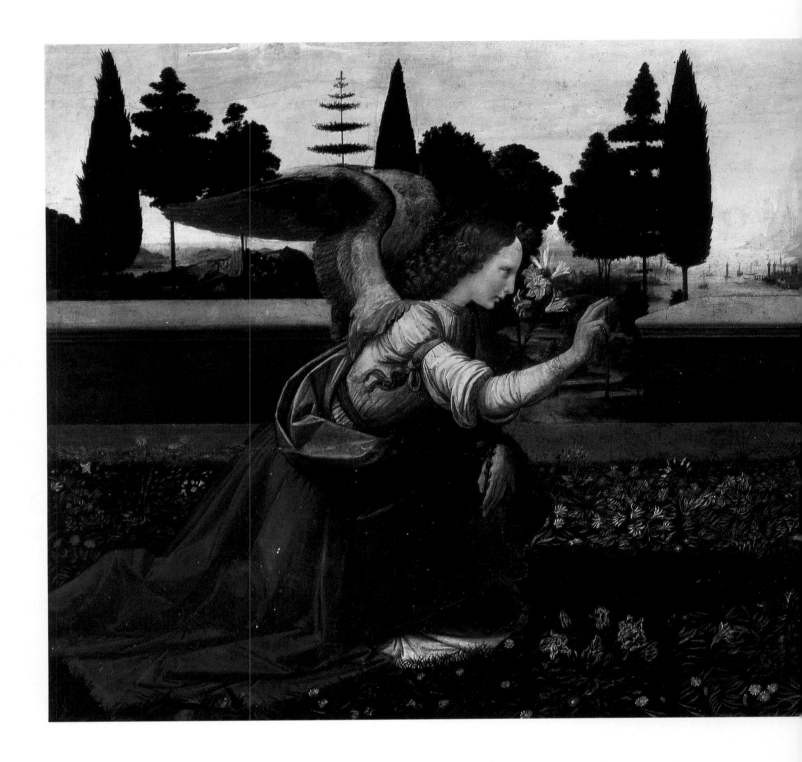

Observation and reconstruction. Everything is true and everything is false. Or rather everything we see is in the mind. The image is something mental, seen by the mind, its coherence based not on the static symmetry of volumes but on the subtle imbalance of a harmonious counterpoint. The massive, light verticals of the building on the right are contrasted with the tall, dark boles of the cypress trees on the left. The foreground with the profusely flowering meadow is opposed to the smooth, bare surface of the terrace. The right hand which gives is opposed to the left hand which receives.

And the play of contrasts culminates in the foreground in the ambiguous metamorphosis of the lectern, a kind of mineral emanation of the vegetable kingdom in which it is rooted, serving simultaneously as a rampart for the Virgin and a paradoxical betrayal of her feminine nature which is denounced twice, by the heaviness of her already impregnated hips and by the conch, the symbol of Venus, its curves referring back to the wider curves of the Virgin's cloak, the lines of which converge on her entrails draped in gold and purple. While toward the rear, subtly prepared by a series of alternating light and dark horizontals, the mystic ecstasy seems to be resolved in the pure golden light of an immaculate sky.

Leonardo da Vinci
Annunciation
Oil on wood
Florence, Uffizi Gallery

Mystery and illusion

To Leonardo, knowing the world meant expressing its mystery, exploring every possibility without exhausting it. His knowledge of the visible had enabled him to understand that reality is not a single entity, but something multiple, changing and elusive. To perfect the illusion of truth, the painter had to invent a technique allowing a breath of uncertainty to hover round the model. This was *sfumato*, virtually the opposite of Botticelli's technique: by toning down the lines and contriving imperceptible transitions from one color to another it gave the composition as a whole a unity and truth such as had never been achieved before.

In contrast to his predecessors, who had been motivated by an obsession with using line, perspective and modeling to create compositions that were fixed, transforming their people into flawless statues, Leonardo understood that the illusion of life can only spring from reaching an improbable equilibrium between symmetry and dissymmetry. A line that is too pronounced, or over obtrusive construction, destroys the vibrancy of reality, while at the other extreme imprecision and confusion can create a visual jumble, making it impossible for the mind to assimilate the scene. It was essential to invent a manner of painting that would reconstitute our way of seeing – our natural mode of vision. When the human eye takes in a scene, it always concentrates on one point; everything round that point is not seen directly, but perceived as peripheral and no doubt partly recomposed by the imagination, especially in the case of a setting we already know well from other occasions. That is why, each time we look at her and wherever our eye focuses, the *Mona Lisa* is "neither exactly the same, nor entirely different."

The same "space" for the imagination can be found in *The Last Supper*, a fresco painted for the refectory of the monastery of Santa Maria delle Grazie in Milan. Yet again, rather than subordinating his composition to the single rule of formal harmony, Leonardo first tried to imagine the drama, and relive it as if it were happening now. Out of a single, frontal, monotonous scene he makes five scenes: four threes and a one! Rather odd arithmetic, but it works wonderfully, with the eye able to range at will from left to right or from right to left, without a break, always returning to the central figure of Christ, withdrawn, motionless and silent, in strange contrast to the bustle of the Apostles.

Leonardo's contemporaries were immediately struck by the note of truth in *The Last Supper*, which was painted on the end wall of the refectory. Unfortunately, by an ironic twist of fate, today we must again use our imaginations to visualize the work in its original state, as it has been damaged by damp filtering through from the primary coat. However regrettable this may be, what has survived is still sufficient to demonstrate that Leonardo achieved his aim of making painting both a major art form and an extension of life, a subtle point of equilibrium between opposites.

Leonardo da Vinci
Madonna and Child with St Anne
Oil on wood
Paris, Louvre

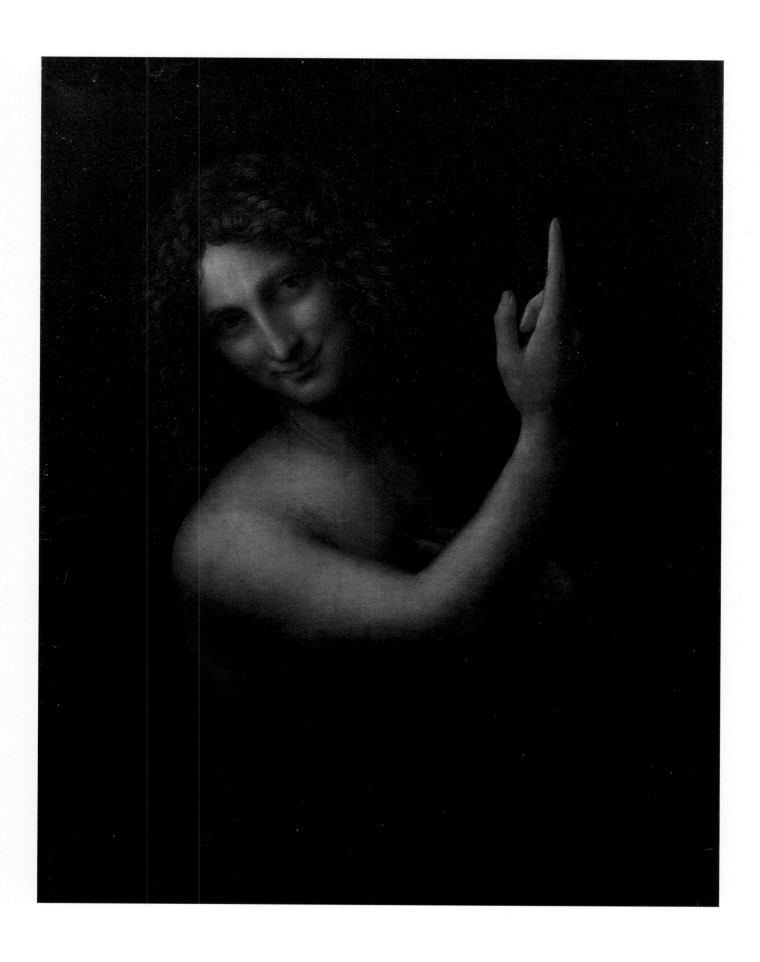

Leonardo da Vinci
St John the Baptist
Oil on wood
Paris, Louvre

This tondo, regarded as the first Mannerist work, is a virtual summary of the contradictions inherent in Michelangelo's genius. Where nothing was needed, he could not refrain from putting something in. The eye is drawn despite itself from the foreground to the middle ground, where a few provocatively naked ephebes are disporting themselves. The concept becomes anecdotal, and for the sake of a few superfluous bodies, by an excess of virtuosity, the scene degenerates into affectation.

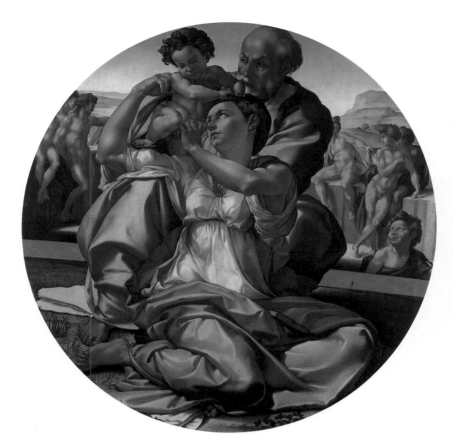

38

Expressing the divine

The new generation, twenty years younger than Leonardo, was dominated by Raphael and Michelangelo. Michelangelo, who had been noticed by Lorenzo the Magnificent in 1490, divided his time between Rome and Florence, sculpting his *David* (1501-1504) for Florence and there painting the *Holy Family* (1504) (reproduced here) on the occasion of the marriage of Agnolo Doni and Maddalena Strozzi, eminent members of the Florentine nobility.

Michelangelo was a solitary, tormented genius who, if he had been left to himself, would perhaps have made sculpture his main field of activity, because no other art was better suited to expressing all the richness and diversity of the human body. However, this was not to be. It all started when Pope Julius II invited him to Rome in 1505 and entrusted him with creating his mausoleum. Michelangelo, who was a total perfectionist, spent six months in Carrara choosing the marble for it. But on returning to Rome he discovered that the project had been postponed. Another still more ambitious enterprise was now occupying Pope Julius's thoughts. He had decided to rebuild the basilica of St. Peter and entrusted the architect Bramante with drawing up the plans. The mausoleum was immediately relegated to the background, especially as the original intention had been to locate it in the middle of the old basilica, now to be demolished. The Pope's decision hurt Michelangelo deeply. Convinced that there was a plot

against him with Bramante behind it, he left Rome and took refuge in Florence. But Julius II was unwilling to lose the services of such a fine artist. He used diplomacy to persuade Michelangelo to return to Rome, asking him to undertake the decoration of the ceiling of the Sistine chapel, an enormous undertaking. Michelangelo, who was already on bad terms which Bramante, believing him to be responsible for the shelving of the mausoleum project, became convinced that the new commission was the outcome of a conspiracy and that the main objective in offering him this work was to isolate him permanently and make him lose face in the eyes of everyone. He tried in vain to refuse the offer. But "the more he tried to refuse," wrote Vasari, "the more imperious and vehement the Pope became, as he was in all he undertook." Eventually yielding to his demands, Michelangelo agreed, and spent four years stretched out on scaffolding, looking up at the huge vaulted ceiling of the room, which is forty meters long and thirteen wide. The fresco was completed in 1512 and inaugurated on All Saints' Day by the Pope himself before an audience which was immediately captivated by the majesty and power of the work which has never since been equalled.

Apart from the monumentality and excess peculiar to Michelangelo's work, what distinguishes him from most of his contemporaries is his perfect, almost clinical knowledge of anatomy; like Leonardo, he derived it

Michelangelo
The Holy Family
Tempera on wood
Florence, Uffizi Gallery

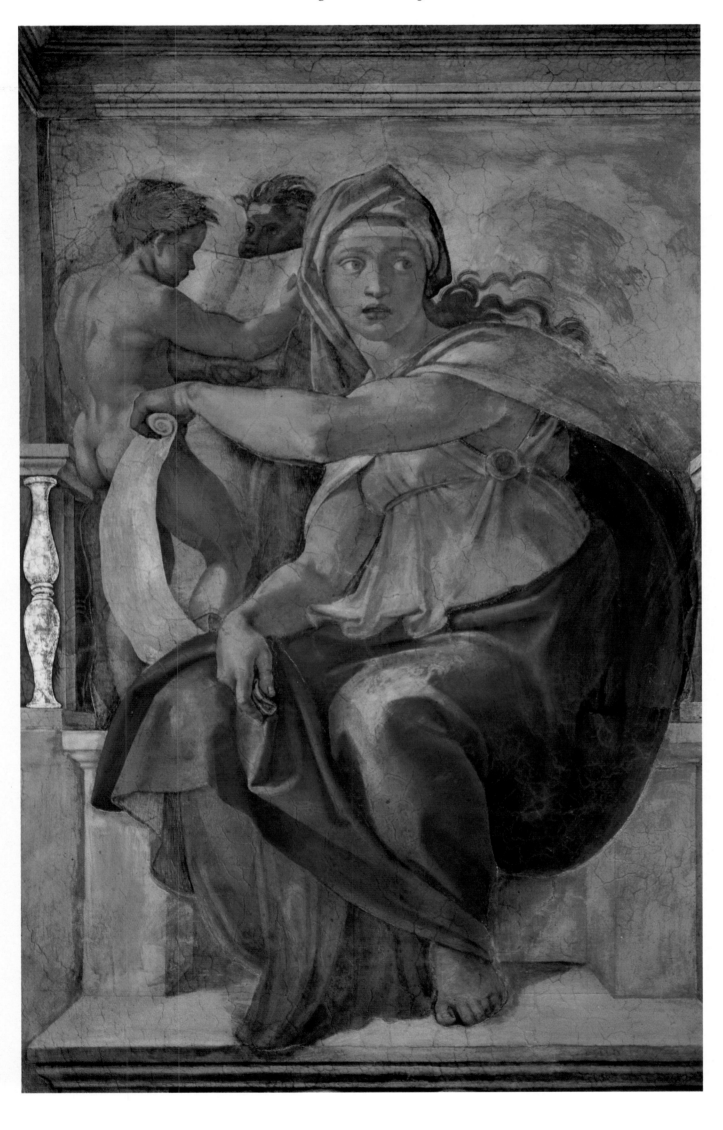

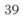

Michelangelo
The Delphic Sibyl
Fresco
Rome, Vatican, Sistine chapel

40

from direct observation of the human body and, as often as not, from the dissection of corpses. But he differed from Leonardo in that the body remained his only great passion. To him the only thing worthy of true interest was the subtle play of muscles beneath the skin rather than the fall or folds of drapery. His imagination always drew him back to representing human forms, to such an extent that some of his detractors claimed to see this as a mark of pagan rather than Christian inspiration.

As far as can be judged from the subject matter of his work, Michelangelo seems in fact to have stuck to the ideas imbibed in his youth at the court of Lorenzo the Magnificent. The Neo-Platonism then current there was in tune with the passion for antiquity that fired the young artist. A doctrine postulating that Christianity and the philosophy of the master of the Academy were compatible inevitably attracted him.

There was both ethical and esthetic continuity leading from the Greek perception of the human body as the measure of the harmony of the universe to the idea of man created in the image of God. Considered in this light, depicting the human body became the surest means of expressing the divine.

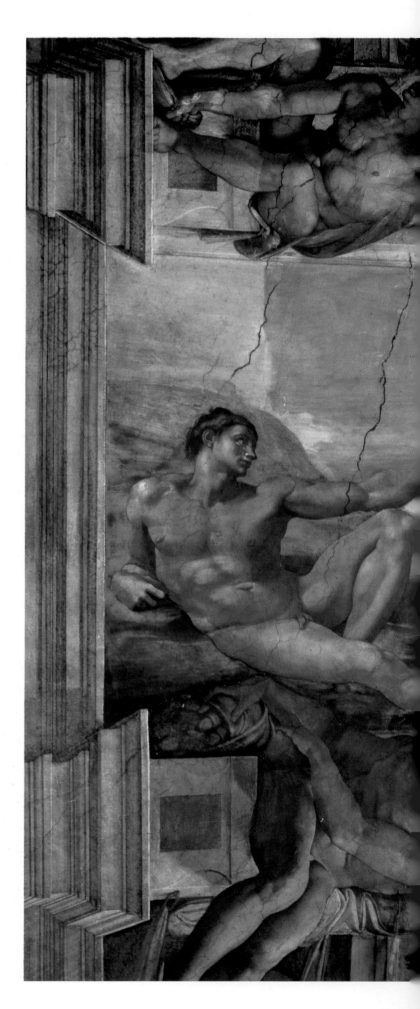

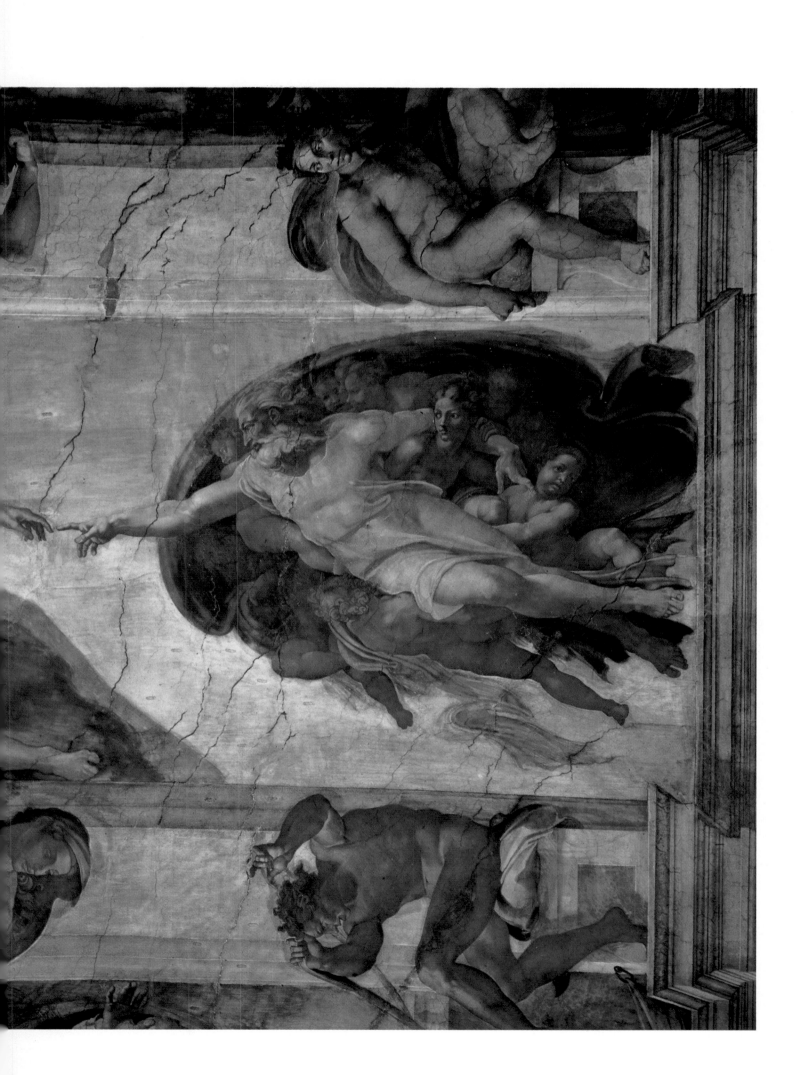

Michelangelo
The Creation of man
(ceiling of the Sistine chapel)
Fresco
Rome, Vatican

The master of harmony

42

Raphael was a kind of miracle. At a time when Italy was brimming over with talent, the young Umbrian achieved the feat of attracting immediate acclaim from all quarters, without arousing jealousy in anyone except Michelangelo, a touchy, irascible man who remained his only rival. Raffaello Sanzio, born in Urbino in 1483, was eight years younger than Michelangelo and thirty-one years younger than Leonardo. The shooting star of painting, as Mozart later was of music (to repeat Taine's comparison), Raphael died at the height of his glory on his thirty-seventh birthday.

From his first master, Perugino, he acquired a sense of harmony and balance and a liking for fair shades. He was in Florence in 1504 when Michelangelo was pitting himself against Leonardo da Vinci on the walls of the Palazzo Vecchio, and immediately established his reputation through a series of masterpieces including *The marriage of the Virgin* (1504), *the Madonna del Granduca* (1504), the *Madonna with the goldfinch* (1507) and the *Entombment* (1507). Familiarity with the work of Leonardo at that juncture gave the finishing touches to his training. Thanks to it, the conventional elegance of Perugino was tempered by a gentler line, as Raphael quickly grasped the *sfumato* technique invented by Leonardo. But the most important contribution was the new attention he devoted to facial expression, a weak point in the painting of his former master in Umbria.

As the ultimate accolade to his talent, which was by then unanimously recognized, Pope Julius II invited him to come to Rome in 1508 and paint three rooms (*stanze*) in the apartments previously used by Nicholas V, so bringing him into direct rivalry with Michelangelo, who was just starting on the fresco for the ceiling of the Sistine chapel.

The death of Julius II in 1513, then of Bramante in 1514, and the accession to the papacy of Leo X, the son of Lorenzo the Magnificent, conclusively consolidated Raphael's position in Rome. While the Pope appointed Michelangelo to Florence, where he was entrusted with decorating the Medici sanctuary at San Lorenzo, he put Raphael in overall charge of building work at the Vatican. At the age of thirty-one Raphael was responsible for the rebuilding plans for the basilica of St. Peter, though this did not prevent him from continuing to work as a painter, decorating the Villa della Farnesina for the banker Agostino Chigi (*Triumph of Galatea*) and producing the cartoons for the tapestries intended for the Sistine chapel, completed in 1519.

The most amazing aspect of this incredibly overloaded schedule was that in spite of everything Raphael never deviated from an impressive serenity, always confronting things with poise and giving the impression that for him inspiration was a spring that would never fail.

To sum up, Raphael the great organizer was also an assimilator of genius. He retained the harmony he had acquired from Perugino; he borrowed the *sfumato* technique and an enigmatic languor of facial expression from Leonardo. Finally, Michelangelo showed him how to engender pathos, teaching him a sense of the dramatic. But it was Raphael's achievement to bring together such widely differing strands to create a style which is undeniably both coherent and powerful.

Raphael
St George and the dragon
Oil on wood
Paris, Louvre

Raphael
The Madonna del Granduca
Oil on wood
Florence, Pitti Palace

The loveliest faces

44

The word harmony is certainly the hardest to avoid when talking of Raphael, and one would like to banish it from one's vocabulary as banal. But irresistibly the idea returns and insists on being used: harmony is the governing principle of his work – harmony in the composition, in the expressions and in the tones. Whereas Michelangelo (another unavoidable comparison, tired though we may be of it) struggled amid Titanic visions, Raphael placed his figures with such ease that people since have often been inclined to minimize its significance. Raphael's art is so sure that it seems easy. It is "obvious," i.e. accessible to everyone. This is so true that even today, five centuries later, it is still the norm of beauty. The generations of artists that have followed him have never managed completely to eradicate this conviction from the mind of the public: anything that approximates to the ideal set down on canvas by Raphael is beautiful. Raphael along with Phidias has established the criteria of universal beauty – universal meaning ideal. The lovely faces painted by Raphael, unlike Mona Lisa's, have never existed

other than in the painter's imagination. With him the quest for reality embarked on with Giotto reached the paradoxical point of denying itself in order to attain fuller expression, and Renaissance art disclosed its true nature as an art of illusion. Raphael created a world that is truer than nature, and that makes him the greatest Neo-Platonic artist of the Renaissance. In any case nature interested him less than beauty, the only true subject of his art. Raphael does not copy or reproduce, he pursues a "certain idea" peculiar to him, or rather which he sees as being shared by all. Taking issue with those like Aristotle, who show the Earth and Nature (*physis*), Raphael adopts the position of Plato who in the *School of Athens* points to the world of ideas. So it is not surprising that nature figures so little in his work, the backgrounds in his pictures as often as not being either monochrome or architectural. It is as if the mind, always the mind, had been along to reconstruct and purify reality and make it both more intelligible and more beautiful.

Raphael
The Deposition
Rome, Villa Borghese

45

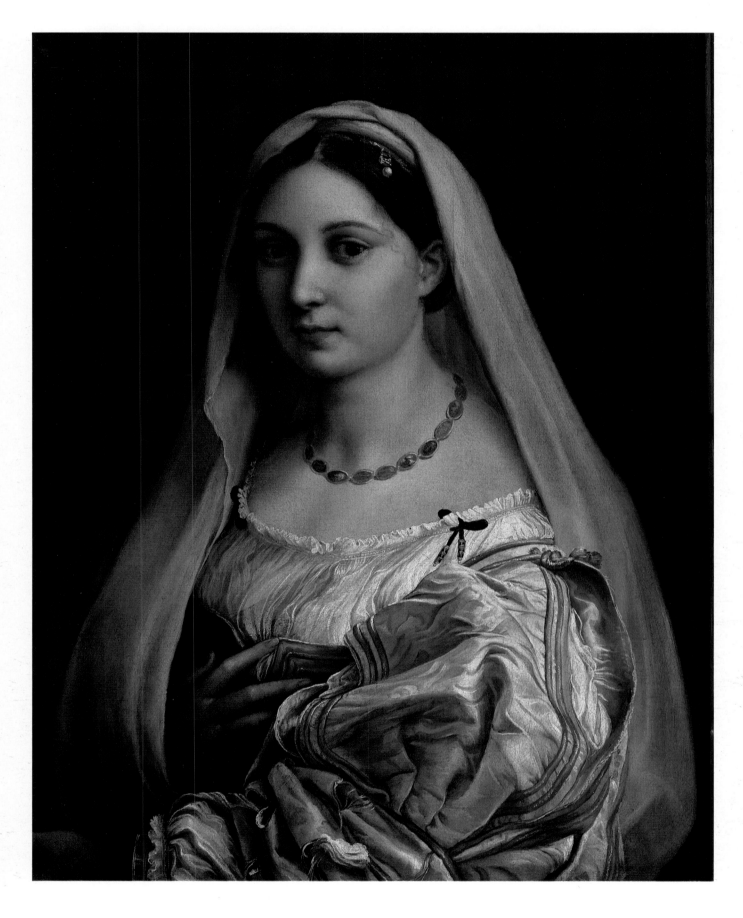

"*With Raphael the
Florentine line which
suffered so much to get
under way and not be
extinguished breaks free,
giving surface definition
and three-dimensional
reality to the succession of
planes and the
uninterrupted progression
of reliefs, and in a
harmony in which grays
and reds, greens, blacks,
purples and silvery whites
become one with the damp
substances of the walls on
which they are
permanently fixed, the
expressive unity of line,
mass and color becomes
manifest for the first time.*"

Elie Faure
*L'Art renaissant
(Histoire de l'art, vol. III)*
Plon, 1939

Raphael
The veiled women, known as La Velata
Oil on canvas
Florence, Uffizi Gallery

The annals of color

Another giant in this century of giants was Titian, who ruled over Venice and Europe for more than sixty years. While the discovery of America hastened the economic decline of the Republic which started when the Turks captured Constantinople in 1453, the city of the Doges riposted by shining in the arts. The 16th century belonged to Venice, so bringing to a close two centuries of Florentine supremacy.

Elie Faure describes Titian as the "father of painting." A statement of that kind is of course always debatable, and there are others with a good claim to such distinguished paternity. Nonetheless there is some truth in the claim. Up to the time of Titian painting had remained closely bound up with drawing and architecture. The temptation of science, very present in the *quattrocento*, had linked it with the thorny question of perspective, from which neither Leonardo da Vinci, Michelangelo nor Raphael had been able to free it. In their way, they had even contrived to make it more dependent on it. It took Titian to set painting free and restore its complete autonomy by exploiting the only weapon that was really its own: color.

In Titian's work architecture is color. Everything is organized in huge colored masses, purple red, golden or azure, from which the figure emerges like a kind of epiphany. The figure does not stand out against a background, it results from it. It is a synthesis of color, the fruit of the gestation of color. For in Titian everything is alive, since everything is color. Everything palpitates in the light, the sky and the cold metal of the armor alike, both the architecture and the features of a face.

More than any other painter Titian had a genius for making the transition from one block of color to another and from light to dark without ever bungling or petrifying his composition, foreshadowing both Rembrandt and Caravaggio.

In the words of Vasari, Titian proceeded by "large lines applied with a broad brush and by flecks ... so much so that (his works) cannot be seen close to, but from a distance the result is perfect." Making no preparatory drawing, he painted "with nothing but colors" which he brought together using only his fingers, working with frenzied urgency, but guided by the amazing certainty that he would always get things right. It was from this bold technique, imbued with the vibration of the instant, that Manet and the Impressionists drew inspiration three centuries later.

This anxious, sometimes somber and tormented painting which marked the start of the Mannerist period was paradoxically enough the work of a serene yet astute man. He was a friend of the powerful d'Este family and the Gonzagas of Mantua (*Federico Gonzaga with a dog*, 1525), and was equally able to gain the confidence and esteem of Pope Paul III Farnese, King Francis I of France and, above all, Emperor Charles V, who made him a Palatine count in 1533. These powerful connections might have caused the artist's inspiration to dry up, but not a bit of it – at over eighty years of age Titian was still painting, and as he had nothing left to prove he could freely abandon himself to its joys. This resulted in some of his most powerful canvases, of which the *Entombment* (1559) is the most typical example.

Titian
The concert
Oil on wood
Florence, Pitti Palace

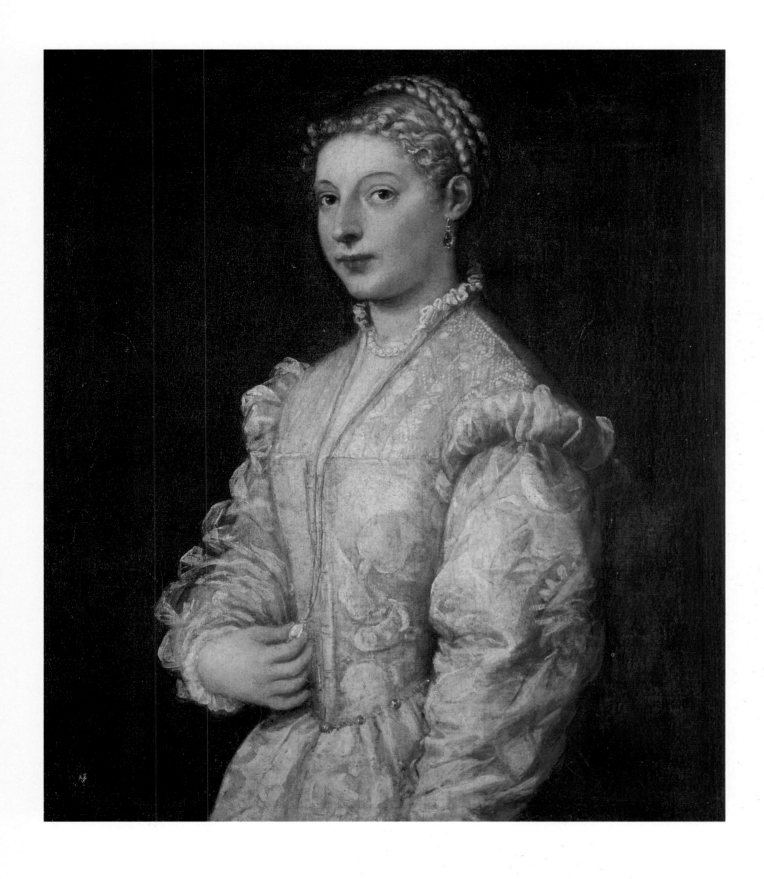

Titian
Portrait of Lavinia Vecellio
Oil on canvas
Naples, Capodimonte Museum

48

"*The beautiful full bodies which the courtesans of Venice displayed for him on deep beds, wearing only a necklace round their necks, a bunch of roses in the hollow of one hand ..., radiated the same serenity that he had found in the earth. ... For them love was a function ..., filled with a quiet intoxication The heads had the calm eyes of animals in which tawny gleams reflected the heavy hair and the peaceful space that enveloped them in amber.*"

Elie Faure
L'Art renaissant
(Histoire de l'art, vol. III)
Plon, 1939

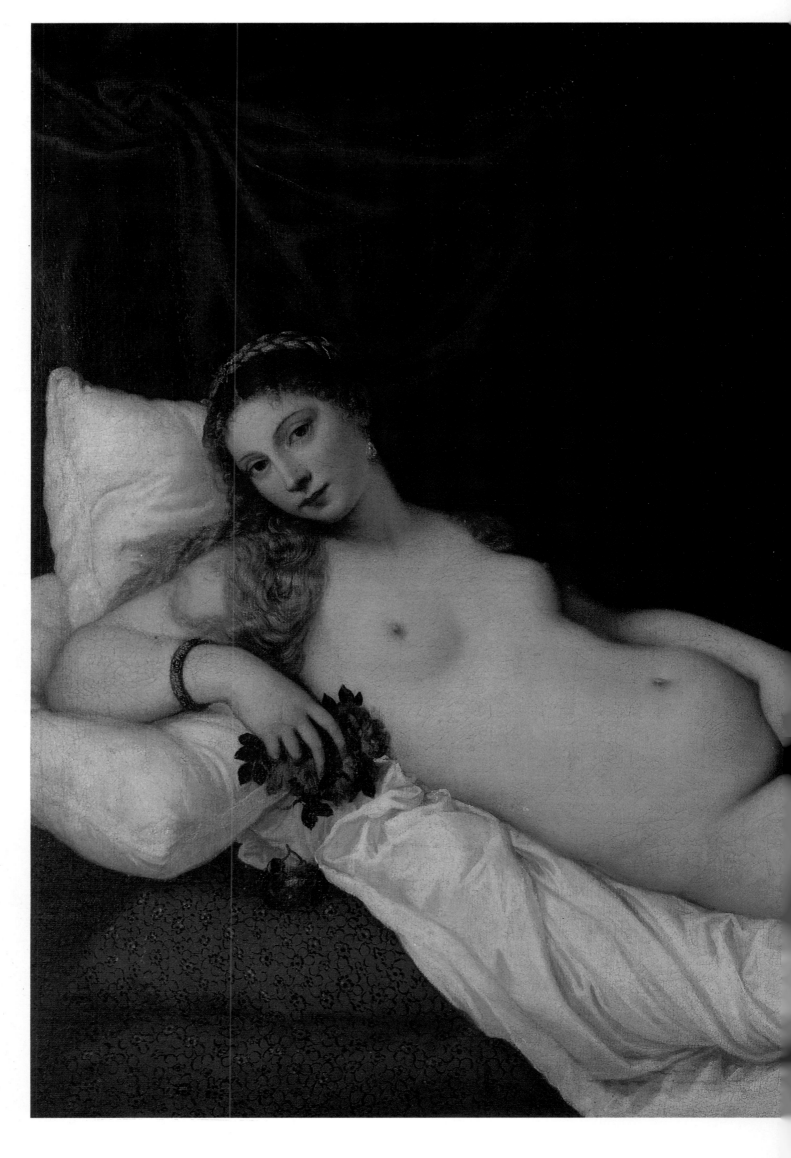

Titian
Venus of Urbino
Oil on canvas
Florence, Uffizi Gallery

The expression of desire

50

Correggio's career, definitely less prestigious than Titian's, was also shorter since he died in 1534 at barely forty-five years of age. Not much is known about him as a man, so he was probably self-effacing. According to some he was of humble birth, while others claim that he was noble; at all events he grew up, lived, painted and died in Correggio.

Less powerful than Michelangelo, less solemn than Raphael, less flamboyant than Titian, Correggio was the painter of desire and voluptuousness. This choice which is the basis of his charm earned him the homage of the libertine 18th century, then the slightly scornful rejection of the Realist 19th and the iconoclastic 20th centuries. Yet if Correggio borrowed a lot, he could also invent. And the completely personal way in which he synthesized the discoveries of his contemporaries marked the beginning of the Baroque movement which acknowledged him as its true initiator.

He borrowed a heightened sense of perspective and foreshortening from Mantegna's work, then added sensuality to the mixture. In Correggio's work, the painted body is not a scientific object, but a body that is loved, the object of physical desire. He is not concerned with displaying perfection or suggesting harmony, but with imparting attraction and inspiring enjoyment. His art is based on imbalance, celebrating lascivious abandon; dedicated to curves and diagonals, it rejects the straitjacket of the frame and the norm of architecture.

Correggio's bodies, floating on drapes resembling clouds, like the *Danaë* in the Galeria Borghese, or alternatively swathed in wafts of vapor like Io innocently responding to Jupiter's caresses, move with troubling, flowing weightlessness. The eyes are drawn less to the men than to the women, and when it comes down to it, it is quite therapeutic to see these delightful naked bodies confidently disporting themselves in the holiest places. Even though some of his contemporaries expressed shocked disapproval at such a display of fresh, rosy flesh on the ceiling and walls of Parma cathedral, it has to be admitted that there is always something childlike about the desire expressed by Correggio. His women are women, but the virility of his male figures on the other hand is open to question – they are almost always depicted as harmless youths.

If his painting is joyful and sometimes mawkish, does that mean it is minor? This reproach has been leveled at it, and its ease and elegance do sometimes come close to affectation. But why should this be a reproach, since these are its values and it adheres to this esthetic? Why reproach it with not being classical since in fact in its manner it transcends classicism, offering an alternative vision, a different world, and a different morality?

If he is less grandiloquent than Michelangelo and less perfect than Raphael, might not these very factors mean that Correggio is subtler, more touching and hence more human? But it would seem that this kind of humanism, emotional rather than intellectual, does not fit in well with great art's claims to universality – as if painting was duty-bound to be something more than an accomplished compilation of colors and light.

Correggio
Allegories of the Vices and Virtues
Gouache
Paris, Louvre

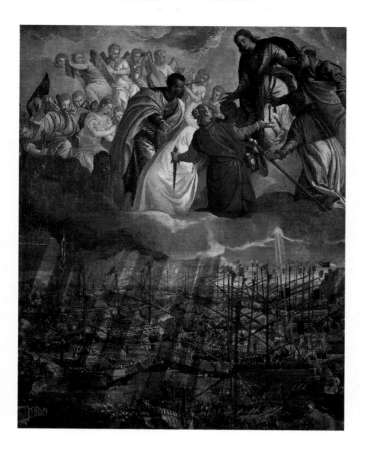

The rule of balance which characterized the first two decades of the 16th century was replaced in the following decades by the rule of excess. Correggio had already pointed the way by gaining acceptance for his compositions constructed on diagonals. Under his influence Parmigianino developed an elegant, refined style of painting. Deliberately distancing themselves from the classic sculptural solutions introduced by Raphael, though still drawing inspiration from his example, the artists of the new generation in their desire for innovation were persuaded to abjure the rule of symmetry, or rather to seek a different symmetry, a different balance, based not on the identity, but on the opposition of masses and the intentional distortion of anatomy. This deliberate search for effect earned them the name Mannerists.

Mannerism is not really a movement. Defined in negative terms by the renewed questioning and perversion of the classical rules, it really relates to a period and covers the most varied painterly tendencies, ranging from the anguished, unreal style of El Greco to the coldly decorative, impeccably drawn works of Bronzino. So it would be fruitless to look for unity or coherence in the work grouped together under the term "Mannerism."

Behind the excess and outrageousness doubt and uncertainty very often show through. To gain a proper understanding of the precise implications of Mannerism, it is useful to remember that the second half of the 16th century was marked by considerable turmoil, in both the political and religious spheres. While northern Europe was being won over by the Reformation, the Council of Trent was the signal for the unleashing of the Counter-Reformation in the south. Christianity was torn apart. And the first materialist theories were appearing in print, maintaining the primacy of reason over dogma. Giordano Bruno, who defended the theory that the sun was the center of the planetary system, was burnt alive in Rome in 1600. The proud certainties of the early 16th century gave way to doubt and violence.

In these circumstances it was each man for himself. In Venice, Veronese won acclaim with huge, splendid scenes, at the opposite pole from Correggio's intimate pictures. Each work served him as a pretext to exalt luxury and splendor. Veronese glorified Venice, and his painting overflows with costly clothes, jewels and fair-skinned flesh. Sophistication in his hands verged on intoxication. In bravura paintings like the *Marriage at Cana* (c. 1571) or the *Feast in the house of Levi* painted two years later, things are piled on top of each other in such a way that it would be virtually impossible to distinguish what is essential from what is of secondary importance in this milling throng, if the artist by his organizing talent had not succeeded in saving the scene from chaos through a clever play of perspectives.

While in his taste for overloading Veronese foreshadows certain aspects of 17th-century Baroque, in his sense of order and balance, however, he is very different from it: the drawing is clear cut, the colors

Veronese
Allegory of the Battle of Lepanto
Oil on canvas
Venice, Accademia

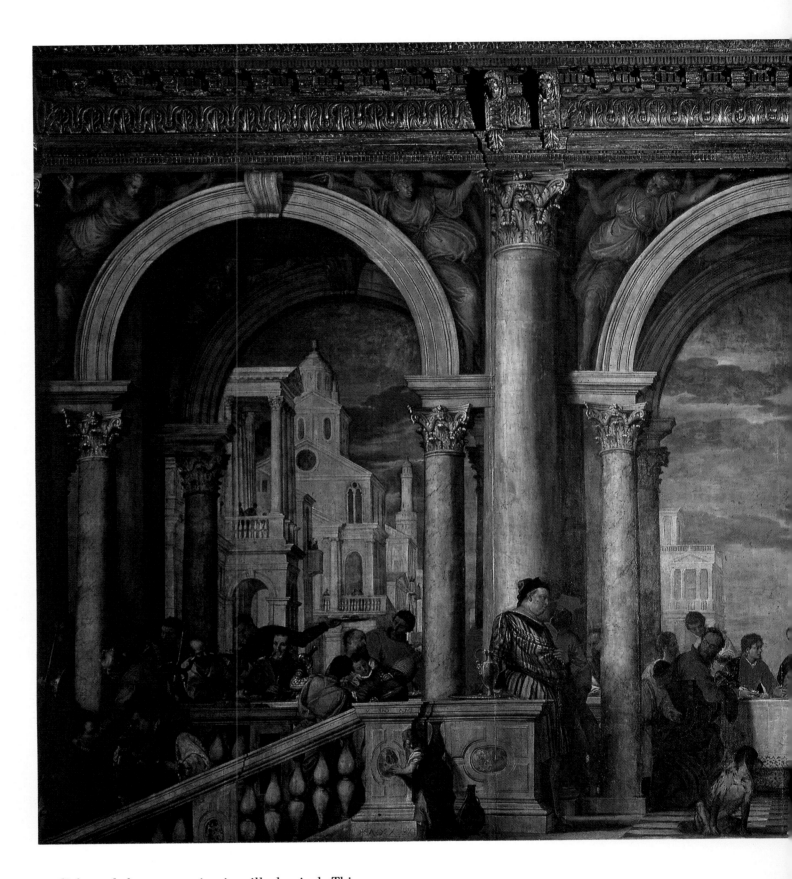

52

are light and the perspective is still classical. This means that in spite of the bustle of the people and the tangle of architecture, in spite of the glorious colors, the overall effect is ultimately one of stability and coldness – a defect or an attribute? – as this worldly, glittering painting lacks the little extra of a soul, that indefinable something, almost nothing, which is the mark of a masterpiece.

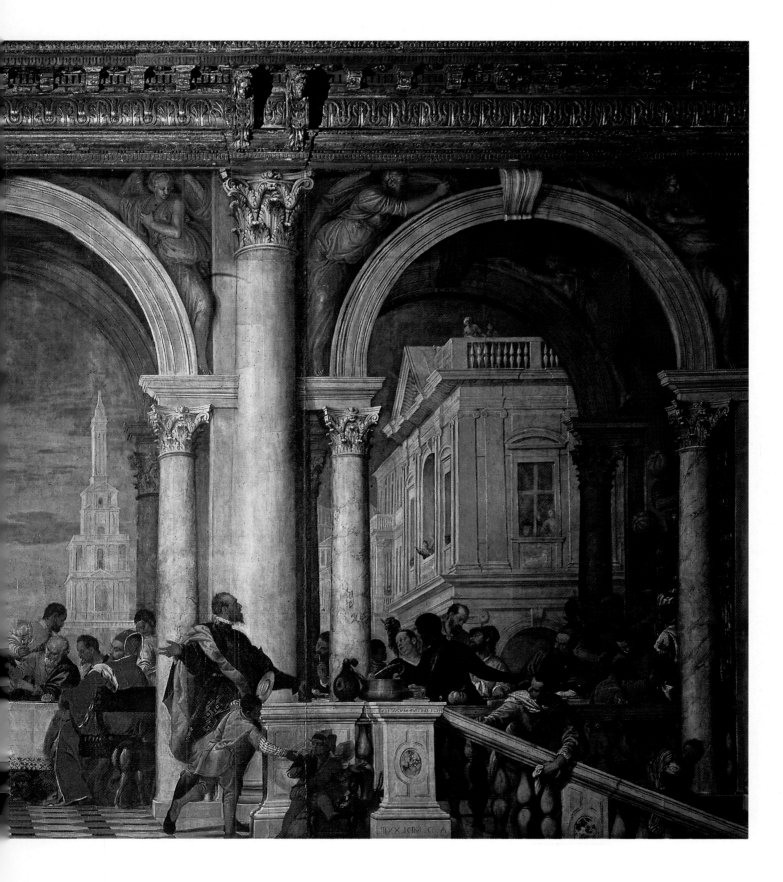

53

Charged with immorality
because of this painting,
Veronese was summoned to
appear before the court of
the Inquisition.
"What have these German
soldiers with their
halberds got to do with
the Last Supper?" the
Inquisitor asked him.
"We painters," Veronese
replied, "take the same
license as poets and fools,
and I put those
halberdiers in to show that
the master of the house
was a rich and powerful
man who could afford
servants such as those."

**Minutes of the tribunal of
the Inquisition**
18 July 1573

Veronese
Feast in the house of Levi
Oil on canvas
Venice, Accademia

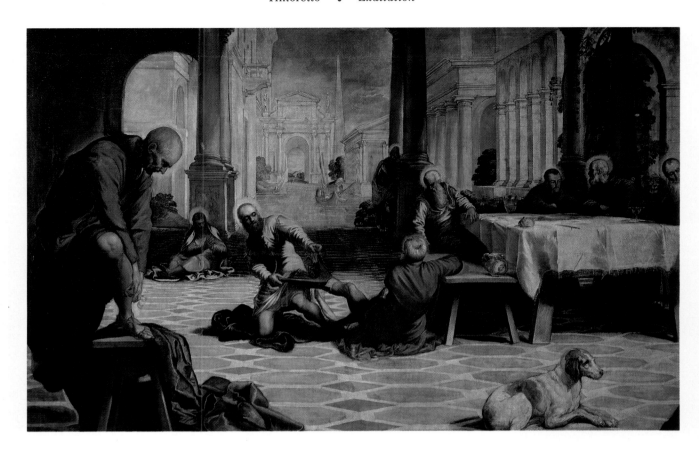

54 *Oblique bodies*

Tintoretto, the son of a Venetian dyer, never enjoyed the fame of Titian or the wealth of Veronese. Regarded by his contemporaries as a painter of less stature, he had to fight throughout his life to win recognition for his ideas and his art. Tintoretto the "Furious" was a difficult, touchy man, the archetypal visionary artist. All he wanted to do in life was paint.

His brain was overbrimming with images, and he was always on the lookout for walls to paint. He frequently offered his services for nothing to achieve this end. For the panels of the Madonna dell'Orto he charged a hundred ducats, not even enough to cover his expenses. At the Scuola di San Rocco, sensing that the brothers were reluctant to give him the commission, he turned up on the day of the competition with a completed canvas, whereas the other competitors brought only sketches, as had been requested by the monks. His audacity paid off, and Tintoretto got the commission. He hardly left the place for the next twenty years, painting a Titanic cycle of sixty canvases which are unquestionably his crowning achievement.

As in the work of Veronese there is a proliferation of bodies in these huge canvases, but unlike Veronese Tintoretto does not arrange his figures according to the classical rules of the horizontal and tiering. Bodies jostle one another, intermingling and regrouping in accordance with the uncertain laws of the vortex, repelled or attracted by strange waves of light that defy the elementary principles of realism. Everything is convulsed, twisted, exaggerated. It is odd, disconcerting painting to put it mildly, and Tintoretto has no compunction about relegating his subject to the background, as in *St. George and the dragon* (1565) or to the edges of the picture as in the *Finding of the body of St. Mark* (1562) where the saint is depicted twice, in the form of his earthly remains in the top right-hand corner, and as a haloed figure appearing to verify the authenticity of the discovery, on the left. No painter before him had been so bold. The painting spills out of the frame, crossing its bounds, leaping out at the viewer.

Sartre wrote: "The painter will always maintain the right to express the presence of the Supernatural by supercharging the being and by his control of the release of light ... the picture 'is not beautiful.' But

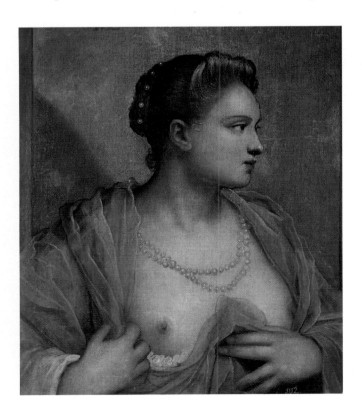

Tintoretto
Woman baring her breast
Oil on canvas
Madrid, Prado Museum

Tintoretto
The washing of the feet
(left-hand part)
Oil on canvas
Madrid, Prado Museum

"Behind a smokescreen of order – borrowed from Titian and through him from the Middle Ages – a painter is trying for the first time to reconstitute the material reality of the physical relationships between men and things; he cherishes the strange plan of demonstrating the laws of nature at the moment when they are suspended by the will of the Almighty. He is asked to paint a miracle: he uses it as an opportunity to prove causal links and universal determinism."

Jean-Paul Sartre
Le Séquestré de Venise
Gallimard 1961

55

what is meant by that? Everyone will agree with me that ugliness is not the pure, perceptible appearance of disorder: quite the opposite, it is the appearance of order where it is being gnawed at by a more or less concealed disorder That is what ugliness is: a ceremonial order eaten into by materiality."

Tintoretto fights illusion with illusion. He unmasks the myth that there is harmony between the divine order and natural order. They are neither interdependent nor concordant – between them there is combat, chaos and confrontation. The very existence of matter is a constant challenge against the purity of the Idea, worse still it casts doubt on its efficacy. In Tintoretto's work everything is falling, everything is heavy, as if movement could end only in the final immobility of superfluous matter, like dough that goes solid because it has been overfed. Tintoretto deplores the impossibility of transcendence. We do not go up or rise. Everything falls back down. Disorder reigns, and we see the frenzied celebration of a disaster which the very actors seem anxious to escape, but to no avail, for they are swallowed up in it. They are the disaster.

Tintoretto
The purification of the captured Virgins of Midian
Oil on canvas
Madrid, Prado Museum

56 *A mystic drama*

Domenikos Theotokopoulos, known as El Greco, was born in 1541 in Crete, which was then ruled by Venice. He came from a middle-class Catholic family. He went to Venice when he was probably about twenty and was a pupil of Titian, whose teaching had a profound impact on his style, still influenced by the Byzantine heritage which was transmitted in Crete through Greek *madonneri* (painters of Byzantine Madonnas).

In 1570 he left Venice for Rome. His departure, which may be interpreted as a desire to escape from a city where art was almost entirely dominated by Titian and Tintoretto, gave him an opportunity to become acquainted with the "Mannerist school." This visit also enabled him to see the frescoes in the Sistine chapel, which did not impress him unduly. Forty years later he would say of Michelangelo that he was "a great man who did not know how to paint."

In Roman circles, where Michelangelo could do no wrong, this was heresy. Realising that he would not be able to make a name for himself in Rome, El Greco looked for support elsewhere. The year 1577 found him in Toledo, where he won the patronage of Philip II after painting him together with Pope Pius V in the *Adoration of the name of Jesus* in 1579. However, the king disliked the next painting he commissioned from El Greco, the *Martyrdom of St. Maurice* (1580-82) intended for the Escorial monastery. Though no longer in favor at court, El Greco decided to settle in Toledo, where he remained until his death in 1614. Coming to this decision did not involve making any sacrifice since Toledo was the real intellectual and artistic capital of the Iberian peninsula. In the home of Spanish humanism El Greco met the greatest minds of the period, becoming a friend of Cervantes, Lope de Vega and Tirso de Molina.

With the *Burial of Count Orgaz* painted in 1586 for the church of Santo Tomé, El Greco finally came into his own. A new style had been born which could no longer be traced back directly to the Byzantine tradition, Venetian naturalism or Roman Mannerism. After the successful reception accorded to the retable for Santo Tomé El Greco's career was assured, and the young Cretan could at last satisfy his taste for ostentation by moving into a huge, twenty-four-room house rented from the Marquis of Villena.

In contrast to this worldly side of the artist's personality, his work curiously enough betrays an unquiet spirit and an anguished perception of existence. From Byzantium El Greco retained a frontal approach in composition and a clear disdain for the academic rules governing the construction of space, and from Titian a feeling for color and the value of the "unfinished" touch. But his originality lay in stretching the unreal quality of people and situations to its utmost. For El Greco does not paint reality. His painting is expressionistic and resolutely subjective. His slender, elongated bodies and his spectral light ultimately made him the painter of the Spanish soul, the painter of a dark mysticism deeply marked by a vision of the human destiny essentially understood as drama.

El Greco
Holy family with St Anne
Oil on canvas
Toledo, Tavera Hospital

El Greco
Burial of Count Orgaz
Oil on canvas
Toledo, Church of Santo Tomé

58 *An uneasy concern for detail*

Dürer was born in 1471 in Nuremberg, Franconia, the third child in a family of eighteen. He started an engraving apprenticeship in the studio of the painter Michael Wolgemut at the age of fifteen, and on a visit to Colmar in 1491 had the opportunity of acquiring several drawings by Martin Schongauer, a master of the German late Gothic, who had a crucial influence on him (until he discovered Italian art) and who is no doubt the source of his concern for exactness and attention to detail.

Dürer was already familiar with Italian work through engravings and prints. Visits to Venice in 1494 and 1505 enabled him to meet Gentile and Giovanni Bellini and study the works of Mantegna and Leonardo da Vinci. As a result his art was enriched by new preoccupations: the representation of space and the correct proportioning of the human body. This interest, which would never cease to absorb him, led him to write several theoretical works the most famous of which was the *Treatise on human proportion* published in 1528, the year of his death.

One very important contribution made by Dürer was to serve as a meeting point between the Flemish and Italian schools and the German late Gothic tradition, which was still very much alive along the Rhine. Dürer's art, with its religious, almost mystical spirit is symptomatic of a conflict between two concepts of the world: the medieval tradition which saw art as no more than an inspired transcription of divine thought, a simple translation process celebrating the miracle of creation, as against the humanist tradition which saw the artist as fully responsible for his own work and – while not the equal of the Creator – able to be regarded as his favored confidant.

The synthesis effected by Dürer resulted in a sort of saturnine humanism: man's melancholy meditation on himself, torn between the desire to create and doubt concerning the precise significance of his creativity. In contrast to the proud, self-confident art of the Italian Renaissance, Dürer's art is notable for modesty and humility. He sees the artist not as God's rival but as his servant, whose main mission is to depict sacred history. The careful detail with which things are represented is evidence of his submission to a higher order beyond his comprehension, which he can do no more than glimpse: "I am incapable of knowing what beauty is," he would say.

At a disturbed time when religious debate concerning the end of the world had again become a highly topical issue in northern Europe, Dürer found some answer to his metaphysical disquiet in the preaching of Luther. Rather than the universally orientated humanism of Rome, both Luther and Dürer advocated a return to the Scriptures and the possibility of a direct dialog with the Creator, undertaken in humility and submission. This new spirit combining mysticism, individualism and realism, which he was the first to succeed in expressing in the name of the re-emerging German nation, would result in his being proclaimed three centuries later as the "father of German art" and becoming the figurehead artist of the Romantics.

Albrecht Dürer
Adoration of the Magi
Oil on wood
Florence, Uffizi Gallery

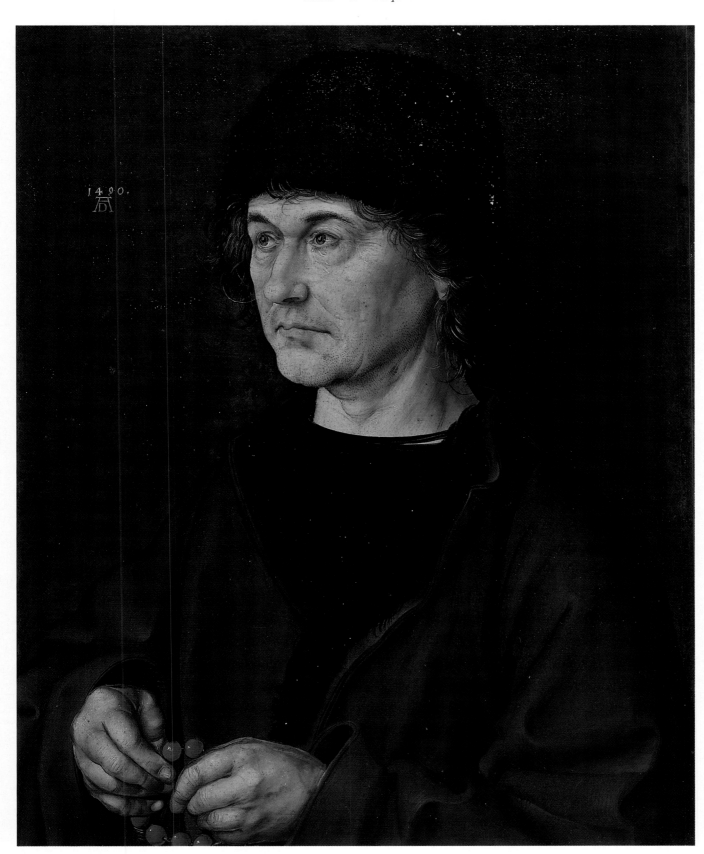

59

*"If humanity interests him
in the same way as an old
half-gnawed bone that has
been left lying around, it
attracts him no more.
While he put his signature
to powerful portraits using
tight, strong relief ..., the
same rugged vigor and
concern for life in its
dense totality can be
found in tree bark, a vine-
plant, or a rock projecting
from a tuft of grass
Each detail is so
thoroughly apprehended
with every fiber of his
being ... that a tremor
and a murmur run
through everything"*

Elie Faure
*L'Art renaissant
(Histoire de l'art, vol. III)*
Plon, 1939

Albrecht Dürer
Portrait of the artist's father
Oil on wood
Florence, Uffizi Gallery

A return to sources

Lucas Cranach the elder, who was born in 1472, belonged to the same generation as Dürer. Regarded as one of the founders of the Danube School, he was also a court painter and, first and foremost, through his friendship with Luther, a Reformation painter.

Historically speaking the Danube School coincided with the last phase of the Gothic period in Central Europe. While it was influenced by the Italian Renaissance, it differs from it in the special role assigned to nature. In contrast with the symbolic, primarily decorative or anecdotal role of nature in the International Gothic style, in the work of painters of the Danube School nature acquires a personality of its own. It reflects a state of mind enabling the figure to be harmoniously integrated into the landscape. Through the realism with which it is depicted, it also gives people topicality and places them in a context. Three centuries later this spiritualization of nature would form one of the main characteristics of the German Romantic movement.

However, Cranach's "Danube" period was of a strictly limited duration. We know that he was in Vienna between 1500 and 1504. He was then summoned by Elector Frederick the Wise of Saxony and settled in Wittenberg, becoming burgomaster there in 1537. A journey to the Low Countries in 1508 also gave him an opportunity of becoming better acquainted with Flemish art, the influence of which is discernible in his portraits and genre scenes, while humanist patrons at the Saxon court prevailed on him to incorporate certain aspects of the subject matter of Italian painting into his work. From then on his style became more Mannerist in execution, with elegance being more important than any attempt to integrate people and landscape harmoniously.

It is therefore possible to distinguish several strands in Cranach's enormous output. First of all there are mythological themes, with Venus occupying pride of place; his mannered, coldly sophisticated treatment of her is far removed from the generous sensuality of Titian. Then there are his portraits for which he abandoned Mannerist contrivance in favor of real psychological analysis of his sitter. And lastly there is his religious painting, revealing him as one of the foremost craftsmen of the Lutheran Reformation. To some extent his religious painting follows the same lines as his portraits, and if we can talk of a return to sources in the case of Cranach, it is in the sense of a return to the individual, a return to the Scriptures and to religion as a private experience. His religious painting is not an act of allegiance, it is a testimony of friendship and loyalty.

Cranach's loyalty to the Reformation never faltered. Luther was his daughter's godfather, and Cranach was a witness at Luther's marriage. When the Protestant princes were defeated by Emperor Charles V at Mühlberg, in spite of his great age (he was then eighty) he chose to accompany Luther during his two years of captivity, returning to Weimar only when he did. He died there in 1553.

Lucas Cranach
Portraits of Martin Luther and
Katharina von Bora, Luther's wife
Oil on wood
Florence, Uffizi Gallery

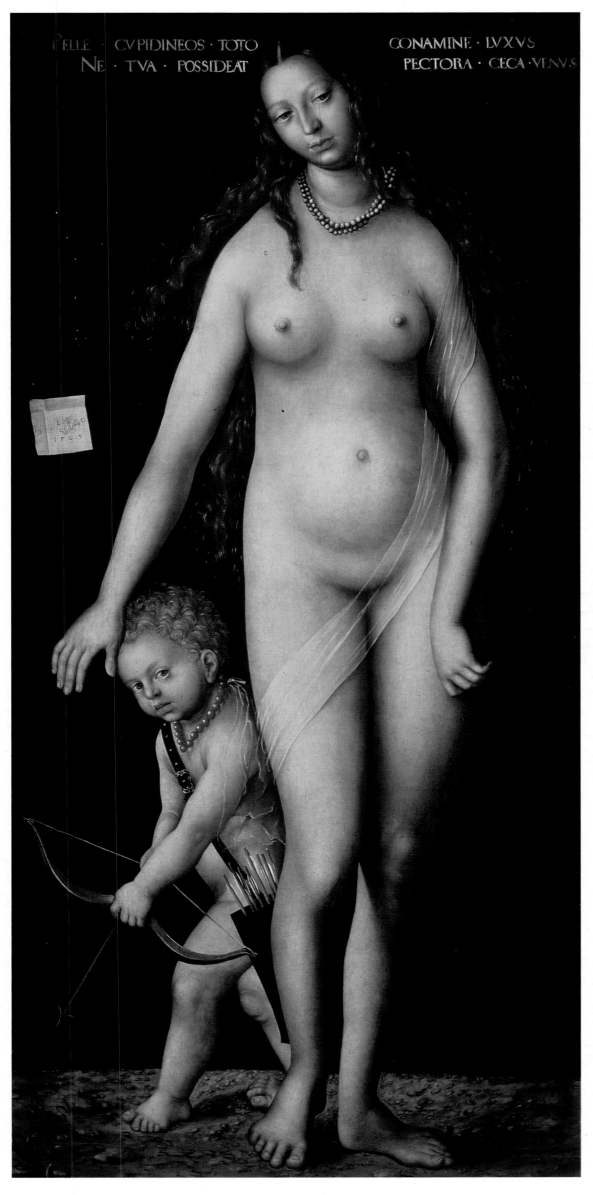

Lucas Cranach
Venus and Cupid
St Petersburg, Hermitage

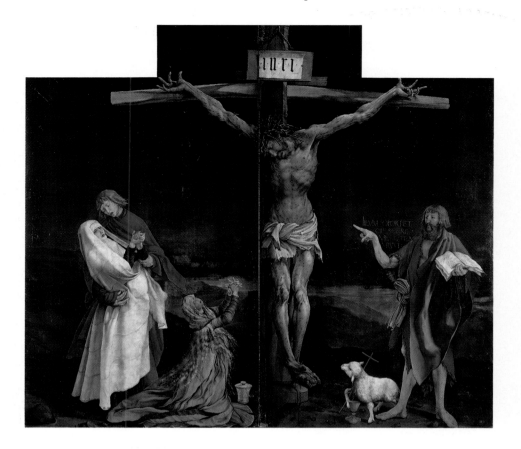

62 *The mysterious "German Correggio"*

Even today art historians know very little about Grünewald as a man. Presumably far less responsive than his contemporaries Dürer and Cranach to the ideals of the Reformation, he was a painter at the court of the archbishops of Mainz between 1508 and 1525. It was during this period, from 1511 to 1516, that he created his masterpiece, the famous Issenheim altarpiece now in Colmar museum.

A painter defying categorization, whose real name was Mathis Gothart Nithart, Grünewald was not a theorist. We have nothing written by him, not even a letter, that would give us a better idea of the man and his inner motivation. As for his work, only about twenty pictures have survived, nine belonging to the Issenheim retable, so that it is mainly of it we think when Grünewald's name is mentioned.

Unlike the Italian Renaissance painters, Grünewald did not make the pursuit of beauty one of his prime concerns. His angels in the *Concert of angels* may be reminiscent of Italian art, but his *Crucifixion* is very far removed from it. Tragic expression is more important than the pursuit of elegance. In his representation of a gaunt Christ writhing in pain on the Cross there is even a certain morbid jubilation, which forms a striking contrast with the sweetness and delicacy of the *Concert of angels*.

Thus Grünewald draws impartially on naturalistic, fantastic or expressionist registers according to the requirements of his subject, without worrying too much about a possible hiatus between these different languages, painting like an honest craftsman and using every facet of his skill without self-doubt.

This useful naivety allowed him to readopt some aspects of the medieval tradition, including varying the statures of people symbolically not according to their position in the painting, but based on their respective roles and importance. What is predominant in Grünewald's painting—as this procedure demonstrates — is its spiritual message, a desire to give greater importance to the church's canons than to the canons of beauty, at least to the kind of beauty then being defined by Michelangelo and Raphael in Rome.

In a strange way this painting, which did not balk at depicting horror in the name of realism, has taken on a degree of unreality through this very horror, to some extent influencing the whole trend of fantasy, while at the same time remaining faithful in its somewhat cold stylization to the late Gothic tradition.

Mathis Grünewald
The Crucifixion
(retable of the Antonites in Issenheim)
Oil on wood
Colmar, Musée d'Unterlinden

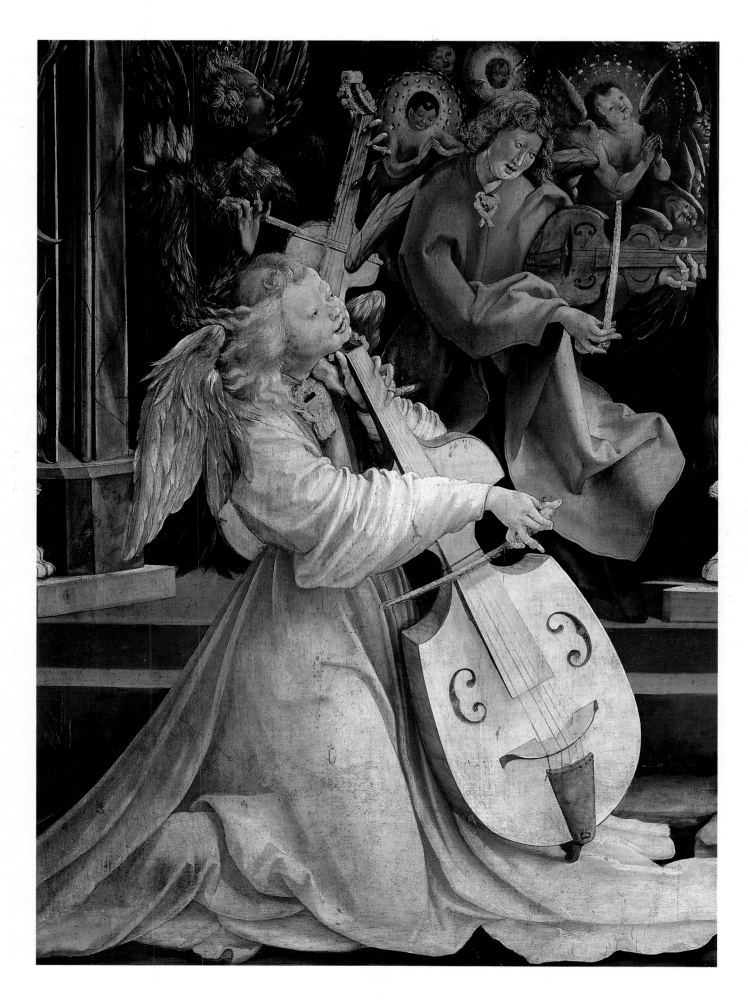

63

From the macabre horror of the Crucifixion to the slightly mawkish grace of the Choir of angels Grünewald's work displays an eclecticism that makes the most daring stylistic associations and confrontations possible. The craftsman of Issenheim, secure in the belief that well-mastered skill could not produce bad handiwork, has taken liberties that an Italian artist would have denied himself in the name of the all-powerful esthetic canons.

Mathis Grünewald
Angels' concert
(detail from the retable of the
Antonites in Issenheim)
Oil on wood
Colmar, Musée d'Unterlinden

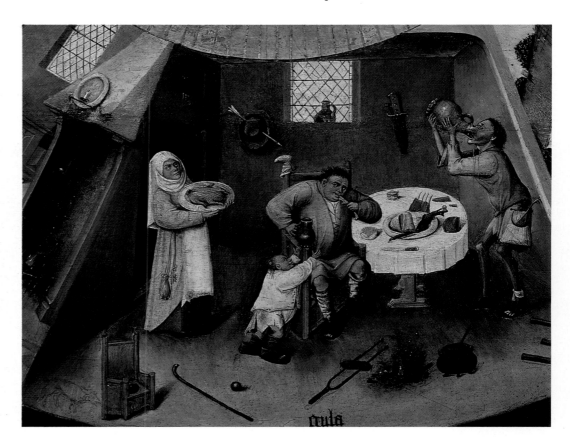

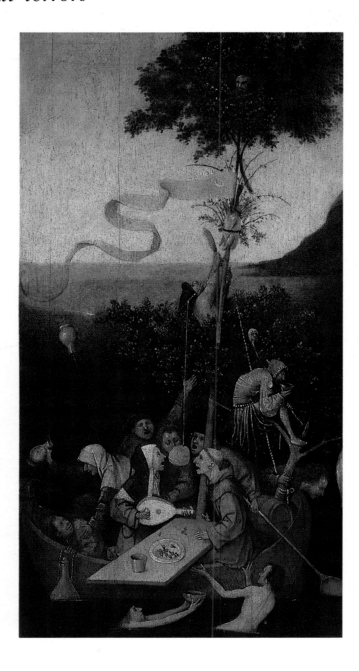

Another famous figure of Renaissance painting of whom little is known, Hieronymus Van Aken, better known as Hieronymus Bosch, was thirty years older than Grünewald, having been born at s-Hertogenbosch in Brabant c. 1450. Like him he still bore the mark of medieval tradition.

Hieronymus Bosch was trained as a miniaturist, as is obvious from his painting. From this background he retained a liking for large numbers of people, richness of detail, a feeling for anecdote and humor. But Bosch's humor is always there for a reason. And while very little is known about him, he never drew attention to himself by scandal or by questioning the established moral order. Hieronymus Bosch was a member of a religious brotherhood and a servant of the Church.

It is customary when considering his work to mention the Devotio Moderna movement and to detect signs indicating a probable knowledge of alchemy when all other interpretations fail. According to this theory, his pictures are in some way painted conundrums, mysterious messages that could be read only by initiates. While this is possible, it is far from certain.

Such an intriguingly romantic interpretation draws on several sources. First of all, the dearth of biographical information leaves us free to make any conjecture. Then the manifest presence of a great many symbols supplies fuel for this theory. And finally, if we consult medieval bestiaries we can establish a relationship between Bosch's art, the Jewish cabbala

Hieronymus Bosch
The ship of fools
Oil on wood
Paris, Louvre

Hieronymus Bosch
The seven deadly sins
(detail: Greed)
Oil on wood
Madrid, Prado Museum

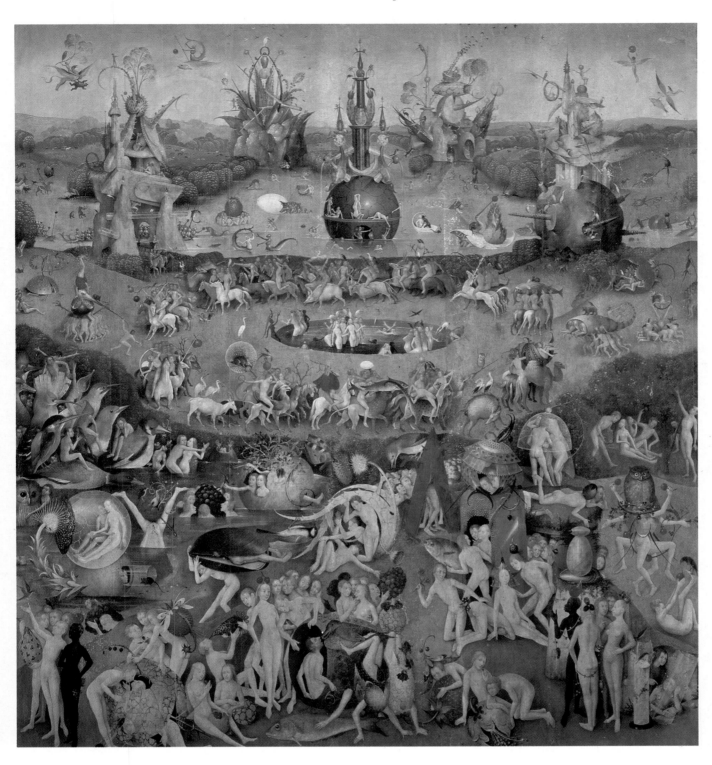

65

and medieval freemasonry.

Without going so far, it is possible to see similarities between the spirit of his work and the writings of Erasmus, who at the same period in Basle was attempting to formulate a synthesis embracing antique wisdom and the spirit of the Gospels, dismissing the excesses of the Reformation and the reprehensible drift of the papacy alike. This touches on the deepest springs of humanism, also echoed by Dürer, which sees man as a fallible but innocent being, fragile but essentially good, who must be directed toward prudence and moderation.

Mockery and derision therefore spring from a feeling of deep compassion for mankind. Bosch derides because he loves. Feeling the same disquiet as his contemporaries regarding the future of Christianity and anticipating the rupture in it, he responds with a redeeming laugh and dreamlike fantasy.

Twentieth-century Surrealists have not failed to stress this oneiric aspect. But things are never as simple as we might wish, and in Bosch's work the phantasm has a completely different function. Profoundly anchored in reality, it is in fact the paradoxical expression of a morality of peace and tolerance.

Hieronymus Bosch
Garden of delights, triptych
Central panel: Allegory of lust
Oil on wood
Madrid, Prado Museum

66 **Fidelity and sobriety**

Working in the same spirit but drawing on a more traditional iconographic register, Hans Holbein the Younger also embodies the link between the Gothic tradition and the new humanist concerns. Holbein, who was born in Augsburg in 1498, spent his life between the Rhine city of Basle and the English court, where he placed his talent at the service of Henry VIII.

Settling in Basle in 1515 Holbein soon made contact with the humanist circle. He painted several portraits of Erasmus (*Erasmus writing*, Paris, Louvre) who became his friend. He took up the legacy of Grünewald in his religious paintings (*Dead Christ*, Basle, Kunstmuseum), indulging in extreme tragic effects, but he showed his real originality in portraiture. It has been said of his portraits that they established the "moral outline" of his models. It is true that the gaze, clothes and facial features always reveal a character, a personality, and – perhaps even more – an attitude to life.

In painting all these faces Holbein has created a kind of negative impression of himself: that of a man devoted to calm and truth, attentive to detail – setting himself high standards – and at the same time considerate toward others, someone for whom fidelity to an ideal must have constituted one of the fundamental values of existence. His quite legitimate craving for peace can be understood all the better if the painter's career is put into its historical context.

Basle, which derived its wealth from its trading activity, was at a crossroads in the heart of Europe, where the roads from Flanders, the Baltic and the Mediterranean converged. Meyer, the burgomaster of the city, would have liked to spare Basle the upheavals of the Reformation. His completely commonsense view was that religion should not harm trade. Holbein for his part was quite happy in a city with a wealth of artists, thinkers and potential patrons.

However, the Reformation first made its presence felt in 1526. Erasmus, who had stated his opposition to Luther, set off for England to join his friend Thomas More, and Holbein went with him. An interlude of calm in 1528 enabled him to return to Basle, but the ultimate victory of the Lutherans in 1529 forced him to leave in 1532, never to return, except for a quick visit in 1538. In London he probably found something that Basle had not managed to achieve: a middle way between Rome and Luther, guaranteed by the king's authority.

After becoming Henry VIII's official court painter in London Holbein died in 1543; he was barely forty-five.

Hans Holbein
Anne of Cleves
Vellum on canvas
Paris, Louvre

Hans Holbein
Archbishop Warham
Oil on wood
Paris, Louvre

*An enemy of fanaticism
and a friend to men, a
lover of knowledge but an
opponent of certainties,
Erasmus tried, with
Thomas More, to find a
middle way between the
asceticism of the
Reformation and the too
flagrant abuses of the
papacy. A moderate man,
he saw Christianity as a
moral code and the
Gospels as a spiritual
guide rather than a
dogmatic straitjacket. He
was irritated by dispute,
and stimulated by
friendship. Tolerance was
his overriding passion.*

Hans Holbein
Erasmus writing
Oil on wood
Paris, Louvre

68 *Teeming life*

Bruegel the Elder, born c. 1525 in Breda, Holland, was heir to Bosch and the last great humanist master of the Germano-Flemish school. North of the Alps he signaled the end of the great esthetic upheaval of the Renaissance, a Renaissance qualified by Flemish pragmatism. Though Bruegel might defend morality, he did not pursue the ideal. Man as an end in himself had no place in his work, and the concept of perfection was foreign to him. The individual existed only as an element in a group. In contrast to Holbein, who approached human beings as a psychologist, Bruegel viewed them with the eye of a sociologist. The individual existed only in relation to other people and to things. Man was just a link in reality.

This explains the sense of teeming humanity we experience when looking at Bruegel's works; in this he is obviously close to Hieronymus Bosch, whose work he would have known since Bruegel is thought to have been brought up in Bosch's home town, s-Hertogenbosch. But he differs from Bosch in the importance he attaches to the fantastic element. Apart from the *Fall of the rebel angels*, Bruegel worked in a more popular and realistic vein. Where one artist drew inspiration from humanist mysticism, the other turned to the folklore of the Flemish peasants and popul proverbs for inspiration. Thus Bruegel's work, unli

that of Bosch, aims to be understood by everyone. His painting is educational as well as moral.

In 1552 he was sent to Italy by Hieronymus Cock, a dealer in prints; he returned with a series of drawings, settling in Antwerp in 1553, then moving to Brussels in 1563. Drawing was his first means of expression, and it was not until 1558, when he was over thirty-three years old, that he carried out his first paintings. He painted for just ten years in all, and only forty-five works that can attributed to him with certainty have survived.

Bruegel was familiar with Italian painting, but in the final analysis it made very little impression on his work. Except for *A Village wedding* he did not use monumental figures. The horizon line remained very high, in keeping with the medieval tradition, and his composition was always more surely structured by anecdote than by the theoretical principles of Italian esthetics.

To put it in a nutshell, Bruegel painted as Rabelais wrote. His humanist knowledge never extinguished his feeling for life. Sometimes tragic and often tinged with bitterness and pity (*The blind leading the blind, Beggars*), his painting is preserved from pomposity by its humor. But the laughter here is of a sort that encourages us to reflect.

Pieter Bruegel
Village wedding
Oil on wood
Vienna, Kunsthistorisches Museum

Pieter Bruegel
Haymaking
(Detail: Gathering up the hay)
Oil on wood
Prague, Narodni Gallery

70

Caravaggio
The incredulity of St Thomas
Oil on canvas
Potsdam, Schloss Sans-Souci

Ut pictura poesis

It seemed as if Italian Mannerism had burnt itself out. The 16th century was drawing to a close, and the art of immoderation was threatening to degenerate into excess. Questioning of the teaching of the Renaissance masters and going beyond it were leading to clever but facile sterility.

The reaction against this state of affairs came from Bologna: in about 1585 the Carracci family founded the academy of the Incamminati, which was soon to attract Guido Reni and Domenichino. There were four Carraccis: Ludovico, the founder (1555-1619), his cousins Agostino (1557-1602) and Annibale (1560-1609), and Agostino's son Antonio (1583-1618).

The tough debate between the Baroque and Classicism started with them. Annibale, working toward a return to the great tradition of Raphael and Michelangelo, is regarded as the pioneer of 17th-century Classicism. But Michelangelo was also behind Mannerism, which the Carraccis opposed. The question is thus much less simple than it might appear at first glance: especially as in the eyes of some historians the frescoes in the Farnese Gallery painted by Annibale between 1597 and 1604 represent the first great Baroque decorative scheme.

Mannerism had highlighted the fundamental role of the imagination in the creative process, thereby breaching the Neo-Platonic assumptions of the Renaissance according to which there was a *priori* accord between the idea and its form. If artists still believed in the efficaciousness of the esthetic canons worked out during the Renaissance, the concept that there was such a thing as beauty in itself, a visible expression of truth, was rejected. Raphael's esthetics had ceased to be a panacea, becoming more simply a language used – according to the principle *ut pictura poesis* (as in painting, so in poetry) – to teach a morality primarily based on experience.

It is the duty of painting, as of poetry, to contribute in its way, namely through the image, to the edification of the human race. Once that has been established the problem lies less in the opposition between a Classical movement characterized by sobriety and a Baroque movement characterized by exuberance (a distinction that is probably more relevant for architecture) than in the confrontation between the realism of the instant (Caravaggio) and recollected idealism (the Carraccis). In the Carraccis' work there is nostalgia for a lost paradise, a time when human experience merged with experience of nature, which was the concrete form of the ideal. Seeking this ideal meant drawing on the resources of the imagination while at the same time, in order to express what the imagination produced, turning to the forms worked out by the Ancients. This return to the origins of art brought the Carraccis, Annibale in particular, a success that endured uninterrupted until the 19th century. After the excesses of the Venetian painters, with the advent of the Carraccis painting seemed to settle down again: harmony was once again the watchword.

Annibale Carracci
Sleeping Venus
Oil on canvas
Chantilly, Musée Condé

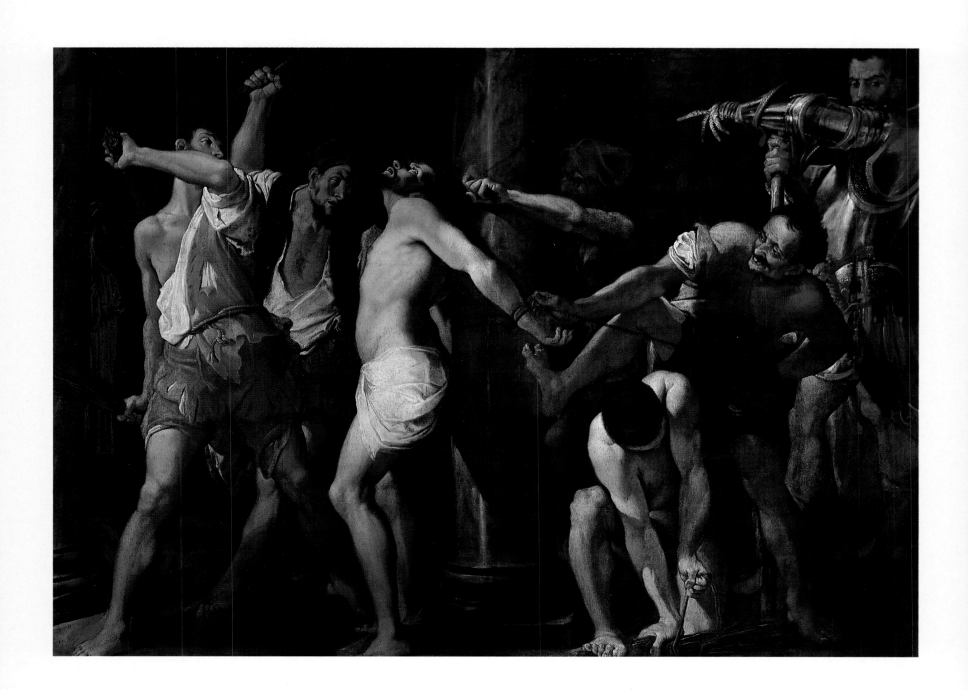

Ludovico Carracci
The Flagellation
Oil on canvas
Douai, Musée de la Chartreuse

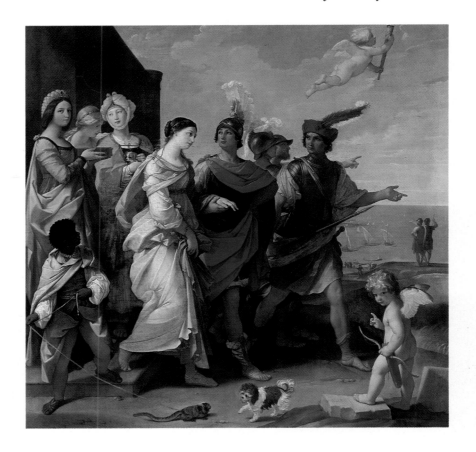

74 *The power of the ideal*

Guido Reni trained at the academy run by the Carraccis. Less impassioned in his approach than Annibale Carracci, he was influenced for a time by Caravaggio's painting, the formal robustness of which appealed to him. But his style very soon gravitated toward more abstract compositions more in keeping with his personality.

Like Raphael – he saw himself as continuing his tradition – Guido Reni rejected realism in the name of the demands of beauty. This debate, which has been gone over so many times that it now seems worn out, was central to the philosophical concerns of the period. According to those arguing in favor of Classicism, regularity was more important than the diversity of reality, and the task of a true artist was not so much to observe reality as to reorganize it. So it was necessary on the one hand to imagine an ideal formal setting, comparable in terms of the plastic arts to the rule of unity of place and time imposed on the theater, and on the other to make a clean sweep of reality, retaining only those elements that were deemed to be essential.

Thus Reni's painting is based on poetics derived from an idea. But reducing it to that would be to ignore the richness of his work. The path he trod was in fact more complex, and as an artist he obviously hesitated between several possible ways. Like all painters of his generation Guido Reni was a product of Mannerism,

having grown up in its ambience. On a visit to Rome around 1600 he discovered both Raphael and Caravaggio, and was attracted by the novelty of the latter.

While he admired the primacy Annibale Carracci gave to beauty of form, Reni differed from him in rejecting decorative excess. The attraction of Reni's painting, moral and therefore solemn, had to lie in its ethical content as much as in its plastic skills. Unlike Carracci, who was carried away by a virtuosity that led him to defend art for art's sake, Guido Reni forgot neither the soberness of antiquity nor the rules of the Renaissance. And he no doubt recognized the austerity so lacking in Carracci's work in that of Caravaggio.

But Caravaggio had opted for instantaneity, reality as perceived by the senses, shown as it is even before it has been reconstructed by the mind. Nature in Caravaggio's work was shown in the raw, with its share of ugliness, and the subtle painter of the *Adoration of the shepherds* could not identify with a morality based on the material either. Incapable of choosing between the two great trends that dominated his period, Guido Reni ended up by being admired for the wrong reasons (his elegance, his gracefulness), and if any criticism can be leveled at his painting, it is that it did no more than carry on the legacy of Raphael, his only real master, without going beyond it.

Guido Reni
Abduction of Helen
Oil on canvas
Paris, Louvre

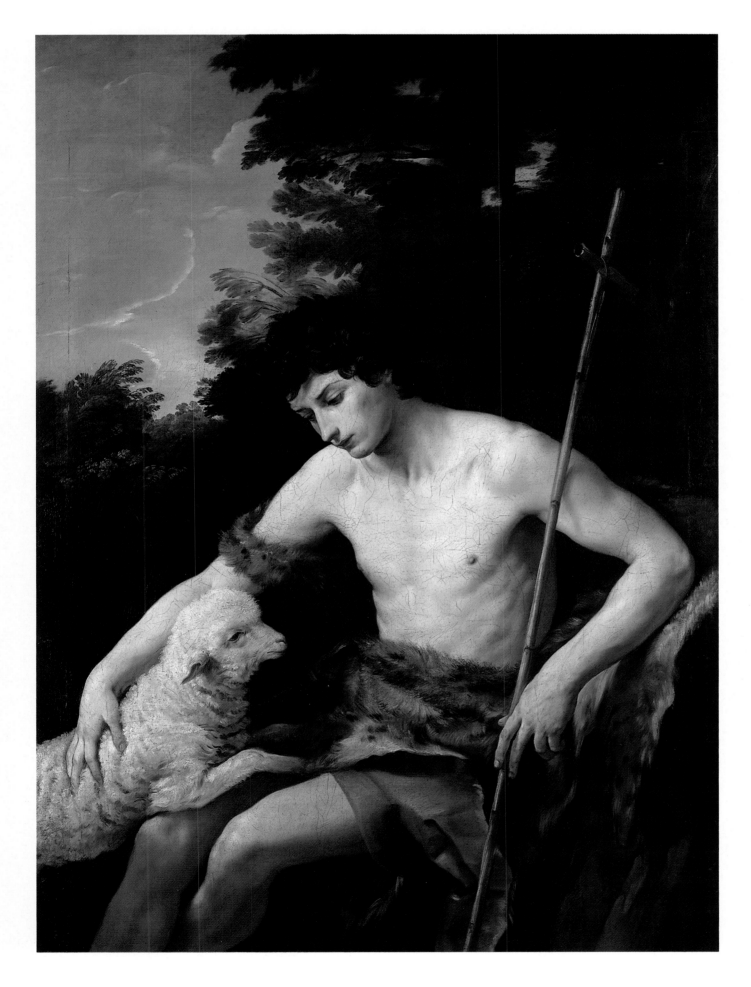

A painter of ideas, Guido Reni (1575-1642) recognized Raphael as his sole master. Seeking to capture the essence of beauty, his painting has neither the inventive freedom of the Carraccis nor the personal touch of Caravaggio. The deliberate coldness of his work, though it was acclaimed by his contemporaries, led in its unjust neglect, and he has only very recently been rediscovered.

Guido Reni
St John in the wilderness
Oil on canvas
Nantes, Musée des Beaux-Arts

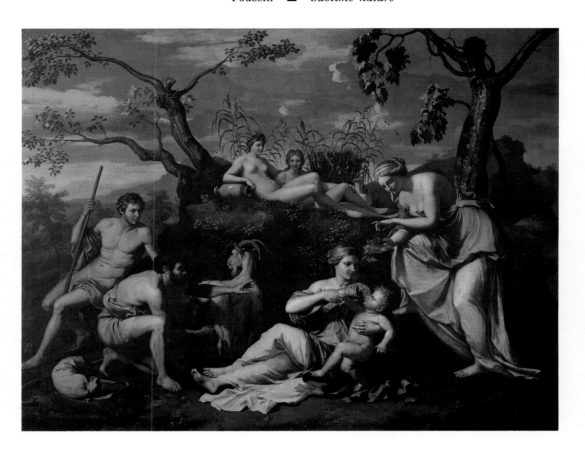

A metaphysical nature

Nicolas Poussin, a direct descendant of Guido Reni though he was never properly speaking subject to his influence, was like him a painter of the ideal. He was Norman by birth (Les Andelys, 1594) but Italian by inclination and culture; he first visited Rome at the age of thirty, and settled in Italy for good in 1642. He modeled himself on two masters, Titian and Raphael – Venetian lyricism and Roman harmony.

The harmony in question, right at the heart of the artistic debate, was universal harmony. The sight of nature led Poussin to believe in an essential community between the natural and the human, between myth and history. This harmony was both the basis and the objective of all morality, using order and simplicity as its weapons.

Obviously such a concept of man's place in the world is to some extent pantheistic, an attitude that became increasingly noticeable as Poussin's career progressed. Initially nature was a mirror regulating human passions, but progressively it became the central theme of the work, while human beings disappeared or became fewer in number, soon consigned to the margins of paintings wholly occupied by natural elements, the concrete form of the divine.

In *Diogenes throwing down his bowl* (1648), the philosopher occupies only a tiny area of the composition which is almost entirely reserved for the landscape and buildings, because in giving dramatic expression to such a scene Poussin would have gone against his intention, namely to celebrate a return to the primary truth of the elements. This pursuit of simplicity, both moral and esthetic, brings Poussin close to the Stoic position: a voluntary submission to the forces of nature insofar as they express a transcendant will, and a rejection of emotion, perceived as blindness, contribute in the *Funeral of Phocion* for example toward giving a completely individual sense of tone to mourning. A body is borne away almost stealthily, while beyond, or rather here in the world below, the day's plowing is continued by discreet, anonymous representatives of mankind.

As a result of his growing reputation Poussin was recalled to France by Richelieu in 1640. He was promoted to the rank of first painter to the king, but soon had to contend with the jealousy of other artists unsettled by the uncertainty looming over the future of the kingdom as Louis XIII's reign drew to a close. Poussin went back to Rome in 1642, escaping from the intrigues of court. When France plunged into the murderous strife of the Fronde, Poussin like a sensible Norman chose not to return; no doubt he found a serenity more conducive to creativity in Italy, a country that was foreign enough to him for him to be able to relish its flavor and nostalgic sweetness to the full.

Nicolas Poussin
The nurture of Jupiter
Washington, National Gallery of Art

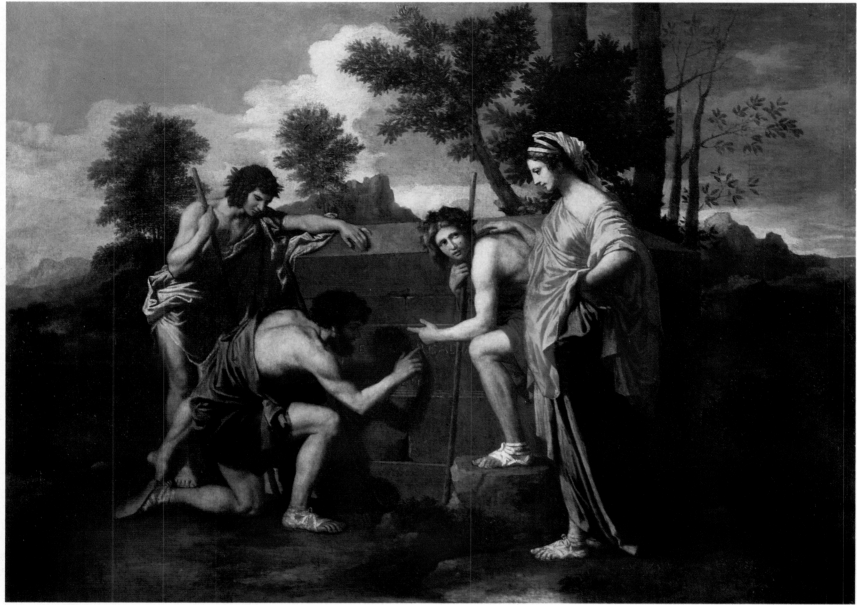

Nicolas Poussin

Shepherds of Arcady
Oil on canvas
Paris, Louvre

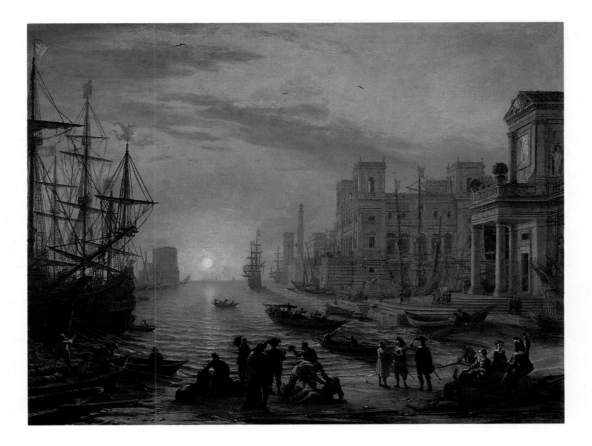

The golden light of the beginning of time

Claude Gellée, called Lorrain, was born at Chamagne in 1600, but apart from a spell in Nancy between 1625 and 1626 he spent the main part of his life in Rome. Lorrain's approach, which has similarities with Poussin's and is in some respects derived from Bolognese Classicism, works through idealization. But Lorrain's ideal, more private and personal than the Carraccis', sprang directly from the artist's imagination and never claimed to be an absolute.

The interest of Lorrain's *oeuvre* lies in its ability to combine analysis and synthesis. The eye, fixed on the motif, analyzes and decodes. The imagination then recomposes and synthesizes. Thus Lorrain alternated spells of work out of doors and sessions in the studio. Nature provided him with a repertory of forms which he noted and accumulated as his raw material. Once his general theme had been established, he was then free to concentrate on the second phase of work, which involved reorganizing these fragmentary views, or rather retaining of them only those parts that could usefully be inserted into a composition which was the brainchild of his imagination.

But nature, for all that it is arbitrarily recomposed according to subjective criteria, governs the work in that it fills almost all of the space. Matters relating to man, religion or myth are there only as pretexts or anecdotal adjuncts: anecdotal because, unlike Poussin, for whom nature as an echo of myth took on a metaphysical dimension, nature in Lorrain's view was first and foremost tangible, perceived by the eye rather than the mind.

As a result of the interest Lorrain devoted to light in his treatment of landscape he was unfairly undervalued. According to the taste of the day, his painting no doubt lacked a moral dimension and without that a work could not claim to achieve sublimity. But it is in this very respect that Lorrain appears completely modern, in the sense that he anticipates 18th-century English landscape painting, and to a lesser extent the pre-Romantic movement in Germany and French Impressionism. For while it is true that the Impressionists prided themselves on working from nature and rejected any idealization of reality, they were nonetheless indebted to painters like Lorrain for elevating landscape to the status of a noble theme and – two centuries before them – considering the role of light when conveying a landscape three-dimensionally as being the fundamental structuring element in imparting a state of mind through the plastic arts.

Claude Lorrain
Harbor, with setting sun
Oil on canvas
Paris, Louvre

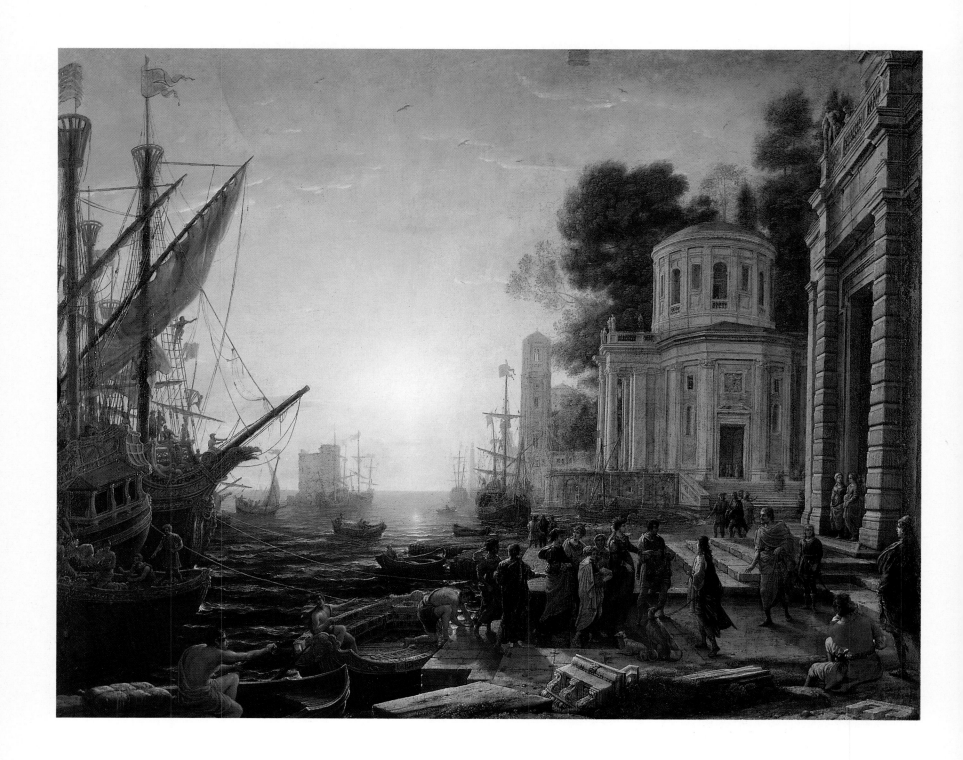

Claude Lorrain
Cleopatra disembarking at Tarsus
Oil on canvas
Paris, Louvre

The truth of the instant

80

Michelangelo Merisi, the enfant terrible of painting, was born in Caravaggio, near Milan, in 1571. He started his apprenticeship in Milan in 1584, then in 1592 set out for Rome, where he became a protégé of Cardinal Francesco Maria del Monte, for whom he painted *The fortune teller* and the head of the *Medusa*.

Whereas the century was moving toward Classicism based on the authority of history and the assumption that a natural order did exist, Caravaggio very early on chose to explore a different path, perhaps traveling in the opposite direction. This choice is usually summed up in two words: luminosity and realism. Unlike Classical painters such as Poussin, who relocated their work in the wider framework of metaphysics based on the ideal, Caravaggio chose the realism of an instant. Each work is an event in itself, a fragment of space and time deliberately severed from any context. The phenomenon is presented in all its purity and all the density of its appearance, with no justification beyond itself and no organizing principle other than the elements that constitute it.

Esthetics of this kind were shocking. His realism, often thought to be too crude, caused him to be regarded on more than one occasion as blasphemous. His *Death of the Virgin* (c. 1605) painted for the Madonna della Scalla in Trastevere was eventually turned down by the clergy. The dead woman must have appeared too human. Despite the halo and the purity of her features in death, the pervasive heaviness of her slack body, draped in purple, sets the event in the context of a material grief.

Though it could comprehend ecstasy, Caravaggio's faith did not conceive of it as divorced from a concrete presence. In his works nothing is inserted to historicize a scene, for the painted instant knows nothing of history. Nor are things pictorial accessories indicating space and time, alluding to a Being who is fully realised in the idea, as the Neo-Platonic concept of the world would have it. Quite the opposite, in fact;

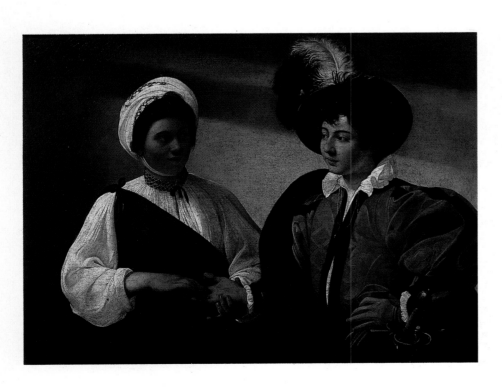

Caravaggio
The fortune teller
Oil on canvas
Paris, Louvre

Caravaggio
Medusa
Oil on canvas fixed to wood
Florence, Uffizi Gallery

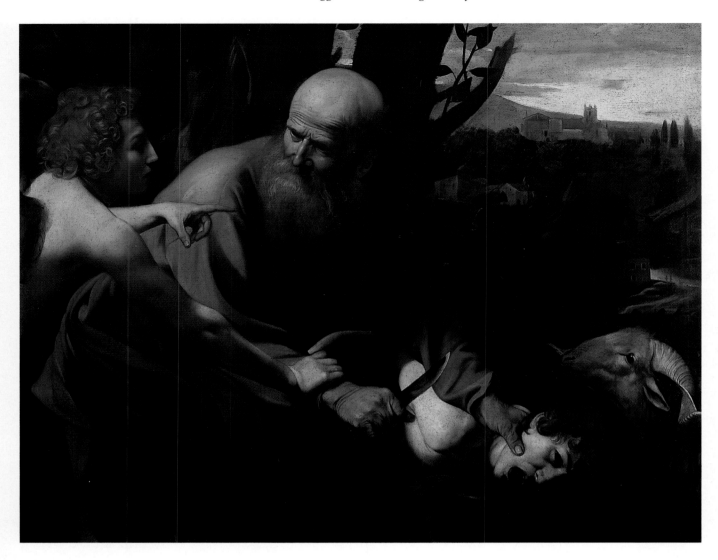

this also helps explain the repudiation of this painting. For the object in Caravaggio's work just as much as the human being is a symbolic manifestation of the divine presence – not that the object should be venerated, but like the people depicted it is bathed in a light that is the sign of the will of God. God is not in the object any more than the soul is in the body, but He is in, or rather manifests Himself by, the meeting of light and object – a meeting that is effected in an instant and is true only for that instant. Each instant is ignorant of the one preceding it, and is not linked to it by any necessity. It is in itself the total sum of the Being in which all the material elements that constitute the scene participate on virtually equal terms. Seeing anything as superfluous, decorative or incidental would amount to casting doubt on divine perfection. For if God were less present in the horse's rump than in the face of St. Paul He could not be perfect. Nothing that is can escape the One who is.

Obviously this metaphysical approach carried to its logical conclusion would have verged on heresy. A few decades later Descartes and Spinoza after him

were to prove that one could not venture onto such ground with impunity. But what saved Caravaggio, at least for a time, was the fact that he was a painter and not a philosopher. His contemporaries, seeing in his work only what offended the canons of good taste, did not see what might have been spiritually repugnant.

Moreover, Caravaggio in his way of life gave them every reason to believe themselves justified in their error. A notorious rogue, possibly a pimp and even a murderer, he was obliged to leave Rome in a hurry after killing a man called Tommasoni one May evening in 1606 after a quarrel that arose during a game of tennis. He took refuge in Naples (1607), then Malta (1608) and finally Syracuse (1608-9), continuing to work in a climate of ever-increasing drama, while in Rome his protectors made efforts to persuade the Pope to grant him a pardon. But it came too late. When an official letter from the Holy See published his pardon on 31 July 1610, Caravaggio was already dead; two weeks before he had succumbed to the effects of malaria on the beach at Porto Ercole.

Caravaggio
The sacrifice of Isaac
Oil on canvas
Florence, Uffizi Gallery

82

Caravaggio
The incredulity of St Thomas
Paint on canvas
Potsdam, Schloss Sans-Souci

*"Caravaggio has the great
temerity to tear away the
veil from the face of
fiction. Despising the story
that unfolds according to
a logical order and fixing
his gaze on the event as is
happens, he sees death as
the 'true' event, having
neither cause nor effect
.... Physical death is not
followed by celestial glory,
but by the darkness, cold
and loneliness of the
grave."*

G.-C. Argan
*L'Europe des capitales,
1600-1700*
Skira, 1964

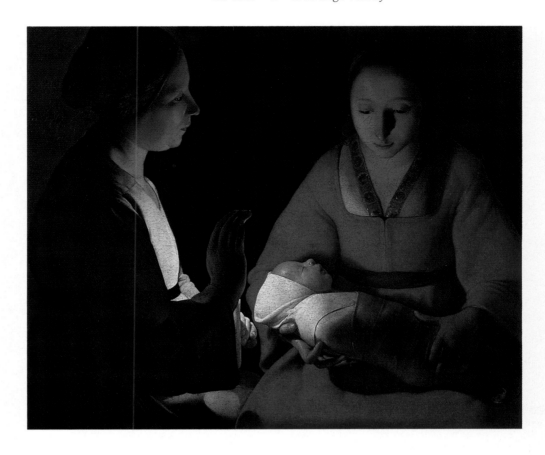

84

An internal light

Georges de La Tour was born at Vic-sur-Seille in 1593 and moved to Lunéville in 1618. Apart from a hypothetical journey to Italy he seems not to have left Lorraine after that date. His work nonetheless follows on very much from Caravaggio's, as has been confirmed by recent studies, carrying on and amplifying Caravaggio's research into light.

Tempting and justified though it is, this parallel should not disguise the differences between La Tour and Caravaggio. While the overall atmosphere of La Tour's pictures is close to Caravaggio's realism, there are several far from negligible aspects in which they differ.

La Tour does not have Caravaggio's ferocity, and in his work you would look in vain for a composition liable to offend even the most delicate susceptibilities. Though original in his extreme luminosity, he is completely conformist in his choice of subject. Unlike Caravaggio La Tour paints a motionless instant; not a fragment of time, but the whole of time condensed into an instant. This excludes drama, which would have the effect of distorting temporality. Caravaggio paints an event, La Tour a state. His instant is eternal.

Looking beyond the similarity of style, we are dealing with two conflicting versions of realism. Whereas the first results from exploring the potential of passion, the second subscribes to the rationalist point of view according to which reality exists only insofar as it is apprehended by thought. So it must aim for balance and a dispassionate atmosphere.

As for light in La Tour's work, it has often been emphasized that this is internal to the picture. The source of light never comes from outside the picture: it is shown, not transcendent, but immanent. For the mind delimiting form and inventing it through thought is first and foremost the human mind. All that exists is what the light illuminates, and all that exists is what

Georges de La Tour
St Joseph with the angel
Oil on canvas
Nantes, Musée des Beaux-Arts

Georges de La Tour
The newborn
Oil on canvas
Rennes, Musée des Beaux-Arts

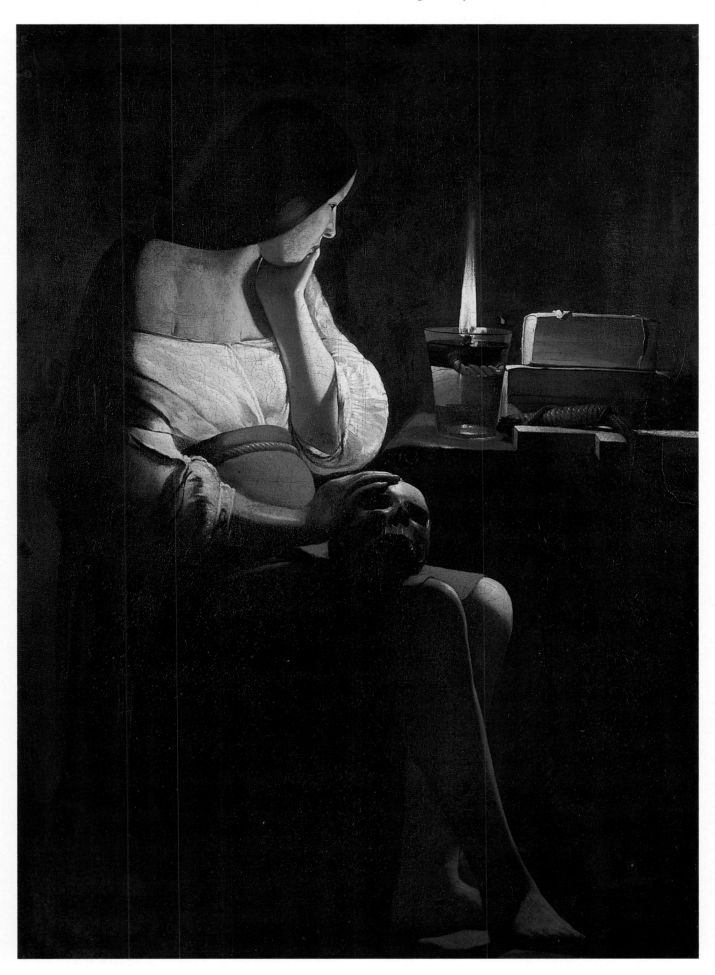

the mind itself can apprehend. And if God necessarily exists outside the self, which the self cannot deny since He is infinite, the self can on the other hand test His existence only within itself.

In this desire to reduce what exists to essentials, there is a kind of asceticism and demand for divestment in some ways reminiscent of the method adopted by Descartes shut up with his stove. It is like moving in the direction of the elementary, the only path making an authentic grasp of reality possible.

Georges de La Tour
Magdalen with the night light
Oil on canvas
Paris, Louvre

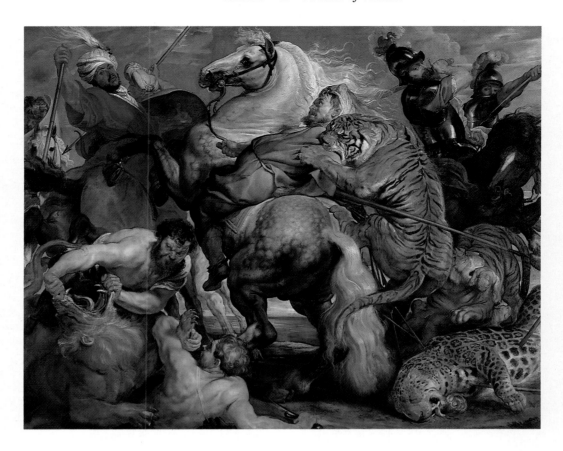

86

Flesh in full bloom

The son of an Antwerp alderman living in exile in Germany, Peter Paul Rubens returned to Flanders at the age of ten. After a period as a pupil of the landscape artist Tobias Verhaecht and of Adam Van Noort, he set out in 1600, in his twenty-third year, on a journey to Italy and Spain which was to last eight years.

Rubens was attracted by all the great masters, but never belonged to one school. Titian, whose work he discovered in Venice, may have been the artist with whom he felt the greatest affinity, but he was also influenced by the works of Michelangelo, Raphael and Mantegna, and the researches – albeit contradictory – of the Carraccis and Caravaggio. He was first and foremost a painter, and nothing that might solve a difficulty relating to the plastic arts was alien to him.

When talking of Rubens, it is more appropriate to talk of eclecticism than of synthesis. Both a realist and an allegorist, unhesitatingly mixing myth and history, he seems to make nonsense of the normally accepted categories. If art historians need an exception to prove the rules they pronounce, it could obviously only be Rubens.

Drawn by the truth emanating from Caravaggio's pictures, he was equally attracted by the virtuosity displayed by the Carraccis in their reinterpretations of antique myths. But to what he learnt from them he added a powerful zest in the very act of painting which is his own particular hallmark.

On his return from Italy at the age of thirty-one he was appointed painter to Archduke Albert. He lived in Antwerp, but his fame spread throughout Europe; a prolific painter, Rubens also knew how to manage his career with the talent of a true businessman. The *Raising of the Cross* (1610-1611) and the *Descent from the Cross* (1612) established his reputation definitively. The truce between the northern and southern parts of the Netherlands between 1609 and 1621 resulted in a new flow of commissions, of which his workshop was a major beneficiary.

On the archduke's death Rubens became an adviser to the Infanta Isabella, distinguishing himself both in Spain (1628-1629) and England (1629-1630) through his diplomatic talents, and becoming the friend of Philip IV of Spain and Charles I of England. After knighting him Charles commissioned nine pictures for the ceiling of the banqueting hall at Whitehall.

Equally at home in huge mythological groups and intimate portraits, Rubens came to be regarded, *a posteriori*, as the creator of Baroque. But his work transcends the confines of that movement, and his influence on posterity was so huge that one is reluctant to put a label on a talent of that order. The heir to Titian, Rubens in the two centuries following his death influenced artists as different as David, Delacroix and Renoir. He was likewise responsible for a synthesis between the Flemish and Italian traditions, as successful as it is unexpected.

Peter Paul Rubens
Tiger hunt
Oil on canvas
Rennes, Musée des Beaux-Arts

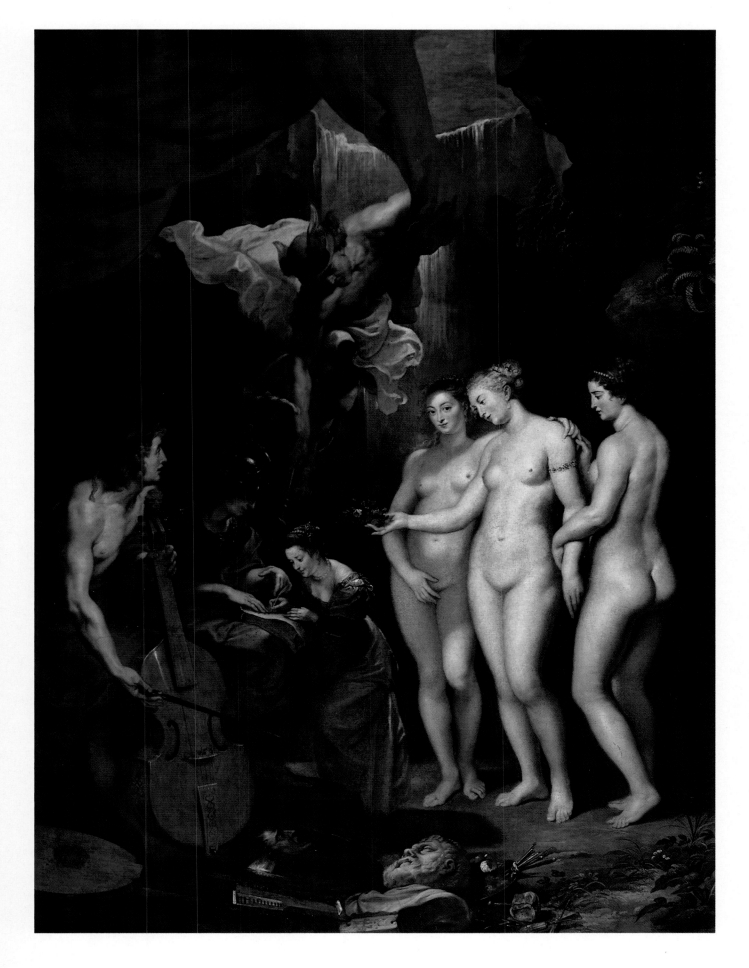

Marie de Medici, the widow of Henry IV and the mother of Louis XIII, with whom she came into conflict immediately he reached his majority, was far from being the figure Rubens depicts here. But historical truth is less important than mythological truth, and myth less important than the pleasure of painting opulent flesh: that was the true order of priorities as far as Rubens was concerned.

Peter Paul Rubens
The education of Marie de' Medici
Oil on canvas
Paris, Louvre

Peter Paul Rubens
The martyrdom of St Stephen, triptych
Arguing with the doctors – Stoning – Entombment
This picture has been restored – the central part
has been transferred onto canvas
Valenciennes, Musée des Beaux-Arts

Velasquez **4** *Virtuosi of realism*

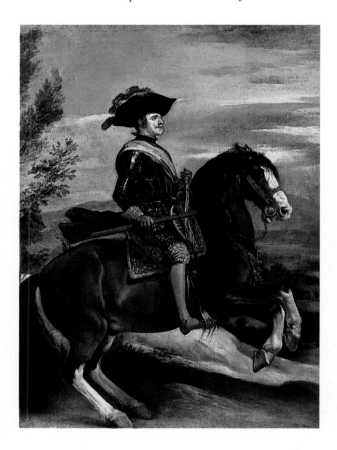

92 ***Recording the instant***

Velasquez, who was born in the same year as Van Dyck, was influenced by Caravaggio, but his naturalism was less lyrical and more distanced. Whereas Caravaggio was in pursuit in the instant of the moment of maximum tension when everything evolves in the interaction of light and matter, for Velasquez the act of grasping the natural world was relocated to lie between the consciousness that perceives and the matter that the eye apprehends. In other words, what light reveals in Caravaggio's work is unmasked by consciousness or human awareness in Velasquez. For him awareness is the light.

But this awareness is impartial – it does not judge. And the painter is concerned less with touching the emotions than with giving an account of what he sees. "Giving an account" means retranscribing by pictural means the free relationship between one man's awareness and the world. And in this game with mirrors it is sometimes very difficult to make a distinction between the perceiver and the perceived insofar as the object, immediately it has been perceived, becomes an object of the awareness perceiving it.

Velasquez seems to have reveled in these subtleties which enabled him, under cover of realism and objectivity, to give free rein to his own subjectivity. For this affirmation by the self that paints goes well beyond the self-assertion of an artist claiming total mastery of the techniques peculiar to his art. The painter is not asserting himself through his virtuosity, however great that may be. He is asserting himself primarily as a human consciousness comprehending the world, as an individual, as if he wanted to say only, "What exists exists only because we comprehend it," and invite each one of us to do likewise: to take a grip on ourselves by taking a grip on the world.

In painting the *Rokeby Venus* (London, National Gallery) he offers the body of the goddess not to us, the viewers, but to herself. The revelation of the beauty of Venus concerns us only indirectly. Everything takes place in a reflection in a mirror, a metaphor for awareness, between a woman and her image. All we can know of her is what the mirror is willing to tell us, just as in *Las Meniñas* it is through the eyes of the painted subject, King Philip IV of Spain, that we see what the painter sees for himself.

If making intellectual constructions of this type is to some extent playing games, that does not mean that they are irrelevant. Like others before him Velasquez reaffirms the prerogative of painting, namely to recreate reality. But in this case illusion does not result from an attempt to make the ideal coincide with what exists, or to seek in what exists the component that can lead to the sublime. For Velasquez rejects the dualism of matter and thought. Since everything takes place within the movement of the consciousness toward the world, there can be no *a priori* hierarchy between the two. And the seeming impassiveness of his naturalism should not be interpreted as indifference toward the human beings he depicts, but on the contrary as a sign of his certainty regarding his freedom.

Velasquez
Portrait of Philip IV on horseback
Oil on canvas
Madrid, Prado Museum

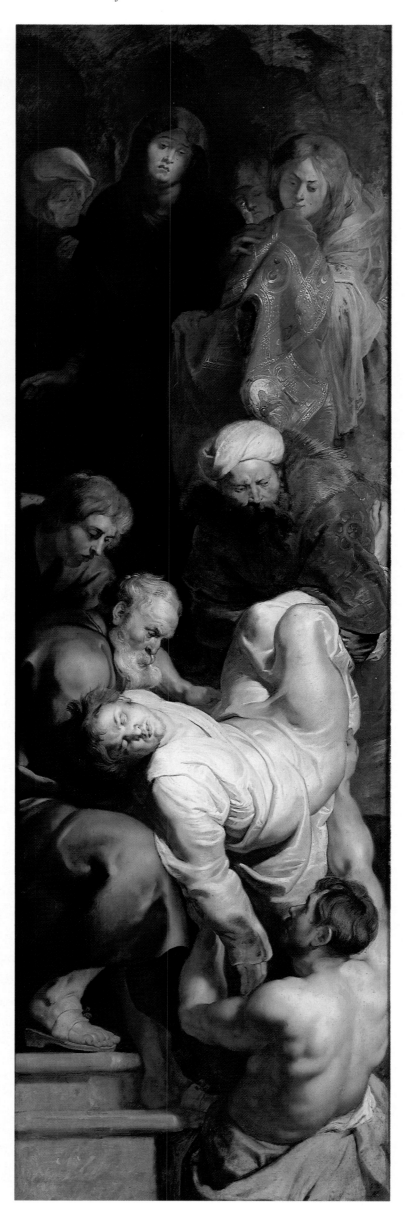

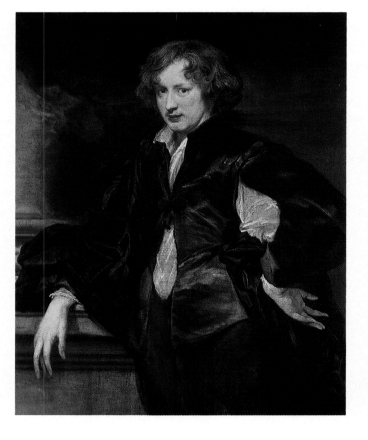

90

At the court of the great

Antoon (Anthony) Van Dyck was born in Antwerp in 1599, and became a member of the Guild of St. Luke in 1618, entering into a fruitful collaboration with Rubens that same year. He was a painter at the court of Archduchess Isabella from 1628 to 1629, then was appointed official painter to Charles I of England in 1632.

After a period when he was influenced by the style of his master, Rubens, Van Dyck turned toward a career as a portraitist, possibly on Rubens's advice. From then on their styles diverged and Van Dyck, freer to do as he wanted, developed a more elegant style of painting than his older colleague. Between 1621 and 1627 he lived in Genoa where, in spite of his difficult temperament, he won the favor of the Italian aristocracy for whom he produced sumptuous paintings designed to show his sitters off to best advantage.

On his return to Antwerp in 1627 he renewed his ties with the more austere tradition of Flemish art while at the same time preserving something of the monumentality he had mastered in Italy. The Italianate aspect of his work attracted attention in England, and he was invited there by the king himself in 1632. He would remain there until his death in 1641, except for two short visits to Flanders and France.

Van Dyck saw the portrait as a psychological study. His painting is frontal, showing little concern for perspective; his backgrounds, which are often dark, are reduced to huge, monochrome expanses. In his work everything takes place in the foreground. In Van Dyck's view nobility should be conveyed in the facial expression as much as through the attributes pertaining to the sitter's estate. And the clothes and materials which he painted with striking virtuosity were not the sign but the echo of a superiority imparted less by money than by the privilege of birth. Van Dyck set out to capture the very essence of aristocracy in the physiognomy of his subjects. His attempt to idealize his model did not, however, go so far as to transform the sitter. Van Dyck flattered with restraint. The principle of reality, inherited from the Flemish school, still governed his work.

However, the art of portrait painting which brought him fame turned against him in the final years of his life. Locked into a genre that was financially rewarding but probably frustrating, because his portraits were exposed to the often very partial judgement of the sitters, Van Dyck wanted Charles I to engage him for more ambitious projects. This hope was never fulfilled. The artist died prematurely in 1641.

Anthony Van Dyck
Self-portrait
Oil on canvas
St Petersburg, Hermitage

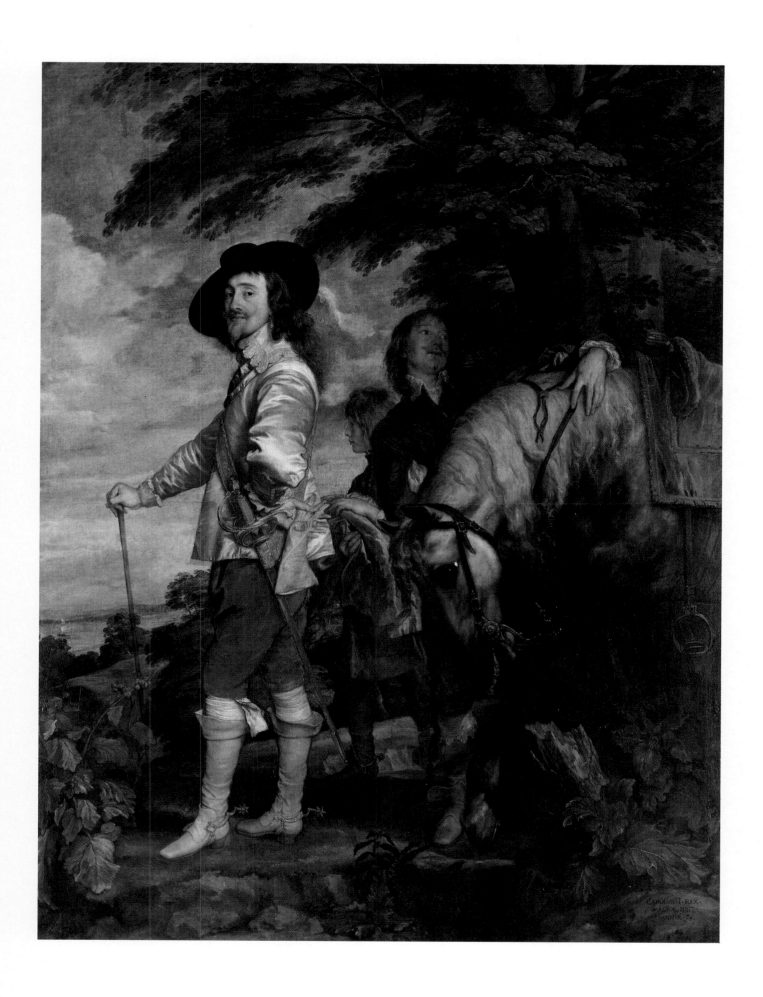

Anthony Van Dyck
Charles I 'à la chasse'
Oil on canvas
Paris, Louvre

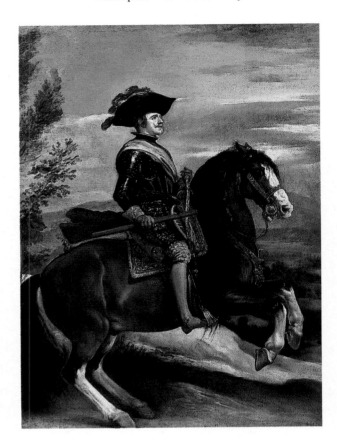

Recording the instant

Velasquez, who was born in the same year as Van Dyck, was influenced by Caravaggio, but his naturalism was less lyrical and more distanced. Whereas Caravaggio was in pursuit in the instant of the moment of maximum tension when everything evolves in the interaction of light and matter, for Velasquez the act of grasping the natural world was relocated to lie between the consciousness that perceives and the matter that the eye apprehends. In other words, what light reveals in Caravaggio's work is unmasked by consciousness or human awareness in Velasquez. For him awareness is the light.

But this awareness is impartial – it does not judge. And the painter is concerned less with touching the emotions than with giving an account of what he sees. "Giving an account" means retranscribing by pictural means the free relationship between one man's awareness and the world. And in this game with mirrors it is sometimes very difficult to make a distinction between the perceiver and the perceived insofar as the object, immediately it has been perceived, becomes an object of the awareness perceiving it.

Velasquez seems to have reveled in these subtleties which enabled him, under cover of realism and objectivity, to give free rein to his own subjectivity. For this affirmation by the self that paints goes well beyond the self-assertion of an artist claiming total mastery of the techniques peculiar to his art. The painter is not asserting himself through his virtuosity, however great that may be. He is asserting himself primarily as a human consciousness comprehending the world, as an individual, as if he wanted to say only, "What exists exists only because we comprehend it," and invite each one of us to do likewise: to take a grip on ourselves by taking a grip on the world.

In painting the *Rokeby Venus* (London, National Gallery) he offers the body of the goddess not to us, the viewers, but to herself. The revelation of the beauty of Venus concerns us only indirectly. Everything takes place in a reflection in a mirror, a metaphor for awareness, between a woman and her image. All we can know of her is what the mirror is willing to tell us, just as in *Las Meniñas* it is through the eyes of the painted subject, King Philip IV of Spain, that we see what the painter sees for himself.

If making intellectual constructions of this type is to some extent playing games, that does not mean that they are irrelevant. Like others before him Velasquez reaffirms the prerogative of painting, namely to recreate reality. But in this case illusion does not result from an attempt to make the ideal coincide with what exists, or to seek in what exists the component that can lead to the sublime. For Velasquez rejects the dualism of matter and thought. Since everything takes place within the movement of the consciousness toward the world, there can be no *a priori* hierarchy between the two. And the seeming impassiveness of his naturalism should not be interpreted as indifference toward the human beings he depicts, but on the contrary as a sign of his certainty regarding his freedom.

Velasquez
Portrait of Philip IV on horseback
Oil on canvas
Madrid, Prado Museum

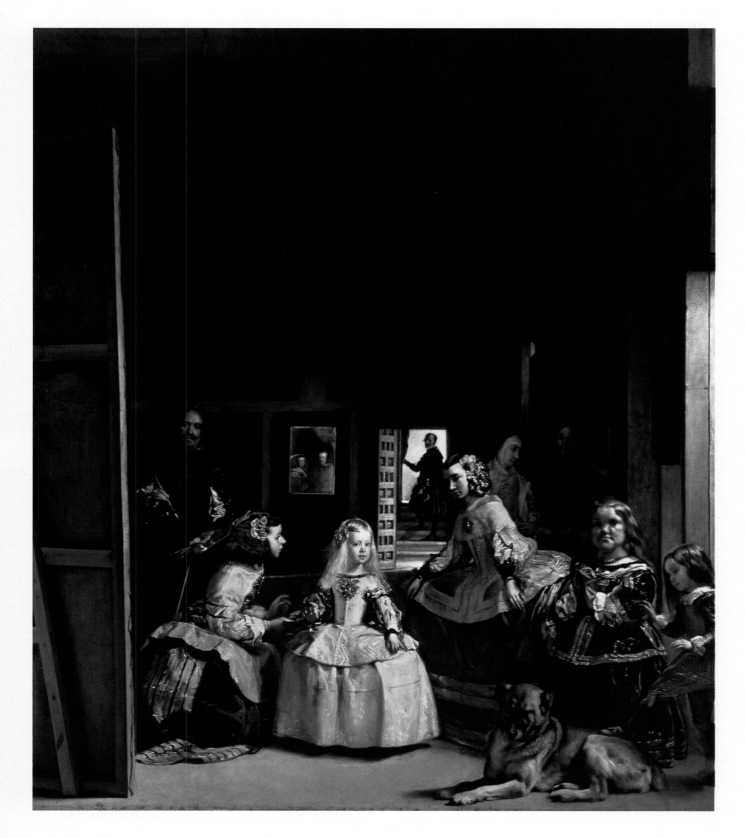

*"[Velasquez] averts the
necessity for psychological
interpretation by abjuring
heroism and the
analytical penetration of
his model. He keeps the
necessary distance: Pope
or beggar, king or clown,
all are grist to the mill for
the experiment that
painting effects."*

G.-C. Argan
*L'Europe des capitales,
1600-1700*
Skira, 1964

Velasquez
Las Meniñas (or The family of Philip IV)
Oil on canvas
Madrid, Prado

94

Velasquez
The spinners (or The fable of Arachne)
Oil on canvas
Madrid, Prado

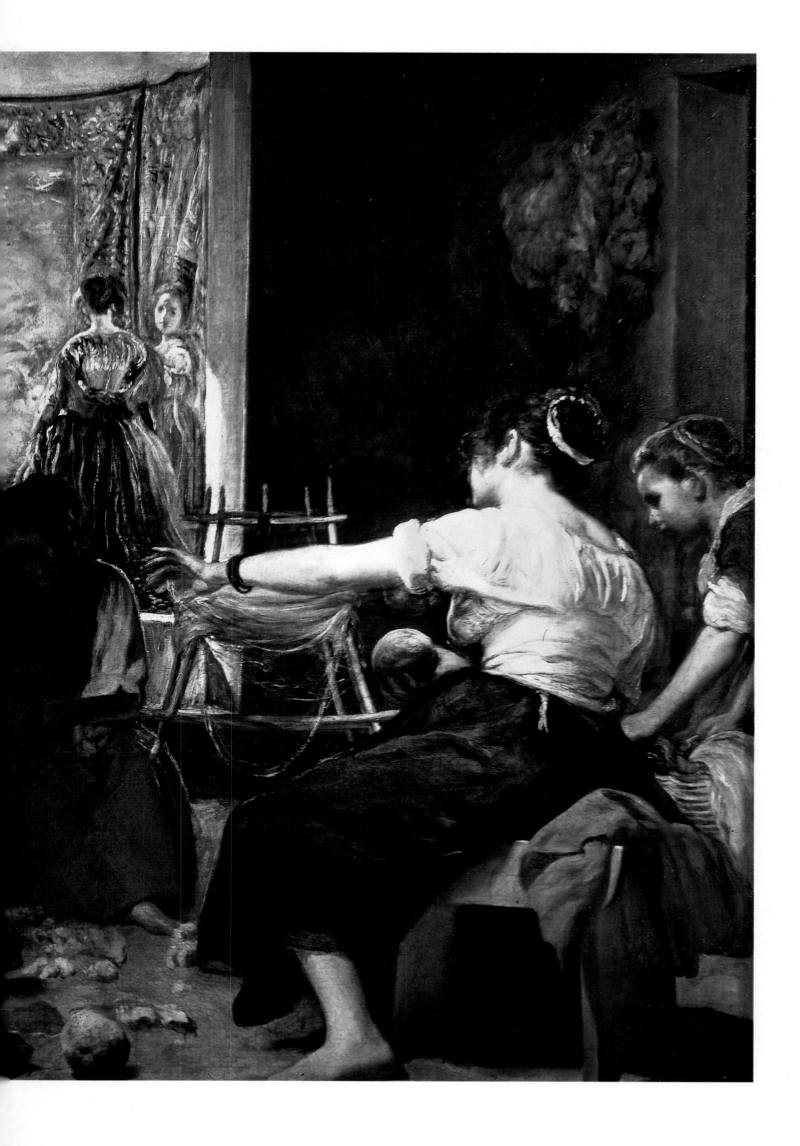

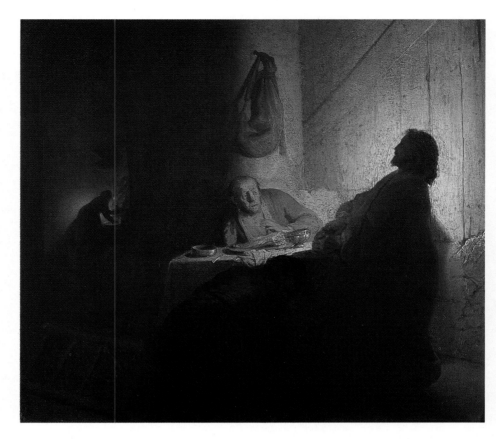

96 *The world as bitter comedy*

Rembrandt van Rijn was born in Leyden in 1606. He, too, was influenced by Caravaggio's painting, as can be seen in his *Pilgrims at Emmaus*. After settling in Amsterdam in 1631 he moved away from his first style to show a remarkable skill in portraiture – though he never specialized in one particular genre.

Equally unresponsive to the raptures of the Baroque and the analytical attention to detail of Flemish realism, Rembrandt treats his subject by enveloping it in an

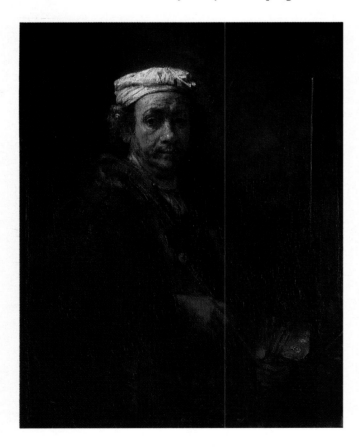

aura of mystery which is intended not to conceal, but rather to reveal what is not immediately obvious or visible. The truth that Van Eyck had hoped to grasp by means of outlines and surfaces Rembrandt sought in a vibration which he expected to take the eye beyond appearances.

In such an ambition he was obviously very far removed from the more pragmatic concerns of the Dutch middle classes. After experiencing rapid success and marrying the niece of a rich art dealer in 1634, Rembrandt believed that he would be free from the cares of everyday life and need no longer heed the demands imposed by his clients' taste. Unlike Van Dyck, who was anxious to paint a portrait of his sitter as a social being, emphasizing those aspects in the sitter's appearance that could justify his membership of a social class, Rembrandt painted with the intransigence of a man wishing to get to the bottom of things. His refusal, or rather his failure, to make any concessions toward his model ultimately counted against him.

After the death of his wife and his three children there were ever fewer commissions, and in 1657 Rembrandt had to stand by and see the valuable collection he had patiently built up throughout his life sold at auction. After the house in the Jewish quarter which he had occupied for over twenty years was sold, he ended his life in the humbler setting of a working-class area of Amsterdam with his surviving son Titus, his new companion and the daughter he had by her, Cornelia. Though

Rembrandt
Self-portrait at the easel
Oil on canvas
Paris, Louvre

Rembrandt
Pilgrims at Emmaus
Oil on canvas
Paris, Musée Jacquemart-André

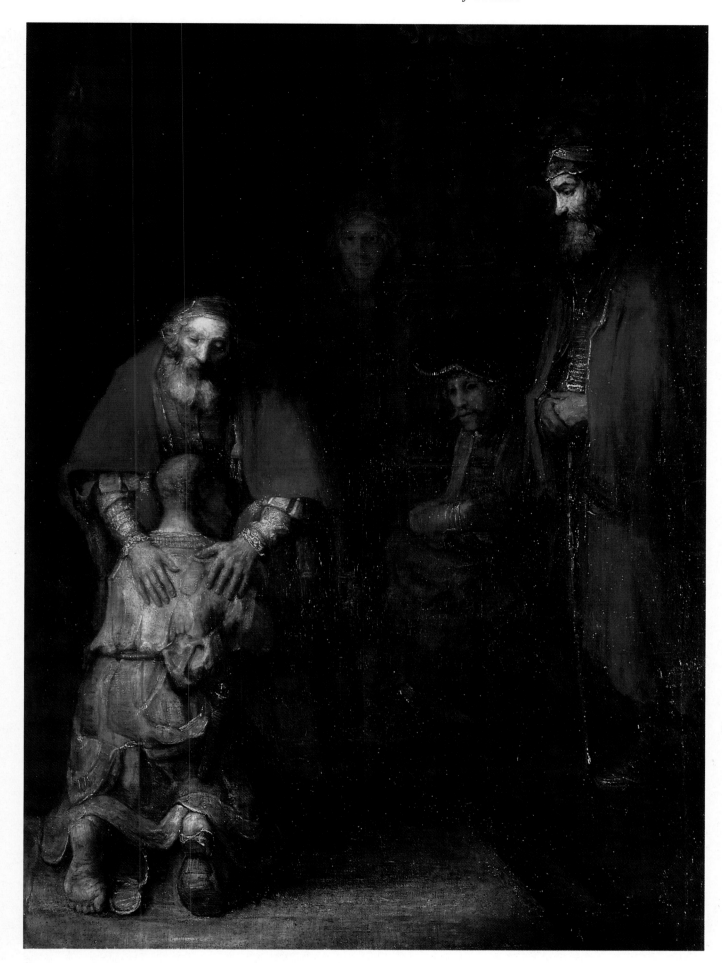

" ... *the younger son gathered all he had and took his journey into a far country, and there he squandered his property in loose living. And when he had spent everything, a great famine arose in that country, and he began to be in want But when he came to himself he said, ' ... I will arise and go to my father, and I will say to him "Father, I have sinned against heaven and before you'."*

The Gospel according to Luke, XV: 13-18

neglected by his contemporaries Rembrandt went on painting; in the absence of any written records of his life his self-portraits provide us with the most precious of autobiographies.

From the *Self-portrait of the artist as a young man* in the Uffizi to the *Portrait of the artist's son Titus* there is a whole cycle of paintings that are the very stuff of Rembrandt's life. The painter questions time, or to be more precise the portion of time that has already elapsed, as if he were trying to grasp its meaning through his own face, progressively furrowed with wrinkles, as if the solution to the mystery were to be found in deciphering these intimate hieroglyphics.

Rembrandt
Return of the prodigal son
Oil on Canvas
St Petersburg, Hermitage

98

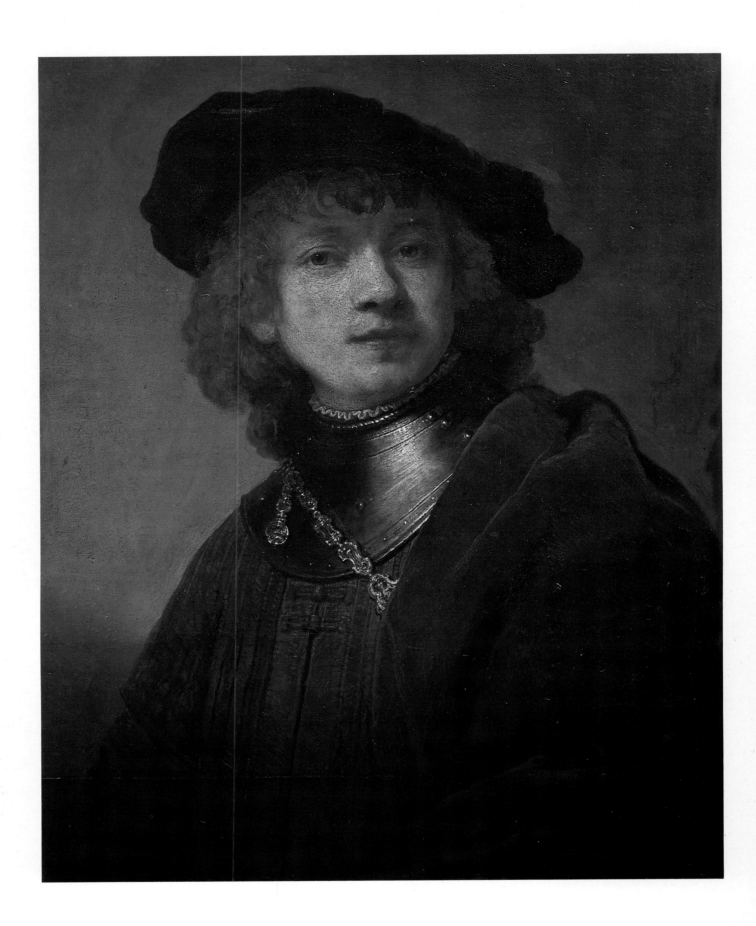

Rembrandt
Self-portrait as a young man
Oil on canvas
Florence, Uffizi Gallery

Rembrandt
Portrait of the artist's son Titus
Oil on canvas
Paris, Louvre

100 *The conscious eye*

Like his father before him, Vermeer worked in the double capacity of inn-keeper and art dealer. His marriage to Catharina Bolenes in 1653 did not make him wealthy, though she came from a well-to-do family. The need to maintain a family of eleven children meant that he was not in a position to live purely through the sale of his work. He was a respected member of the local community, sometimes consulted as an expert, and in 1662 became president of the managing committee of the Delft Guild of St. Luke.

Only some forty works can be attributed to him with certainty, sixteen of which are signed and two dated. Apart from Caravaggio's influence, which is very clear in his early pictures, Vermeer was also affected by the painting of Carel Fabritius, a pupil of Rembrandt's who took up residence in Delft c. 1650, dying accidentally in 1654 when half of the town was destroyed by fire.

Vermeer was a painter of domestic life with a preference for peaceful scenes, interiors, the small acts that make up everyday life, but he treated his subjects with such pared-down simplicity that what might have appeared anecdotal seems all of a sudden to become essential, as if all the light and all the richness of the world were contained for an instant in a reflection in a copper vessel or the whiteness of a thin stream of milk being poured from a jug.

If Vermeer had been no more than a skilful genre painter, he would never have attracted such critical attention. If his only talent had lain simply in combining the three primary colors successfully in a dairy-maid's costume, he would never have been able unfailingly to delight such a wide, uninitiated public. No doubt part of Vermeer's magic resides in these qualities, but it cannot be reduced just to them.

In fact, in his concern for perfection Vermeer has a certain affinity with Raphael. But in Vermeer's work perfection is derived from things, not from an idea of them. They do not serve an ideal, themselves being the ideal that the painter is expressing. This is what is astonishing in his work: the capacity to get us to find beauty in the most ordinary of everyday objects, without in any way magnifying them.

Treating the human face and the object on equal terms, he creates between them a kind of complicity or closeness which is undoubtedly the key to the attraction his work exerts on us. It is as if, by working only on the surface of things and people, he was able to put his finger on the intimate bond that holds them together in the movement of existence.

But genius does not bring wealth, and when Vermeer died in 1675 he left his wife in a calamitous financial position. The invasion of Holland by Louis XIV's troops caused the collapse of the art market, precipitating his widow's bankruptcy, and a mere few months after her husband's death she had to request financial assistance from the town council to enable her to support her eleven children.

Jan Vermeer
View of Delft
Oil on canvas
The Hague, Mauritshuis

Jan Vermeer
The lace-maker
Canvas on wood
Paris, Louvre

102 *A feast of bodies*

Still in the tradition of the teaching of the Renaissance, Giambattista Tiepolo and his son Giovanni Domenico brought a four-century cycle that had propelled Italy to the forefront of western painting to a close. Giambattista, admired throughout Europe for his virtuosity and the speed with which he worked, was particularly noted for making imposing frescoes to decorate the churches and palaces of his patrons.

Tiepolo remained relatively untouched by the theoretical debates regarding the function of his art. As a master of a technique he received commission upon commission and fulfilled them all. Giambattista had rediscovered the chromatic richness and the feeling for grandiose compositions that had brought Veronese renown at the end of the 16th century, and he had a marked predilection for historical, religious or mythological groups. Among the many successes marking his career the following may be mentioned: *Scenes from the life of St. John the Baptist* for the Colleoni chapel in Bergamo (1732-1733), the *Passion* cycle for Santa Alvise church (1738-1740) and the *Story of Anthony and Cleopatra* for the Palazzo Labia in Venice (1747-1750).

Summoned to Madrid by King Charles III of Spain in 1761, he was entrusted with the decoration of the royal palace, where he executed the ceiling frescoes of the *Apotheosis of Spain* in the Throne Room.

Tiepolo seems to have accepted the fact that he was in demand as a decorator without any soul-searching. Any quests in his work were always strictly confined to the pictural domain, and his painting had no mission beyond extending an architectural area and allowing it to achieve, paradoxical as this may seem, its full three-dimensional potential. This may perhaps explain the importance attached to the frame, frequently overloaded with scrolls, which effects a subtle transition from the fresco to sculpted volume. As regards his subject matter, it is important less for the deep meaning conveyed by the subjects selected than for the repertory of forms it afforded to the plastic artist.

Thus Tiepolo's painting is never pedantic or didactic. It is intended to please the eye rather than to stimulate the mind, and is quite simply nice to look at. It is illusionistic, and, like the plump bodies that populate it with the gaiety appropriate to the full curves so beloved of their creator, it is unrealistic.

Giovanni Domenico, who had accompanied his father to Madrid, decided to return to Venice after his death in 1770; in 1780 he was appointed president of the Venetian Academy of Painting. While he was close to his father – he had been his pupil and collaborator over a long period – he differed from him in paying greater attention to reality, which he approached from the perspective of grotesqueness and caricature, sometimes betraying a bitterness that anticipates the work of Goya.

Giovanni Domenico Tiepolo
Christ and the adulteress
Oil on canvas
Marseilles, Musée des Beaux-Arts, Palais Longchamp

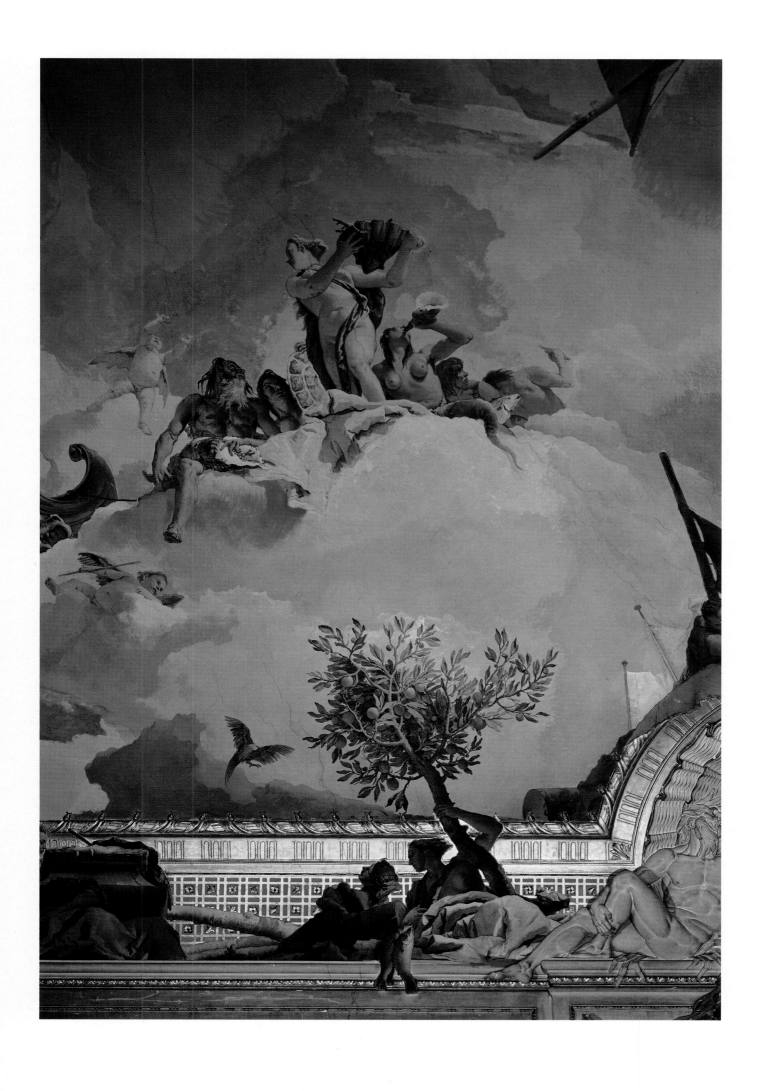

Giambattista Tiepolo
Apotheosis of Spain
(Detail: Cordova)
Fresco
Madrid, Royal Palace

104 *Impressions of Venice*

At the end of the 18th century Italy was the most extraordinary museum in the world, which in a way means that Italian art had stopped living – Italian painting already belonged to the past. And when travel, up until then primarily an aristocratic pursuit, began to be taken up by the upper middle classes, Italian studios, Venetian ones in particular, realised that there was a market to be exploited. The "souvenir" picture was invented, the *vedutà*.

Francesco Guardi, who was born in 1712, was one of the most brilliant *vedutisti*, along with Canaletto. Working with his elder brother, Gian Antonio, he made his name producing views which owed as much to whim and imagination as to scrupulous observation of the locality. While being less rigorous than Canaletto in his compositions, he was more responsive to the effects of light and atmosphere. His touch, sometimes a bare sketch depending on suggestion, anticipates the later experiments of the Impressionists.

Canaletto on the other hand opted for correctness in his drawings, even if he sometimes took liberties with reality as a favor to his clients. Though they were more rigid and anecdotal, his paintings suited public demand better.

Vedute were in fact products made to order, intended for a mainly English clientele. Attached first of all the Duke of Richmond, then to Joseph Smith, the consul who was also a collector and dealer, Canaletto was soon involved in serial production. On these grounds his art, which is called Venetian, ought perhaps to be reassessed as an implant of English taste onto Italian soil.

Irrespective of how these works may have been revalued both esthetically and financially in our century, they are still evidence of a certain decadence in Italian art. With them, painting left the religious field which had been its splendor since the period of Byzantine icons. Pictures became negotiable products, hence very much interchangeable.

This development in the method of producing art is not unconnected with the prosperity of the middle classes: a larger number of pictures for a wider clientele; works in a more restrained format for more modest interiors; and anodyne subject matter for purchasers concerned with respectability. It may be countered that this was not a new phenomenon, as similar criteria had already applied to Flemish art for three centuries. But what was new, a few decades before the French Revolution and with the Industrial Revolution getting under way in northern Italy and western England, was the generalization of this approach to painting right at the heart of the oldest western monarchies. It is as if this final transformation of great Venetian painting were an advance sign heralding the decline of the European aristocracy.

Francesco Guardi
*Departure of the Bucentaur for the
Ascension Day ceremony*
Oil on canvas
Paris, Louvre

Antonio Canaletto
View of the Canale di Santa Chiara
in Venice
Oil on canvas
Paris, Musée Cognacq-Jay

106

Victor Hugo
The cheerful castle (or The sloping town)
Pen, wash and watercolor on paper
Paris, Victor Hugo's house

The fête galante

Watteau invented a way, style or manner of seeing life. In the 18th century, keen on both frivolity and philosophy, he created the universe of the *fête galante*. He was born in Valenciennes in the French part of Flanders in 1684 and came to Paris in 1702. Ten years later he was accepted by the royal Académie, though he did not present the work marking his admission, the *Embarkation for Cythera* (or *Pilgrimage to Cythera*) until 1717.

In Watteau's work life is like a dream, or more accurately a daydream, as if reality, perceived while half-asleep, was subtly and unwittingly altered by the consciousness of the dreamer. This gives the work its paradoxical character: it is heir to the Flemish tradition in its concern for realistic detail, but has an aura of sweet melancholy derived from neither the northern tradition nor the atmosphere of Italy.

His work has been described as excessively "theatrical," and the artificial, precious nature of his compositions has been criticized. For Watteau is neither a classical nor a realist painter. While his work can be linked to the Rococo movement, there is no way he can be described as Baroque. Watteau actually anticipates Romanticism much more than he harks back to Mannerism.

On the face of it the party or *fête* indicates a superficial approach to existence. Parties are for the idle. But they are also the place where roles are reversed and identities transposed. The mask is more than a costume accessory, it is a symbol of this ambiguity which Watteau questions in his work.

In the *Embarkation for Cythera* a whole host of people are leaving the "world," as if reality was disappearing beneath the feet of a class whose values had ceased to apply, or rather as if the norms structuring that reality had suddenly lost their validity. The nostalgia emanating from Watteau's pictures is primarily nostalgia for a lost identity. In contrast to Rembrandt, who is a painter of memory, Watteau might rather be said to be a painter of amnesia: the amnesia of an order that is still at the gaming table when it can already sense that the game is lost, miming a power that it is already slipping away. Louis XIV had just died, Law was speculating, and the Regent was numbing his senses while the people grumbled.

As for the artist, who is he really? Neither completely one thing nor the other. At the end of his short life – he died at the age of thirty-seven – with *L'Enseigne de Gersaint* he seems to have shown a certain shift in his inspiration toward a closer study of life. He was suffering from an illness that left virtually no hope of recovery. When he painted this final picture Watteau knew he was doomed. The deeper meaning of this final work was no doubt that gallantry and love were giving way to friendship and painting.

Jean Antoine Watteau
Nymph surprised by a satyr
(or Jupiter and Antiope)
Oil on canvas
Paris, Louvre

Embarkation "for" or pilgrimage "to"? In the first case this would be a joyful departure for the island of love. In the second it would be the end of the pilgrimage and a nostalgic farewell to Venus – the more likely interpretation if we consider the golden tones that are more redolent of autumn than spring.

Jean Antoine Watteau
*Embarkation for Cythera
(or Pilgrimage to Cythera)*
Oil on canvas
Paris, Louvre

110 *The English countryside*

Thomas Gainsborough, who was born at Sudbury in Suffolk in 1727, was one of the first great post-Renaissance painters not to have studied the great masters. The influences on his work were not Italian but Dutch – van Ruisdael, Van Dyck (there are overtones of Van Dyck in the way he treats drapery in his portraits), and Rubens, and to a lesser extent French, in Watteau – there seems to be an echo of him in Gainsborough's touch.

After attending the school run by the French engraver Gravelot in London from 1740 to 1746, Gainsborough settled in Ipswich about 1750, then left to live in Bath in 1759, no doubt to be closer to his clientele, which consisted mainly of provincial aristocrats. Though first attracted by landscape, like his rival Reynolds he had to bow to the fashion for portrait painting. Gainsborough, more spontaneous and less intellectual than Reynolds, who saw great painting as religious or historical and always had his eye fixed on Italy, gave his portraits a different slant, paying greater attention to the anecdotal.

His sense of landscape led him to endeavor to integrate his subjects into a natural setting: picturesque and welcoming, but already being transformed by man, though the human impact had not impaired nature's charm. With settings halfway between the noisy, artificial world of the town and untamed nature, Gainsborough depicted a certain state of balance, an ideal of existence as conceived by the English landed aristocracy.

In *Mr. and Mrs. Andrews* (London, National Gallery), the man, his elbow carelessly leaning on a bench, has just returned from shooting and rejoined his wife. In the background, clumps of trees alternate with open farmland. The leaves are turning, and the shadows are lengthening on the lawn. The day is drawing to a close, and summer is ending. But for a few gray clouds floating in the distance the instant would seem entirely peaceful.

If there is an ideal, it is an ideal of life, of a way of life we would like to preserve from the onslaught of progress. It is a vision full of confused nostalgia for something we feel is threatened.

A few decades later the Romantics would appreciate this approach, especially as regards the landscape, for Gainsborough's views are first and foremost the reflection of a state of mind. They are the expression of the artist's sensibility and of harmony with nature, which in that instant is speaking for him.

Gainsborough, not as light as Watteau but less tormented than the Romantics, marks a stage in the trend that was bringing painting back toward a more intimate and subjective expression of the world.

Thomas Gainsborough
Mrs Richard Brinsley Sheridan,
née Elizabeth Linley
Oil on canvas
Washington, National Gallery of Art

111

"The aim of these rich
Englishmen dreaming of
Nature without sin,
fascinated by the way the
patricians of the Augustan
age had cultivated rural
pursuits, was to conjure
up in their gardens,
through a controlled
system of literary or
architectural allusions, a
way of life and an
(antique) system of
esthetic values in a
perspective that was ever
more resolutely anti-
Christian."

Michel Le Bris
Journal du romantisme
Skira, 1981

Thomas Gainsborough
George Vernon, 2nd Lord Vernon
Oil on canvas
Southampton, Art Gallery

112 *The triumph of love*

The *fête galante* had started with the Regent; it continued with Louis XV and Madame de Pompadour. The Frenchman may be less of a traveler than the Englishman, but to compensate for this he has something of a reputation when it comes to love. Where the Englishman would hang a view of Venice, the Frenchman prefers to put up a discreetly erotic rustic scene. It is sensually stimulating without getting him into trouble.

Fragonard, an heir to Watteau but with a gayer, lighter style, excelled in conveying those special moments when desire is kindled. His frankness and lack of ulterior motive are beguiling, in spite of the way he openly panders to his clients.

Fragonard's eroticism is deliberately naive. A painter of sensuality, of the simple stirring of the flesh, he associates desire with life and offers us the antithesis of the other purely cerebral face of desire which is starkly expressed in the huge, tortured works of the Marquis de Sade. But the naivety involves complicity, since it is what the client-cum-voyeur wants. The open candor of the prey is a necessary prerequisite for the kindling of desire. If we think of *The swing*, chance has no more to do with it than in a play by Marivaux. When we talk of the game of love, we are also talking of trickery, the dupers and the duped, though we never know who is leading the dance. As in musical chairs, the roles keep changing. Who is being provocative, the girl on the swing or the man who thinks he is sneaking a fleeting glimpse of a white thigh underneath her petticoat?

After winning the Prix de Rome at the age of twenty, Fragonard could have aspired to an official career. But he preferred to turn his back on the Academy, which admitted him in 1765. At odds with the Neo-Classicism which was sweeping France, he embodied the staying power of the declining Rococo, preserving the subtlety of men like Diderot in his pictures, whereas the spirit of the age was eager for a more austere rigor, soon to be satisfied by the dry speeches of men like Robespierre or Saint-Just. Forgetting the disasters that had marked the end of Louis XIV's reign, France was again responding to the lure of greatness.

Unfortunately, pleasure and sublimeness do not make good bedfellows. Fragonard's work encapsulated the aspect of the Enlightenment that the Revolution rejected: fantasy. Fragonard painted without any didactic intention or realist heaviness. The signs of a change of mood were perceptible by 1771, when Madame du Barry, after commissioning four scenes illustrating the theme *Love awakened in a young girl's heart* (the *Progress of love*) from Fragonard, finally rejected them, preferring more classical pictures by a more prudent and shrewder rival.

The Revolution completed Fragonard's downfall. Out of fashion and suspected of having contributed through his work to imaginary, aristocratic debauchery, he narrowly escaped persecution during the Reign of Terror and ended his days with a post on the staff of the Louvre Museum, like a cicada whose life is spared so that it can be forgotten with a clear conscience.

Jean Honoré Fragonard
The music lesson
Oil on canvas
Paris, Louvre

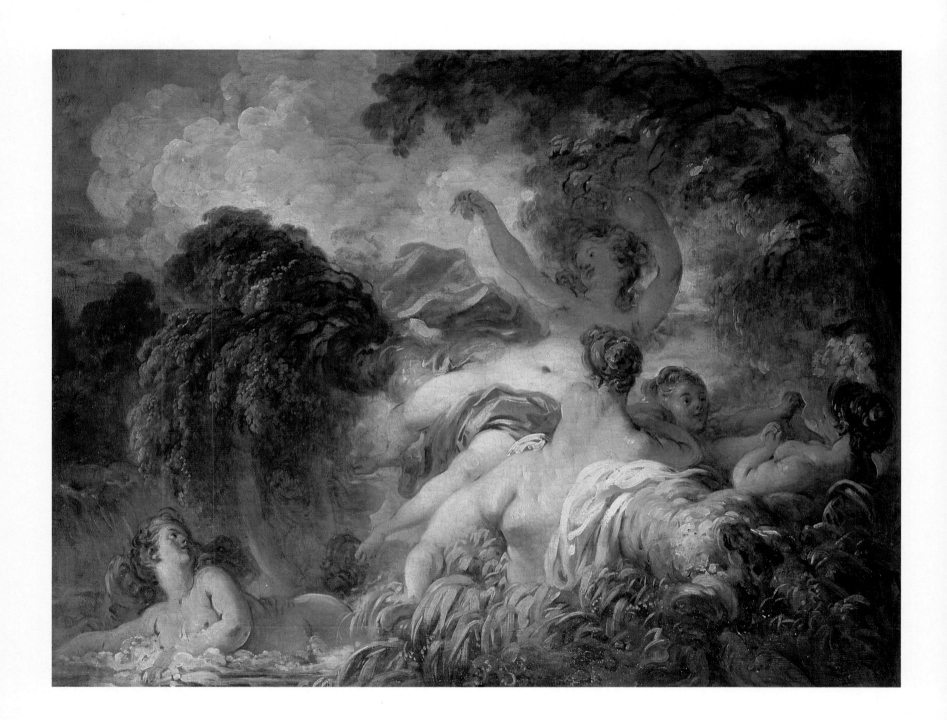

Jean Honoré Fragonard
Women bathing
Oil on canvas
Paris, Louvre

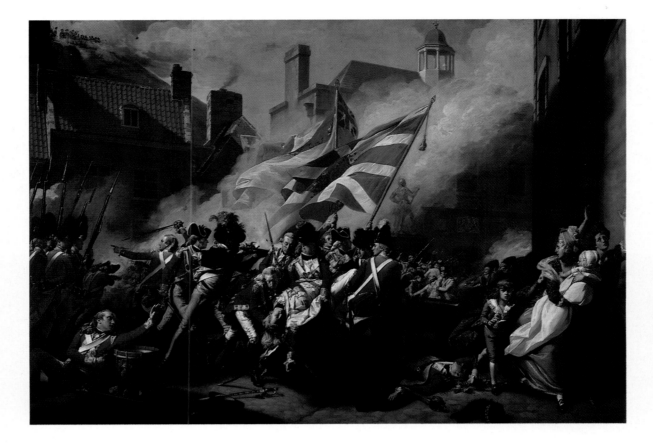

114

Ruins and nostalgia

Hubert Robert was a friend of Fragonard, whom he had met in Rome, but he devoted himself almost entirely to painting ruins and buildings. He went to Italy with the French ambassador, the Comte de Stainville, subsequently the Duke de Choiseul, staying there for over ten years and becoming a friend of Piranesi.

His choice of theme, still regarded as a minor category today, prevented him from being classed as a great master. According to art critics, Robert was at best a graphic artist who painted, mentioned in passing just as one might point out a dead end.

Inspired by Piranesi's series of prints the *Grotteschi* (or *Caprices*) published in 1750 and his *Views of Rome* covering a period going from 1748 to 1775, Robert chose the genre of the "ideal view" as a vehicle for expression. But once again it is important to establish what is meant by ideal. Following in the footsteps of Lorrain, Robert discloses to us a completely personal ideal in which ruins take on an emotional dimension attuned to the sensibility of the painter. Thus his ideal is not universal as Raphael's had claimed to be, but personal, intimate, unique. In contrast to the "view" of Venice, a standardized product, the "ideal view" is concerned less with providing information about the architecture depicted than with shedding light on the state of mind of the artist executing the work.

Though it anticipates the Romantic movement in seeking a point where the soul and the world are in harmony, this approach never goes so far as to wallow in egoism, as is often the case with the Romantics. Quite the opposite in fact: Robert's work tends rather to celebrate the way the self dissolves into contemplation of the world once the point of harmony, in an almost musical sense, has been found.

After returning to France in 1765 Robert was admitted to the Academy the following year and subsequently appointed official designer of the king's gardens. The Revolution, a generous provider of ruins (the Bastille) and grand spectacles (the "Fête de la Fédération"), placed no restraint on his imagination. After avoiding being guillotined in the Reign of Terror (1793-1794), Robert took on the post of conservator of the Louvre Museum during the Directoire.

Hubert Robert
Fire in Rome
Oil on canvas
Le Havre, Musée André Malraux

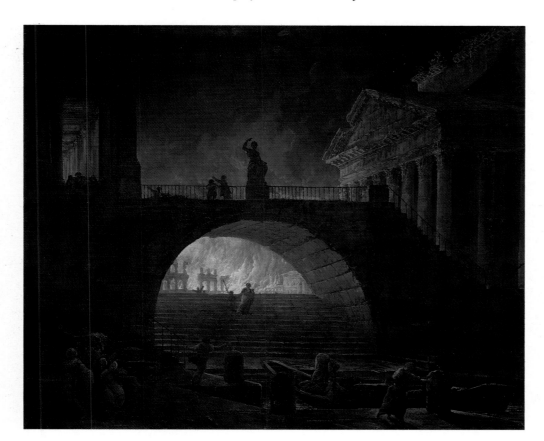

The end of static time 115

John Singleton Copley was American. After making a brilliant start to his career in New England he traveled to Europe in 1774; a Europe which then saw itself as a role model for the New World. After traveling for four years, Copley settled in London where he worked as a portraitist. Faithful to his model, and without idealizing him or her to excess, Copley first tried to bring out the personality of his sitters without in any way falsifying their physical appearance.

However, his popularity was due less to his portraiture than to his history painting – he was one of the great initiators of the genre in Great Britain. Having left a country without a history at a time when it was just beginning to acquire one for itself, Copley devoted his work to the English past. It is a strange paradox that can perhaps be explained by the painter's chosen policies.

Copley opted to look for inspiration in the recent past or current events. No doubt this reflected his American pragmatism. Far freer than his contemporaries in his approach to the founding myths of European civilization, Copley did not feel the need to refer every-thing back to Rome. Whereas French Neo-Classicism could not imagine history painting that did not refer to Antiquity (a concept turning history into a heroic contemporary application of the ideals of antiquity), Copley came up with a much more realistic approach based on treating the deed or event in question purely as a phenomenon of the present. The history he paints is made by men and not by ideas. It is their own property, their wealth.

Seen in this light history became plural, multiple and unpredictable. It became current and immediate. Events had to be described with the greatest verisimilitude to fit in with this new manner of apprehending them, though not to the point of maniacal exactness (an undertaking that would in any case be doomed to failure). For verisimilitude is not the truth: it is only one possible version of it.

Heroism, realism and Romanticism are combined in Copley's painting, which inspired painters such as Vernet, Géricault and Delacroix when they wanted to get away from David.

John Singleton Copley
The death of Major Pierson
Oil on canvas
London, Tate Gallery

116 *Urizen*

Urizen is the face of Evil, and Evil is in nature. These were the two basic premises of Blake's metaphysics. Thus everything that is natural or an imitation of nature leads back to Urizen. This includes history, since it results from the interaction of space and time which are signs of the damnation of Satan.

It follows from this that the evidence of our senses which exist only through space and time is necessarily deceptive. All the values that the Renaissance and consequently painting had handed down for more than three centuries did nothing but reinforce this mistaken concept of what is true, beautiful and good.

An open opponent of Locke's empiricism and of natural religion, Blake went back to a brand of mystical Christianity which caused him to be regarded as a "Neo-Gothic" artist. He shared with the medieval illuminators an absolute indifference for exactness of representation. As he saw it, drawing from nature was an absurdity and an obstacle to "true vision." On this point he was in agreement with Swedenborg's theosophy, contrasting the "vision of the flesh" with a "vision of fire." For everything that highlights man's sensibility adds a new bar to his material prison and serves to block the way leading to transcendence still more.

Thus the path of truth does not lie either in the senses, as Locke and Condillac claim, or in the exercise of reason which is imprisoned by what can be perceived by the senses, but by setting in motion the power of imagination. "But let there be no mistake ... " Michel Le Bris tells us, "this Imagination has nothing in common with the 'fantasy' that gives rise to the imaginary in the usual sense, i.e. the unreal: ... Blake turns the work of art into a place of Revelation, and ties all artistic creation to the questioning of the first mystery of the Word made Flesh, the Word that turns into Holy Scripture, in short the Incarnation."

After breaking with the Royal Academy in 1780 Blake remained virtually unknown by his contemporaries. Illustrating his own poems, making his own books in a reversion to the tradition of the copyist monks of the Middle Ages, he was treated with the condescension accorded to madmen and died in 1827 without having found his true place, bequeathing to the Romantic and Symbolist generations that followed him a determination to reveal the world of the invisible.

William Blake
Jacob's ladder
Watercolor and ink
London, British Museum

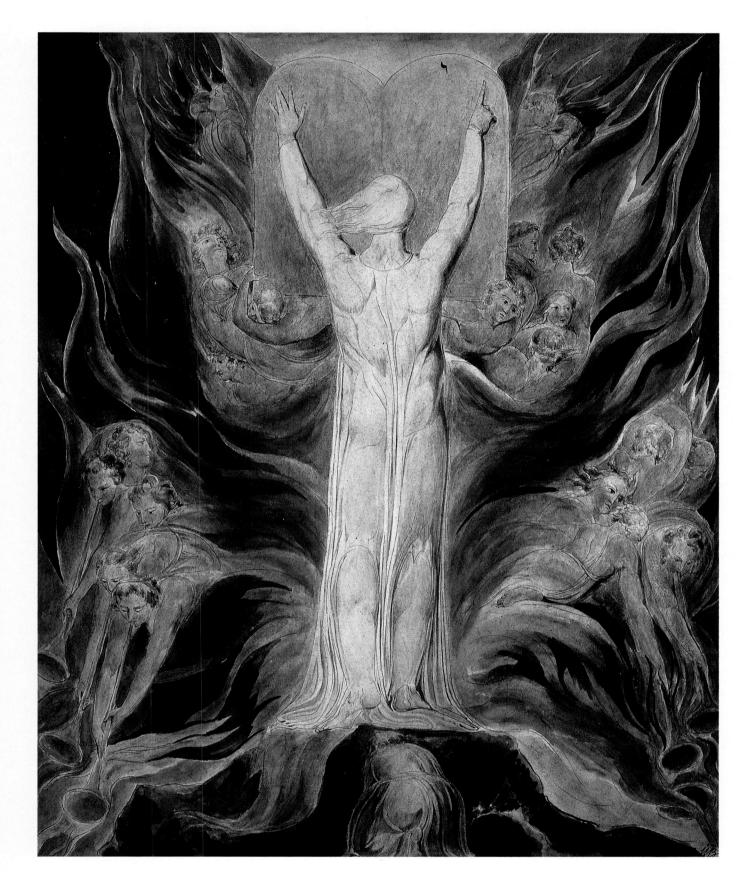

*"Prisons are built with
stones of Law, brothels
with bricks of Religion."*

William Blake

William Blake
*God writing upon the tables
of the Covenant*
Drawing
Edinburgh, National Gallery of Scotland

"*Everything turns into visions*"

For those who had pinned their hopes on the Enlightenment, the end of the 18th century was like a shipwreck. It had been expected that the reign of reason would open the path to happiness; instead it gave birth to the Reign of Terror and the Napoleonic Wars. The French Revolution had made the dream tip over into horror; it had made liberty into a monster in whose name, as Hegel put it, they started cutting off heads as if they were cabbages.

Goya was the painter of this disaster. After several unsuccessful attempts he was admitted to the Academy of San Fernando in Madrid in 1780. He had started off in a completely different spirit, very much at home painting scenes from popular life which captivated an aristocratic clientele who found this genre appealing. On the accession of Charles IV in 1789 he was appointed a Court Painter, and "First Court Painter" ten years later, but his official career came to an abrupt halt after 1804, when the royal family withdrew its support, preferring his rival Gregorio Ferro.

But the real break came earlier, in 1792. That year Goya became seriously ill while traveling in Andalusia. His illness, which has never been reliably identified, caused an almost total loss of hearing, and if it did not alter his character it certainly affected his imagination, marking a crucial turning point in his work.

Very soon after returning to Madrid in June 1793 he started on the series *Caprichos*. This was published in 1799, but unfortunately very quickly withdrawn from sale to avoid the wrath of the Inquisition. The engravings did not confine themselves to stigmatizing popular ignorance and superstition, which would have been accepted by the elite, even the relatively unenlightened. Goya went further, including the thirst for power, stupidity and corruption of property owners in his denunciation of the blemishes in society – not in a misanthropic way, but with a cruelty that matched his disillusionment.

Goya refused to choose between the blind fury of faith and the horrors of the so-called wars of liberation, so trapping himself in an insoluble dilemma which re-animated the power of his dark visions. The irony still present in the macabre scenes of *The Disasters of War* (1810) was succeeded by the completely heartrending vision of the *Disparates* (literally "extravagances") (1820) and the tragic cycle of *Black paintings* with which he covered the walls of his house, the "Quinta del Sordo." It was as if in his home near Madrid, beside the Manzanares, he had sensed the imminent return of fanaticism to Spain, a country always fascinated by death, which he had portrayed in the features of *Saturn devouring one of his children*. His intuition turned into reality in April 1823, when the adventure of the "Hundred Thousand Sons of St. Louis" (French forces fighting in support of the Spanish monarchy) ended with the reestablishment of absolute power, so bringing three short years of liberalism to a close.

Goya
Inquisition scene
Oil on canvas
Madrid, Academia de Bellas Artes
de San Fernando

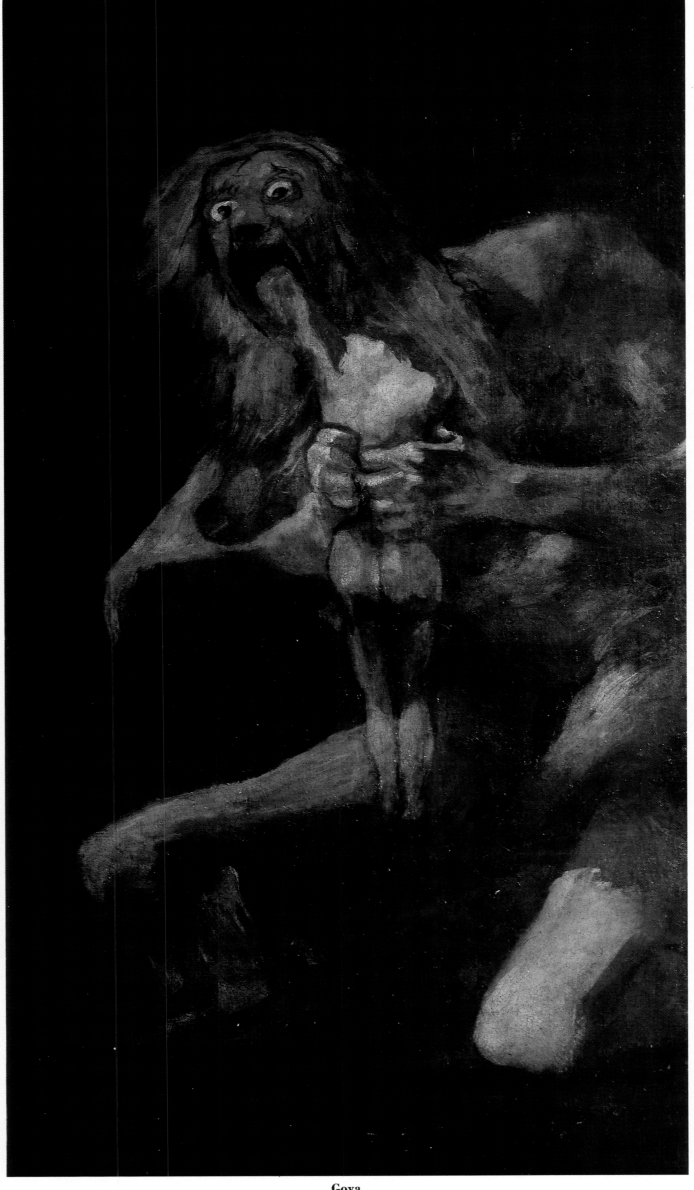

119

"The bond linking atrocity with religion is strong for a people who have been worshipping a tortured man for two thousand years. And Greece which in collective human memory is thought of as Arcadia also expresses this link through a god who devours his children, through specters and the gouging out of a hero's eyes."

André Malraux
Saturne
Le destin, l'art et Goya
Gallimard, new edition,
1978

Goya
Saturn devouring one of his children
Oil on canvas
Madrid, Prado

Goya

120

*Painted between 1800
and 1803 at the time of
the Duchess of Alba's
death, the Maja Vestida,
commissioned by the
Prime Minister Manuel
Godoy y Faria as a
pendant to the nude
version executed in 1795,
represents a kind of
farewell to the woman he
had loved with a violent,
jealous passion.*

Goya
La Maja vestida
Oil on canvas
Madrid, Prado

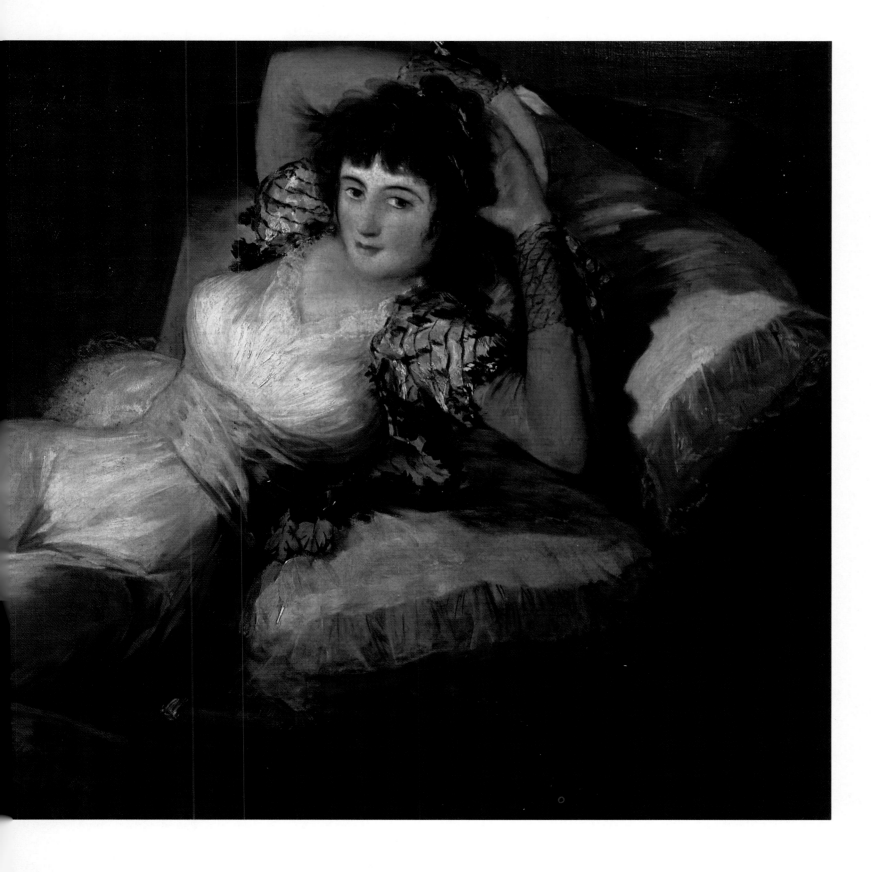

Fantastic dreams

The work of the English painter Henry Fuseli (born Johann Heinrich Füssli), a contemporary of Goya, is symptomatic of the contradictions running through the spirit of the Enlightenment. Brought up in Zurich in an atmosphere dominated by German culture, Fuseli was to some extent associated with the literary *Sturm und Drang* movement which developed from 1770 as a reaction to the Enlightenment.

Faced with an increasingly moralistic, restrictive rationalism, philosophers and poets like Rousseau and Goethe responded by rehabilitating feeling. But the movement, more complex than a simple rejection of the power of reason, asserted the existence of something beyond reason, a sort of unthought area inaccessible to reason itself. This is not the unconscious, i.e. a private and intimate unthought area bound up with the individual history of any one of us, but an original violence common to the species: a violence disguised by history and the regulatory power of civilization, but which is still there, a power that is maleficent because it is ignored and which should be revealed so that we can liberate ourselves from it. Revealing the powers of Evil, causing the nocturnal forces that have been silently at work for centuries, since the existence of the first man and the first woman, since the crime of Cain, to come up to the surface of the inky waters, these were the aims of the demonism that inspired Fuseli in his work – driving violence and passions out of oneself in a surge of superhuman heroism, going beyond one's condition as a mere mortal to make way for a better humanity. For Evil is in the human breast; by denying it reason condemns itself never to be able to engender anything other than Terror. There is sublimeness in such a view of esthetics – it is visionary, and hallucinatory; feeding on drama and tumult it is inevitably paroxysmal. But in what has been described as "18th-century gloom" (in contrast to the light of the Enlightenment), this esthetic is directed toward nothing other than happiness. The means and the path are different, but the aim is identical.

In showing the disturbed and worrying spectacle of the terrors that are at work within us underneath the surface, Fuseli's work aims at catharsis, the purging of passions, a necessary stage in the advent of a new world where nature would be finally free of sin. Nonetheless, behind the proclaimed ambitions there is still ambiguity. A dubious sense of enjoyment in which we share and which gives the work its force enters into the denunciation of Evil. Desire is kindled by the languid bodies of these ghastly, pale beauties, while the demons crouching on their breasts keeping us at bay paradoxically take on the role of protecting their threatened virtue, thus proving that the Evil we are stalking exists only through us, and that the enactment of exorcism is the most secret area of the human soul.

Johann Heinrich Fuseli
Prospero
Oil on canvas
York, Art Gallery

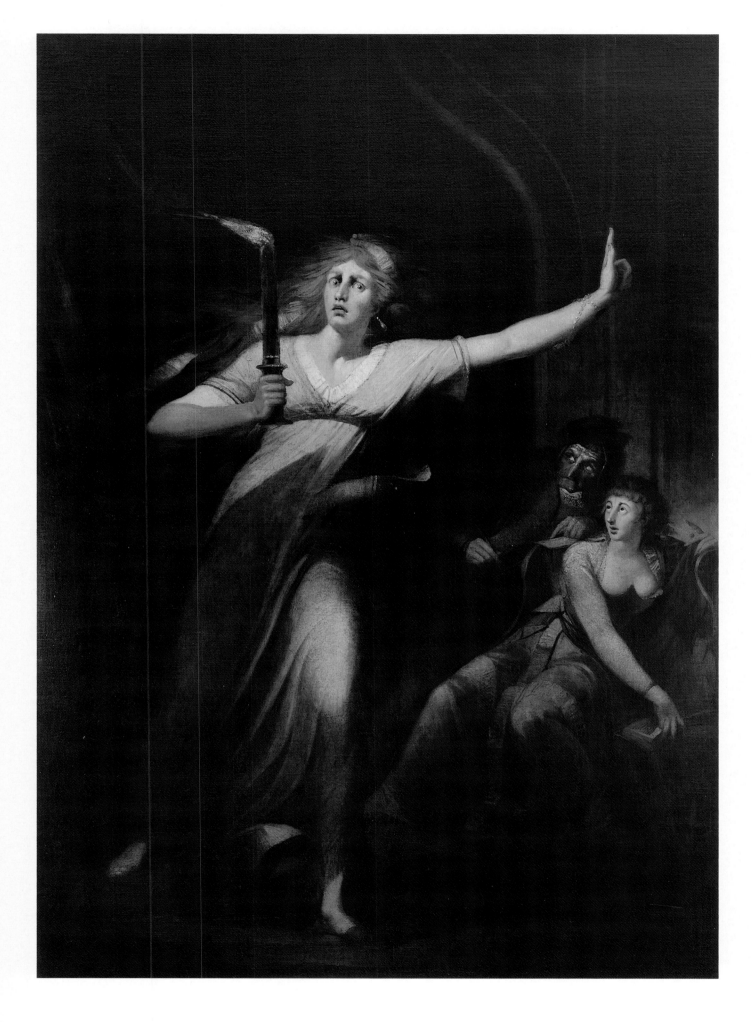

"O, never/ Shall sun that morrow see! ... to beguile the time,/ Look at the time; bear welcome in your eye,/ Your hand, your tongue: look like the innocent flower,/ But be the serpent under 't ... "

William Shakespeare
Macbeth, Act I, scene v

Johann Heinrich Fuseli
Lady Macbeth
Oil on canvas
Paris, Louvre

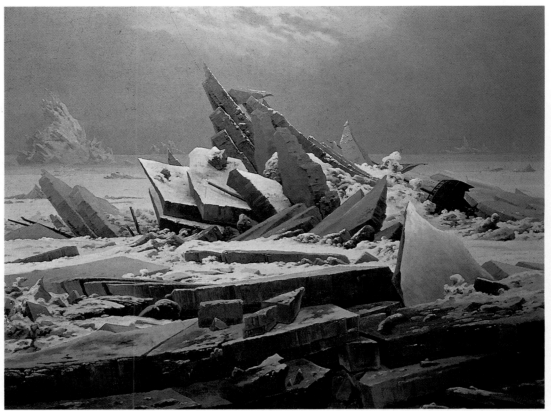

An unreal solitude

124

Romanticism, not as a movement but as a new sensibility, perhaps found its first true interpreter in Caspar David Friedrich at the dawn of the 19th century. With the great dream of freedom that had shaken Europe having been engulfed in the Revolutionary and Napoleonic Wars, and the rule of utilitarianism, pragmatism and money getting under way, a few artists stood up to indicate their rejection of that world.

What is Friedrich saying in his *Monk by the Sea* exhibited in Berlin in 1810? What is he expressing in the *Abbey in the oak wood* painted that same year but the end of hope, the shipwreck of hope (the title of another of his paintings) which leaves man alone facing the immense void separating him from another world, which he is afraid he can never cross? What is he painting but the painful feeling of exile and loneliness that overwhelmed a whole generation of artists after the senseless turmoil of the Revolution: artists who could not identify with the didactic, moralistic mission the new ruling classes wished to assign to art?

The Romantics saw art as essentially a search for the ideal, an aspiration to transcendence. Despite the silence of God art was a revelation of His presence. Such a definition was not new in itself, but the means chosen to achieve the aim on the other hand were radically so. What is shocking, or rather disconcerting, in Friedrich's work is not that he places his art at the service of his faith, a very commonplace procedure, but that he sets out to express it without resorting to the usual religious subject matter that had been codified for nearly a thousand years. Suggesting the infinite power of God in the dark horizon of an empty sea without resorting to the set pieces of religious painting, that was what was breathtakingly radical! Stripped of its artifices, without the help of anecdote or the charm of the picturesque, the landscape has become the empty site where a manifestation of God is awaited. For God is not present in the silence of the ruins in the classical, pantheistic sense preached by Spinoza or Voltaire. Nature is not God, nor is God the sum of all that exists. But the material world in its appearance of disorder is the visible token of his invisible presence.

In the words of Michel Le Bris, "God is not the world, but in this world we are not abandoned by God, which is why we never feel our exile here below and our impulse toward God so strongly as when rapt in the contemplation of the beauty of nature – for beauty is always a manifestation of an infinite in the finite: *theophany.*"

Caspar David Friedrich
Shipwreck of the 'Hope'
(or Arctic shipwreck)
Oil on canvas
Hamburg, Kunsthalle

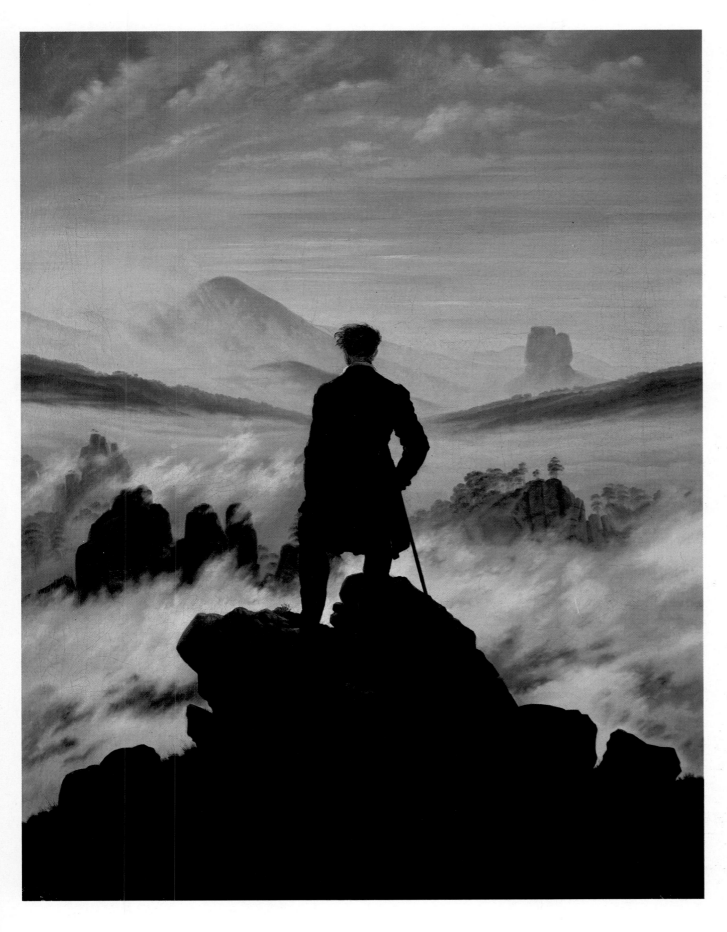

"The painter should not paint just what he sees before him, but also what he sees within himself. But if he sees nothing within himself, let him also give up painting what he sees before him."

Caspar David Friedrich

Caspar David Friedrich
Traveler above the sea of clouds
Oil on canvas
Hamburg, Kunsthalle

126

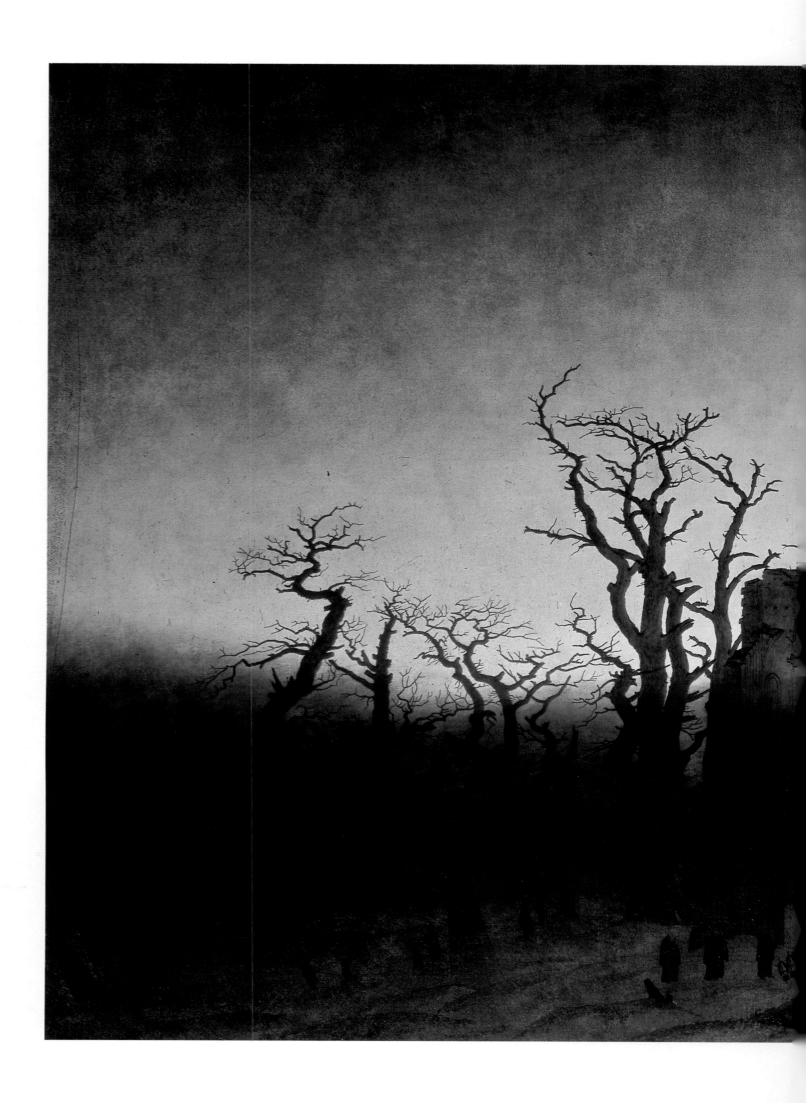

Caspar David Friedrich
Abbey in the oak wood
Oil on canvas
Berlin, Schloss Charlottenburg

The funeral dance of the myths

While Friedrich was working toward his blueprint, his friend Philipp Otto Runge was trying out a different path, based on the search to give tangible form to the idea; this was fully expressed in the second half of the 19th century in the flowering of the Symbolist movement. As early as 1796 Schelling wrote in a letter to Hegel: "As long as we have not transformed ideas into works of art, i.e. myths, they will be of no interest to the people, and conversely, as long as mythology is not rational, the philosopher will be ashamed of himself A superior spirit sent from Heaven must establish this new religion among us: it will be Mankind's last achievement."

Thus Symbolism was the implementation of the ideals of German Romanticism. It could be meditative, allegorical, fantastical or visionary, deriving its unity from the ambition defined by Moréas in 1886: "to give the idea a tangible form." Just as the Romantics had come together in a common rejection of the fixed ideal of Neo-Classicism, so the Symbolists were united by a common rejection of Positivism and Realism.

The foremost interpreter of this movement in Switzerland was Arnold Böcklin. In his landscapes he took over some of Friedrich's discoveries, but the primary characteristic of his work is a return to Greco-Roman mythology. A painter of nymphs, naiads and centaurs, he was not able, like Friedrich, to empty his canvas of living forms. But his quest does not so much reflect the desire for another world as the anguish he feels at the brevity of life and the inevitability of death. And the fact that death is very much present in his work (*Vita somnium breve* and the *Island of the dead*, both Basle, Kunstmuseum) results not from a taste for morbidity, but from love of life: even if, as in his *Combat of the centaurs*, movement cannot be dissociated from its opposite, nor rising from falling, in a struggle the outcome of which is known in advance, but where death triumphs only in order to enable the rebirth of something else in the circular motion of time in myth.

Arnold Böcklin
Diana at the chase
Oil on canvas
Paris, Louvre

Caspar David Friedrich
On the sailing boat
Oil on canvas
St Petersburg, Hermitage

130

Jacques Louis David
The coronation of Napoleon I
on 2 December 1804
Oil on canvas
Paris, Louvre

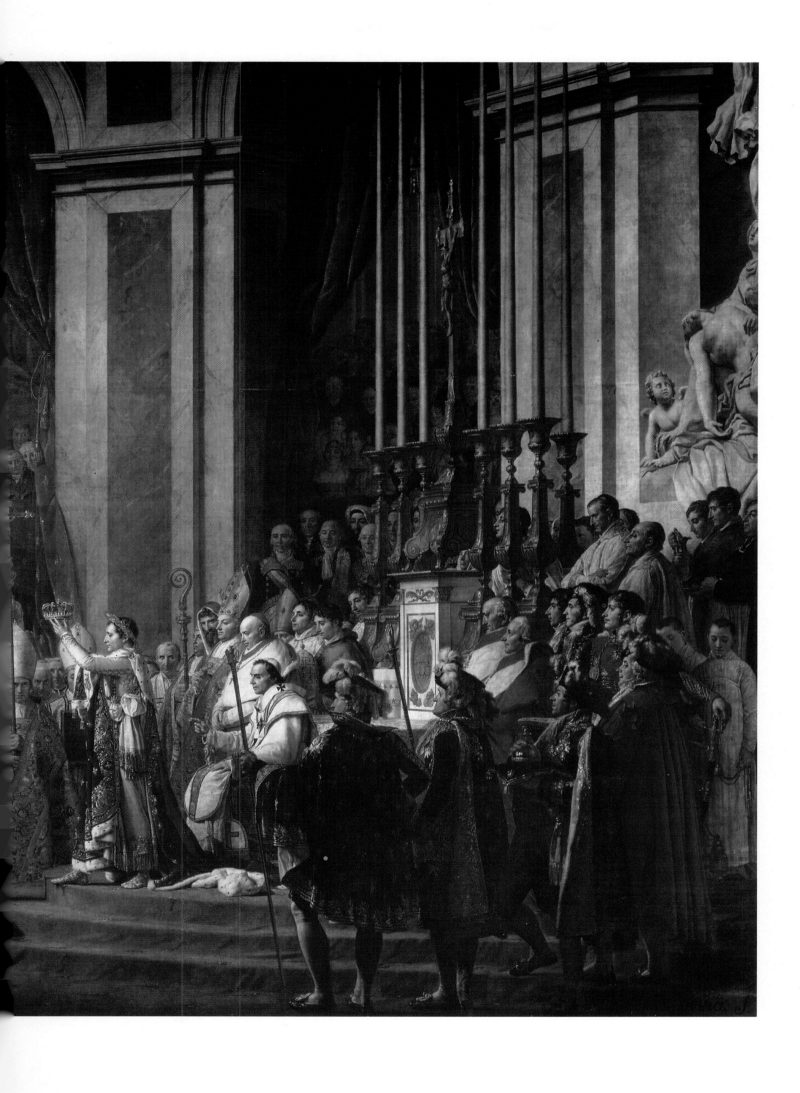

David **4** *The breath of History*

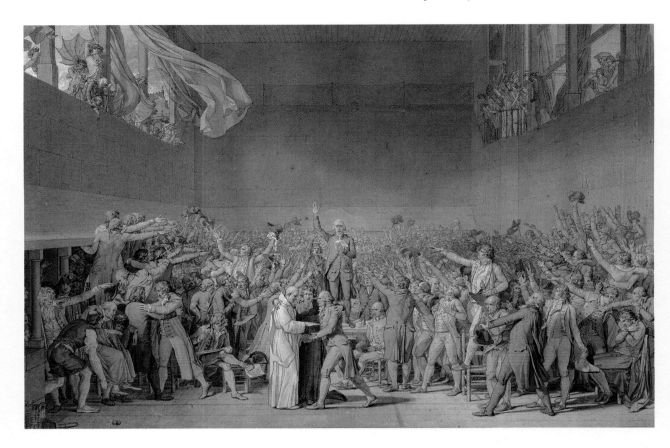

132 *The great organizer*

Both pre-Romantics and Romantics indicated one of the options available in the philosophical and political debate which shook the whole of Europe at the end of the 18th century and the beginning of the 19th. The debate could conclude in one of two possible ways: on the side of natural forces on the one hand, or on the side of the strength of the law – nature as opposed to history, violence as opposed to order, the individual as opposed to the State.

Humanism was in crisis, no longer able to conceive of man's place in the world in terms of harmony. The spirit of the Renaissance had run its course, and its death, indicated historically by the outbreak of revolution, plunged western civilization into a major crisis, producing the tragic picture of man riven by his contradictions, no longer at the center, but both inside and outside nature, involved in it at the same time as he pulled free from it. The picture of reason, the main organizing force of a new world, compelled to borrow nature's own weapons of violence and terror, was also tragic.

Jacques Louis David, the antithesis of artists like Blake or Friedrich, who opted for inner, individual experience or introspection to try and overcome this dilemma, staked his wager on the opposite course. For whatever name we give to the first principle which we all seek – God, Supreme Being, the Universal – there are only two paths leading to it: the path of subjectivity, i.e. plunging into one's innermost self, and the path where the subject is made objective in the common law, the individual is fused into the collective, the State

– a new principle from which man can derive a new legitimacy. Legitimacy here means conforming with the law: no longer divine law, but human law arising from the swearing of a solemn oath by all citizens. It is in effect a social contract as defined by Rousseau, putting an end to the state of nature, based on the violence which had governed human relationships until the French Revolution.

Rather than depicting torments welling up suddenly from the obscure depths of the human soul, David painted the pure, redeeming moment of the oath. In the *Oath of the Horatii* he painted the event underpinning the foundation of the Roman Republic, and in the *Serment du Jeu de Paume* the symbolic birth of the French nation. It is a moment outside time, in suspense so to speak, when the fusion of individuals into a Whole takes place, marking the transformation of individual desires into a common will; a moment of light, of the emergence of reason, immortalizing the end of the epoch of blind passions; a moment of redemption, when men through a freely given act of allegiance to the State reclaim their history.

Yet the birth of this new humanity celebrated by David is not directed against nature; it takes place for it, or rather for man who has rediscovered his rightful place at the heart of civilized, policed nature, refashioned by the working of reason, and modeled on Republican Rome and Homer's Greece. That is why David turned to antiquity, not to the age of Augustus already foreshadowing Nero's, Heliogabalus's and Caligula's

Jacques Louis David
The "Serment du Jeu de paume"
at Versailles on 20 June 1789
Pen, sepia ink with white highlights on paper
Paris, Louvre

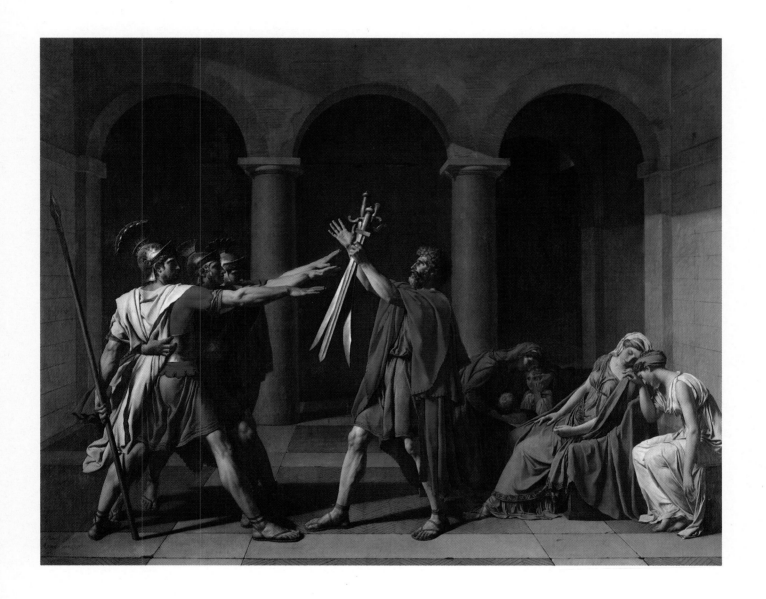

Jacques Louis David
The oath of the Horatii
Oil on canvas
Paris, Louvre

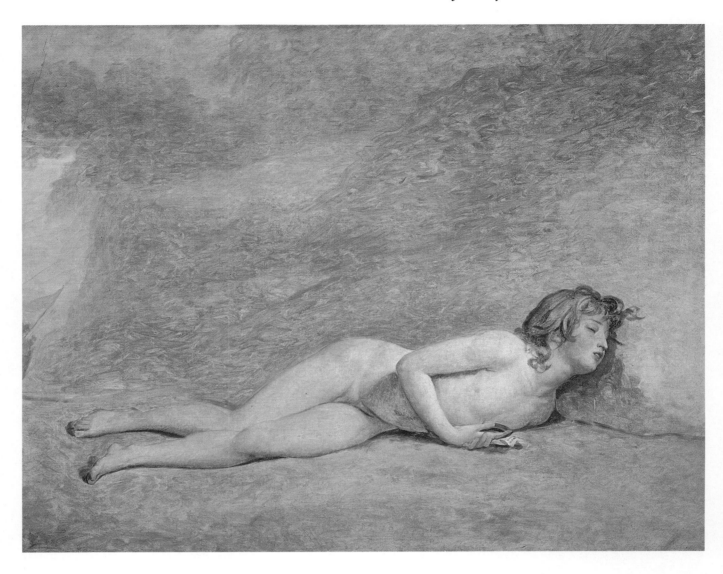

Attacked on a roadside by Royalist Vendeans who asked him to shout "Long live the king!" Joseph Bara, a young drummer boy, replied with the cry "Long live the Republic!" and was immediately slaughtered. The Convention made a hero of him, and at Robespierre's suggestion entrusted David with organizing a patriotic celebration in his honor.

134

follies, but to the stern, harsh antiquity of Brutus and Ulysses.

So the reign of reason was justified by myth. Paradoxically history is not born within history, but outside it, in the unmoving time of myth, as if the strange phenomenon of the oath derived its sole validity from being the present-day manifestation of the archetype of an ideal alliance. In this respect the Revolution was not a break with the past, but quite literally a return to origins. What it invented at the moment of the oath was etymologically a rediscovery of riches that had been lost to memory with the passage of time: civic virtue, courage, self-commitment.

The esthetics associated with ethics such as these inevitably rested on a reaffirmation of the rule. Only the law, and not the self, self that is nothing without the other in the form of the social body, can say what is right, and since it is right true, and since it is true beautiful. Thus it was the State that art should serve, and in accordance with norms fixed by the State. But this State was no longer embodied in the person of the monarch, but in the dramatic figures of its martyrs and heroes: Marat, Bara, Robespierre and above all Napoleon, a real living myth who invented the sense of history.

Nevertheless, David's Neo-Classicism served public authority only insofar as that power remained faithful to its ideals. Having been a member of the Convention, a Jacobin, a regicide, the person who arranged Marat's funeral and the great organizer of the Feast of the Supreme Being, David almost paid for his beliefs with his life on the fall of his friend Robespierre in 1794. Imprisoned on two occasions, he lived in retirement throughout the Directoire, refusing a seat on the Council of State and in the Senate. His return to the forefront of public life after 1799 was due less to a liking for honors than to the fascination the Emperor held for him. After ten years of terrible upheaval David was keen to achieve reconciliation among Frenchmen. This was the meaning of the *Sabine women ending the battle between the Romans and the Sabines* (1799). And this was also the proclaimed ambition of Napoleon. As someone carrying on the ideals of the Revolution, a heroic figure of civic virtue, the emperor-to-be struck David as the only man capable of restoring civil peace.

We know what happened to both the hero and his painter, both drawn into the infernal spiral of the unbounded celebration of courage until the brutal awakening of Waterloo, which resulted for Napoleon in exile on St. Helena and for David in exile in Belgium, where he died in Brussels in 1825.

Jacques Louis David
The death of Bara
Oil on canvas
Avignon, Musée Calvet

"Soldiers, you are short of food and clothing. The government is much indebted to you, but cannot pay you. Your patience and courage do you honor, but are not enough to give you the advantage and win you glory. I am going to lead you onto the most fertile plains in the world; ... there you will find honor, glory and wealth."

Adolphe Thiers
La Révolution française
Volume VIII
Bonaparte addressing the soldiers of the army of Italy
(1796)

Jacques Louis David
Bonaparte crossing the Alps
Oil on canvas
Rueil-Malmaison, Château de Malmaison

136 *The disasters of war*

Reason taking up arms is liberty gone mad. Confronted with the new man, the figure of universal man whose proclaimed intention was to regenerate mankind, real flesh-and-blood men dropped to their knees and fell. Men died under the impact of steel swords and lead bullets: Spanish and French alike, quite impartially, grumblers or patriots. Goya did not paint against France any more than he painted for Spain. Since he could no longer paint in support of liberty which, in the words of Hegel, had become a "fury of destruction," he painted the failure and disastrous end of an ideal, and the no less ignominious end of human beings, for everything is interdependent.

So what is left in face of the palpable absurdity of history? What is left when the world has lost its senses, and happiness, defined by Saint-Just as the "new idea in Europe," offers nothing but the most macabre caricature of itself? What is left is the sight of pain, and cruel derision.

As if in reply to David's monumental *Coronation of Napoleon*, Goya produced *Second of May 1808 in Madrid* and *Shootings of May third 1808 in Madrid*;

while the former is a celebration the latter is not a denunciation. To celebrate, one only has to believe. To denounce, one would have to hope. Goya no longer nursed any hopes. He was simply repeating the absurd scene that had meant the end of the dream. Almost obsessively he reiterated the moment when the future suddenly turned black and closed in, becoming opaque and somber like the sky in the *Execution*, when the light of the Revolution trained on the rebel's white shirt finally put the freedom of nations to death. Henceforth thought would devour itself, in the image of *Saturn devouring one of his children*. Light deserts the canvas and perspectives vanish. It is a slow, long and painful death with grotesque death throes that fascinates the painter. Then, in the words of André Malraux, "an interminable procession of pain surges up from the depths of time toward these terrible figures, accompanying their tortured sufferings with its subterranean chorus; transcending the drama of his own country, this man who has lost his hearing wants to lend his voice to the total silence of death. The war is at an end, but not the absurd."

Goya
The second of May 1808 in Madrid
Oil on canvas
Madrid, Prado

Goya
The Colossus (or Panic)
Oil on canvas
Madrid, Prado

138

*"This is not a war report,
it is a war poem."*

André Malraux
Saturne
Le destin, l'art et Goya
Gallimard, new edition 1978

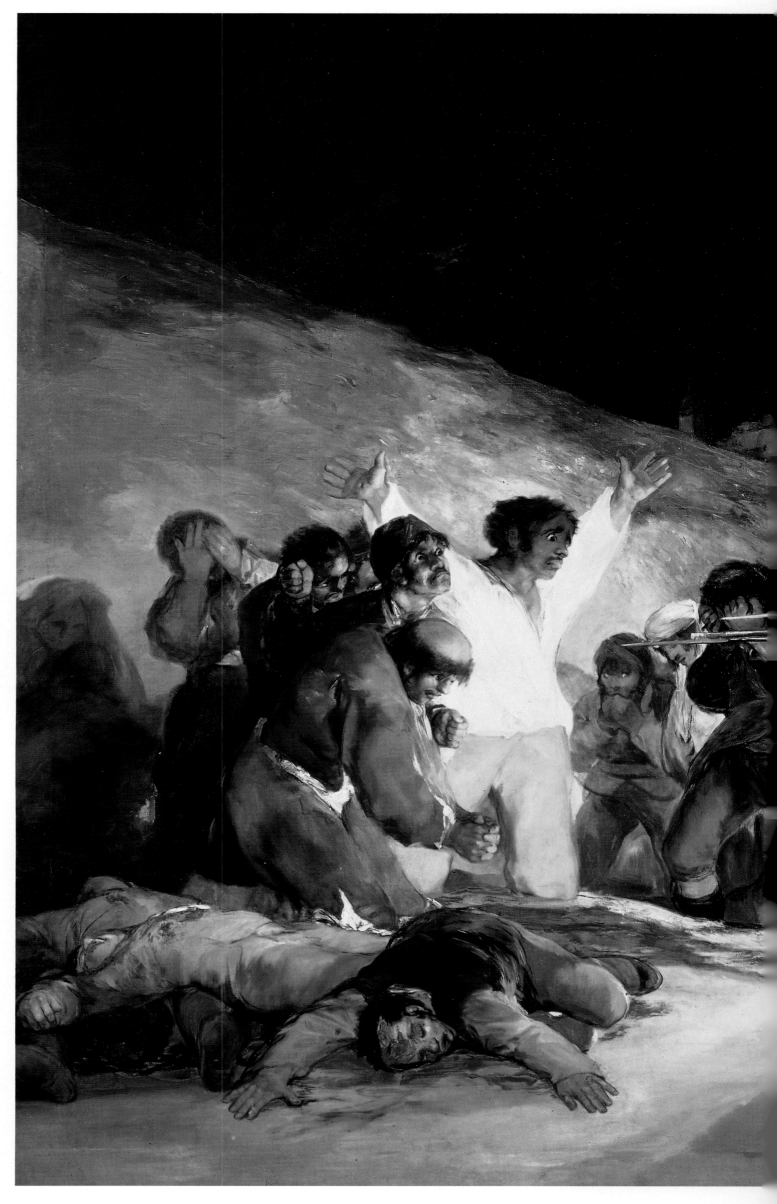

Goya
*Shootings of May third 1808
in Madrid*
Oil on canvas
Madrid, Prado

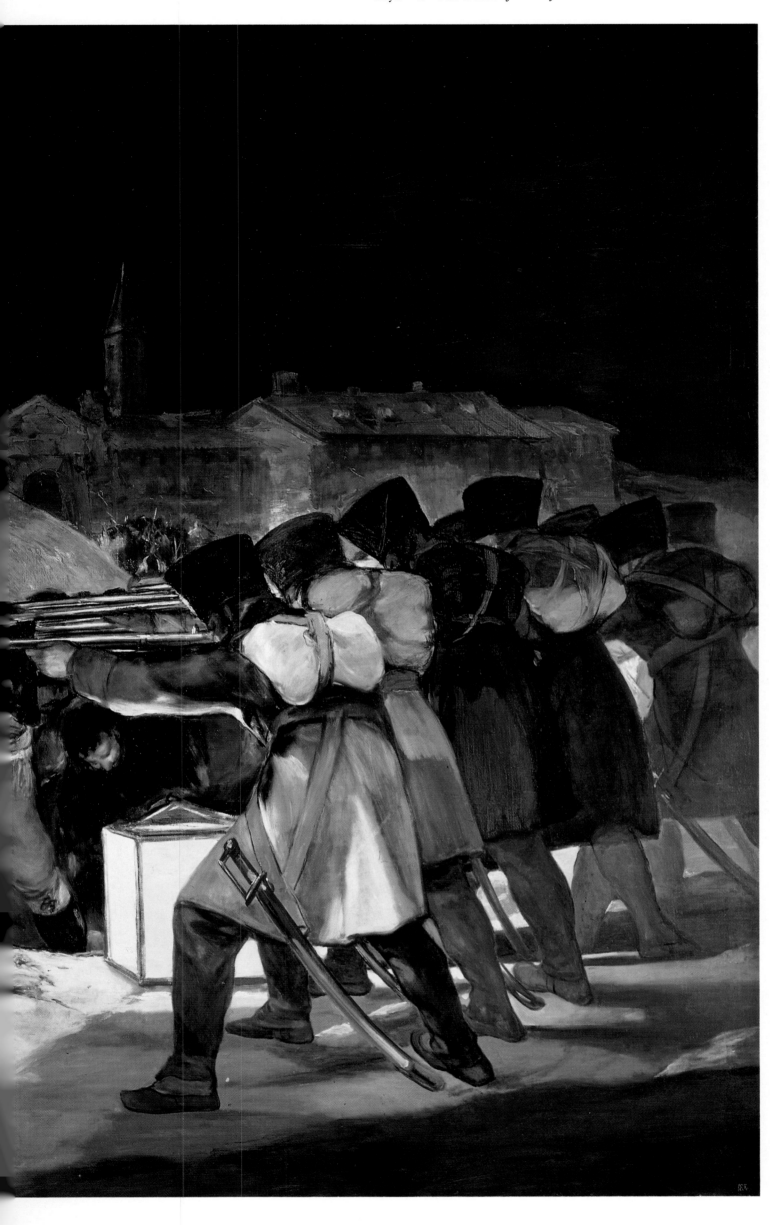

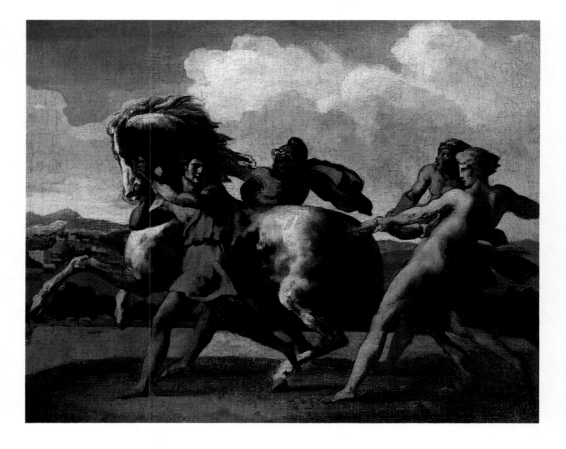

140 ***The tragedy of the humble***

When we lose our senses, our being is split and scatters in incoherent fragments. It was Géricault's ambition to describe "the whole epic of the modern world," but he ran out of time. Torn between David's Neo-Classical rigor, the attraction of the Baroque with its intertwining forms, and Romantic exaltation, he hummed and hawed, producing a plethora of sketches and preparatory drawings. His work is incomplete, veering between phantasm and reality, never coming down on one side or the other.

It is haunted by the shade of Napoleon. For the imperial myth grew in the minds of young people disheartened by the mediocrity that the Restoration offered them. By setting Europe ablaze and bathing it in blood, Napoleon had reinvented the epic, and it was of that epic that an entire generation of young people were dreaming, impatient, but reduced to impotence by the coming to power of the middle classes.

Unfortunately the epic tale had already disclosed its secret: people knew it had been engulfed in horror. So artists painted horror, to denounce not the horror but the duplicity of those denying it had happened. It was as if truth could be found only at the very heart of tragedy. But where could tragedy be found in that dreary, boring epoch, greatness in that chilly world of worried property-owners, or horror in those sensible, knowing minds? For tragedy is a noble genre, light years away from middle-class drama.

Between an aristocracy that was still reeling from the shock of the humiliation of emigration, and a middle-class sector greedy for money and social recognition there was no room left for hope. Wanting to paint "the whole epic of a world" that rejected the epic could only be a mad project, or the project of a madman, and hours of desperate toil would not alter that fact. Géricault's thousands of disparate studies never came together to form the grandiose oeuvre he always dreamed of but never achieved.

Ultimately it was to reality that Géricault turned in search of the material for his undertaking, with amputated arms, severed heads, putrefying torsos and mad faces, but he turned symbolically to a reality that had been abandoned by life. It was the image of a last vain leap toward an unattainable salvation, like a horse shying away from a fence, or the vacant eyes of a monomaniac turned in on his inner madness, a final parrying gesture to avoid seeing the greater folly, that of mankind without a sense of direction, terrified by their own audacity and the discovery of their own cruelty.

Nonetheless, horror cannot be exorcised by repeated representations of it, nor can the accumulation of the fragmentary pave a way leading beyond it to totalization, i.e. redemption. The ship passing in the distance on the horizon will always arrive too late to preserve the shipwrecked figures on the *Raft of Medusa* and history's forgotten figures from horror.

Théodore Géricault
Horse reined in by slaves
(episode from The Corsa dei
Barberi in Rome)
Oil on canvas
Rouen, Musée des Beaux-Arts

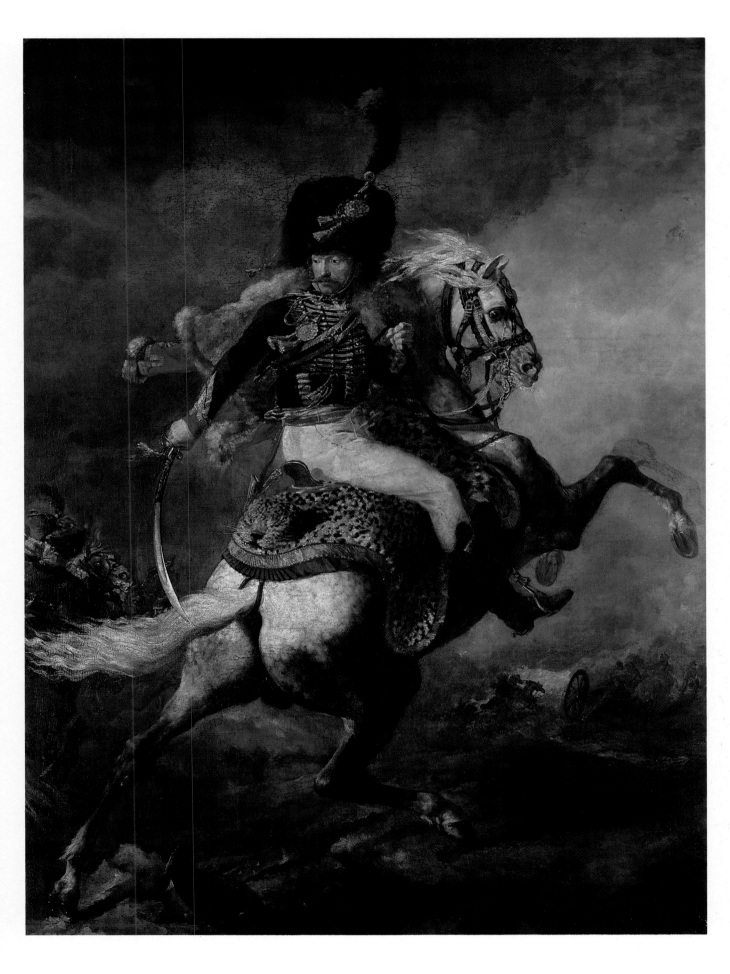

"I loved the proud steeds with their floating manes, and the spurs jangling against the stirrups. I loved the strong men thundering toward a difficult attack; the naked blades of the leaders urging on the docile ranks"

Victor Hugo
Odes

Théodore Géricault
*Mounted officer of
the Chasseurs, charging*
Oil on canvas
Paris, Louvre

142

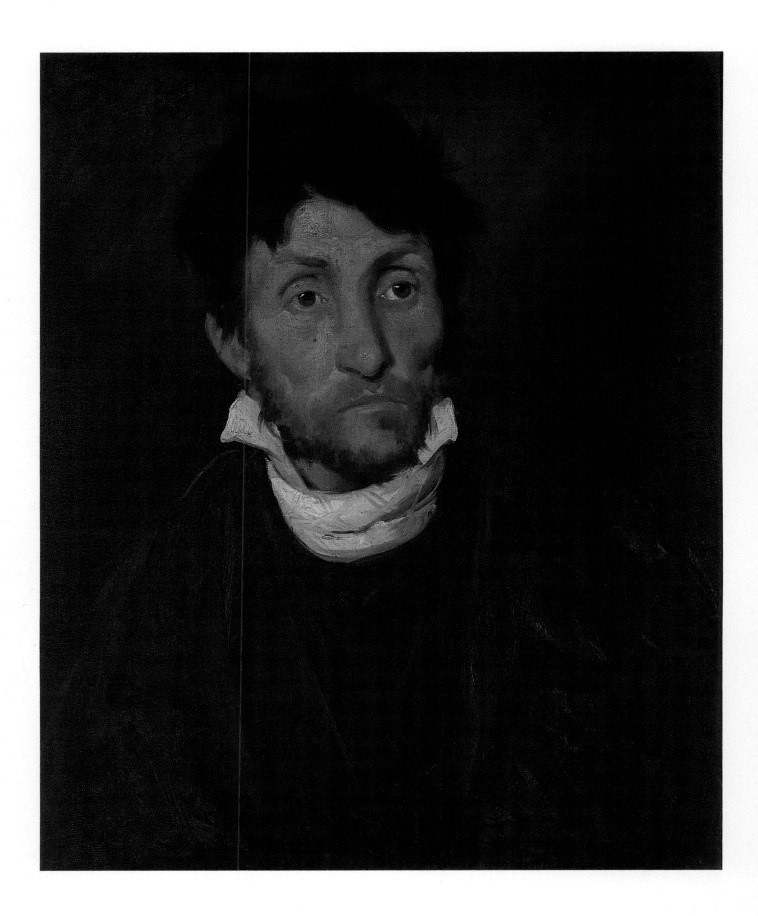

Théodore Géricault
The mad assassin
(or The kleptomaniac)
Oil on canvas
Ghent, Fine Art Museum

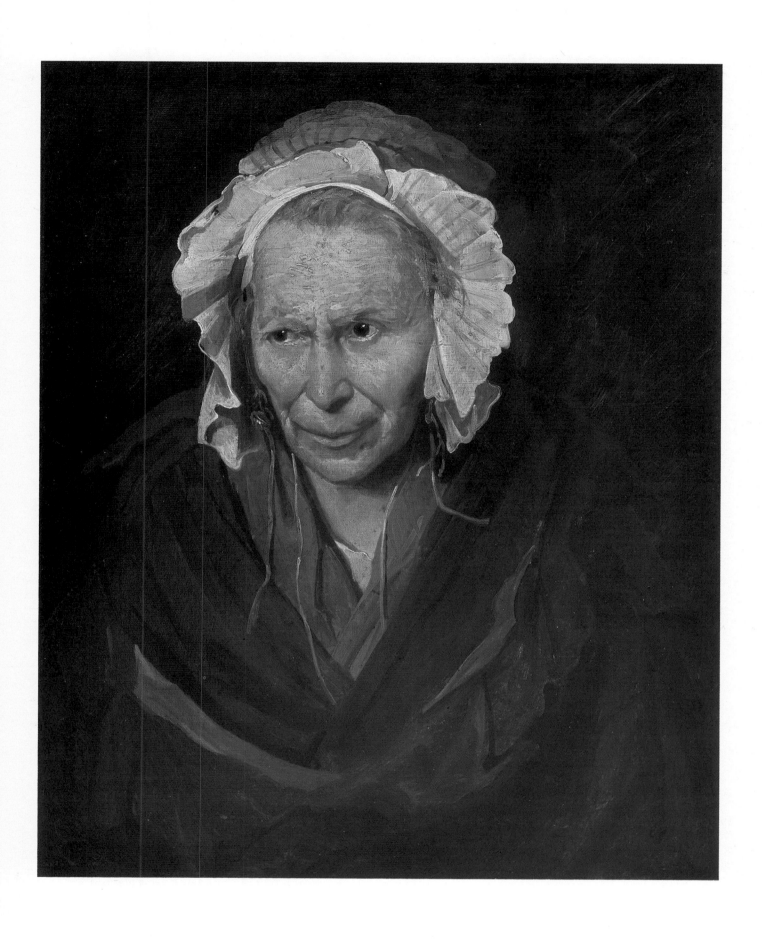

Théodore Géricault
The mad woman
(or Mad with envy)
Oil on canvas
Lyons, Musée des Beaux-Arts

144

"Sound and fury"

Delacroix, who was David's pupil and Géricault's friend, made his reputation by exhibiting *Dante and Virgil in hell* at the 1822 Salon and the *Massacre at Chios* at the 1824 Salon, so becoming the leading member of the Romantic generation in France. The heir to Rubens and of Davidian Neo-Classicism, he was also a precursor of Manet. Tragedy, blood, tumult and death recur in his work, and yet something had changed. Delacroix succeeded where Géricault had failed.

Since life cannot supply subjects worthy of inspiring the artist, the artist himself must turn his own life into a work of art. The dandy's ambition was to extract material for the sublime from everyday occurrences, to turn dreams into reality. He denied reality, not with the aim of finding refuge in myth, but to enforce the acceptance of the phantasm of another life as the true reality. This was what Byron set out to do, as did his disciple in painting, Delacroix.

In the work of the Romantics shipwrecks, massacres and orgies became the cathartic manifestations of the world-weary 19th century. David had thought of Lycurgus, while Théophile Gautier invoked Tiberius and Nero. However, the fascination that terror and slaughter exercised on the Romantics had ceased to be justified by any ideal. The esthetics of horror had become an end in themselves. Artists had understood that sublimeness was engendered not by the search for liberty, but by the unending slaughter that its wild pursuit inevitably entailed. Beauty resides in neither the people nor liberty. True beauty is death prowling inescapably over the theater of these pointless conflicts. True happiness, true enjoyment are inextricably bound up with pain and the cries of its victims.

To be one's own victim and one's own executioner like Sardanapalus; to enjoy absolute disaster unperturbed in the knowledge that no-one will be spared, but believing that you are the only person to have truly understood it: that was French Romanticism, abhorring order but no longer believing that anything would arise from chaos, except for a final esthetic ecstasy like the last cry of the world before the darkness of the void.

Delacroix's target in *Liberty leading the People* painted in 1830 is neither liberty, which is just a word, nor the people, whom he despised. Napoleon had succeeded in giving Europe a taste for heroism, and Delacroix was celebrating its fleeting return. Unfortunately Napoleon was no longer there to lead the people, and we get a strong feeling that the woman advancing with her breast bared had spent more time posing in artists' studios than climbing the barricades. This sums up the drama of the 1830 Revolution: the people manipulated, young people momentarily believing they were caught up in the breath of history, while in the background the same canny, careful middle classes were already negotiating the transfer of power to the junior branch of the royal family. But nonetheless Delacroix asks us to accept these three treacherous days as a great event in French history – and more extraordinary still, he succeeds! In the world of imagination 1830 is first and foremost and sometimes solely this picture celebrating the event. In short, he achieved his aim: turning reality into a myth by substituting the myth for the real thing. From then on the artist set himself up as an inventor of history.

Eugène Delacroix
Barque of Dante
(or Dante and Virgil in hell)
Oil on canvas
Paris, Louvre

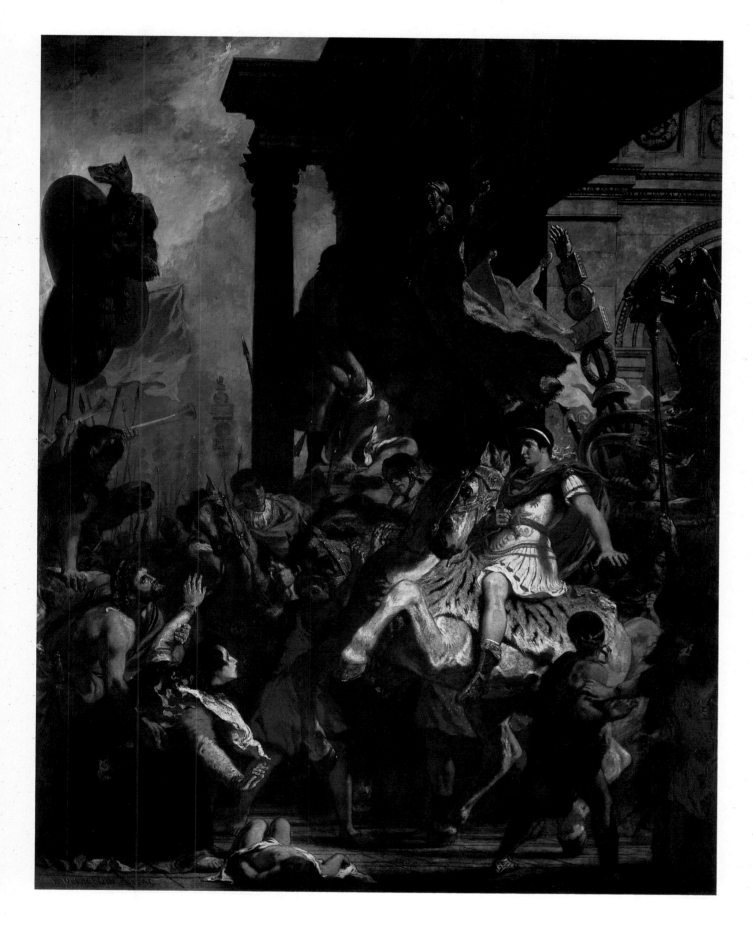

145

"*Delacroix is the most
suggestive of all painters,
the one whose works ...
make us think the most,
reanimating in our
memories the largest
number of poetic feelings
and thoughts that have
already been experienced,
but which we thought
were buried for ever in the
night of the past.*"

Baudelaire
L'Art romantique
Banville and d'Asselineau,
1868

Eugène Delacroix
The justice of Trajan
Oil on canvas
Rouen, Musée des Beaux-Arts

The lure of the East

146

In contrast to the antique heroism of David, based on purity and divestment, Delacroix's heroism comes from intoxication. History in Delacroix's work is not conceived as proceeding logically from a solemn oath, but as a tumultuous unfolding of passions. Wandering, carnage, perversions and sublime horror are its disparate, incoherent ingredients. There is no before and after. Every individual is a history in himself, and the instant of fusion welding all these individual destinies into a potential single-voiced history of the human race is quite simply inconceivable.

Hence liberty is nothing without the barbarity which makes it worthy of being loved, and the West is nothing without the East. Lord Byron was literally bored to death in England, and the so-typically western concept of liberty could be taken to its farthest extreme only in Moslem territory. For what was the East but the paradoxical mirror of the contradictions in which the West had finally imbedded itself? People went to the East to forget an unduly rigid society whose restrictions they rejected. Yet once there, what did they do but defend the culture they were rejecting, while at the same time allowing themselves to be pleasurably intoxicated by the pleasures of that different world which they claimed to love while combatting it, and claimed to annihilate while sacrificing even their lives to it?

But the self never lost itself in the collective, as in the work of David, or in the quest for transcendence, as in the work of Friedrich. On the contrary, it was the collective that was immolated for the enjoyment of the esthete. Sacrifice was good because it was beautiful, and not by virtue of the cause it claimed to serve. This is the crux of the ambiguity in French Romanticism which valued liberalism only because it went against the established order, and was attracted by the East only because it was exotic.

When the Romantics called for values to be overturned and rejected bourgeois conformity, in the manner of Flaubert in his youth, they were doing no more than carrying that conformity to its farthest extreme, and taking its only true value, individualism, to its ultimate conclusion. Romantic youth, from the commonplace middle classes, dreamt schizophrenically of being a sort of synthesis of the common people and the nobility, but was in fact neither one nor the other. The cult of idleness among the young Romantics, fostered in the belief that they were going against their fathers, is more indicative of contempt for the common people than of a denunciation of the managerial classes to which they belonged in practical, everyday terms.

Romanticism therefore turned into dandyism. The esthete's transcendence is neither the dark horizon of a deserted sea nor the icy vertical line of three swords brandished by a father. It lies instead in the suffering of the people. For the people make history without understanding what they are about; they play the role of a blind actor, while the dandy plays that of an impotent Peeping Tom. He derives his glory from this fundamental impotence, raising it to the level of tragedy.

Eugène Delacroix
Crusaders entering Constantinople
on 12 April 1204
Oil on canvas
Paris, Louvre

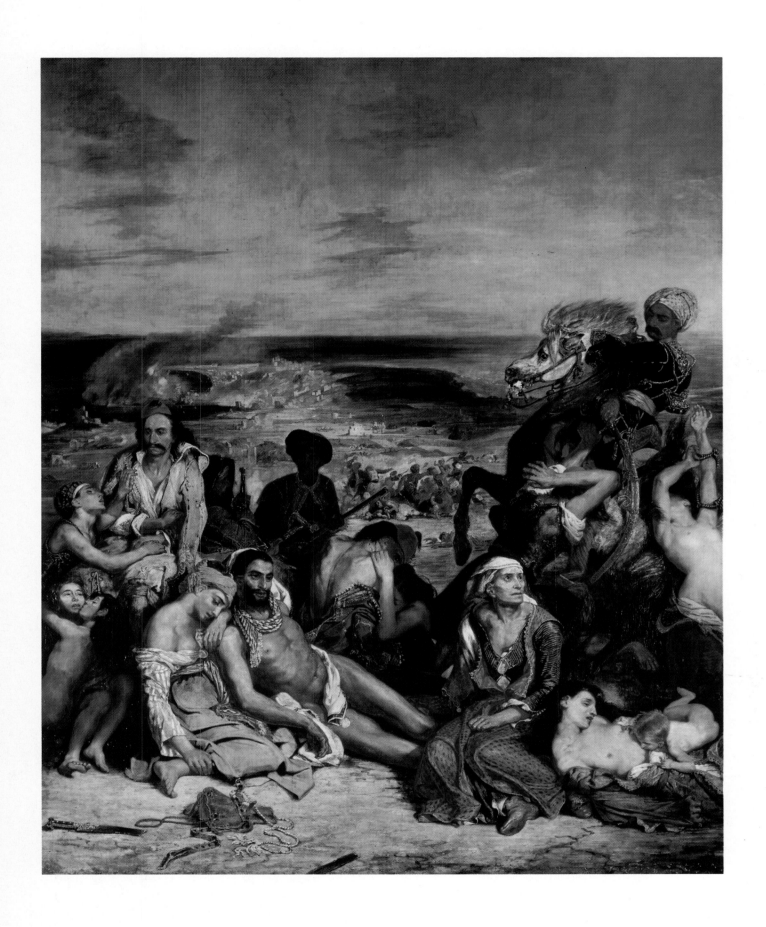

Eugène Delacroix
Massacre at Chios
Oil on canvas
Paris, Louvre

148

*"Here we have the
quintessential poet-
painter! He is one of the
few elect His
imagination, ablaze like
the taper-lit mortuary
chapels, flames and glows
through the whole gamut
of purples. All the pain
inherent in passion
impassions him He
pours blood, light and
darkness in succession
onto his inspired
canvases."*

Baudelaire
L'Art romantique
Banville and d'Asselineau,
1868

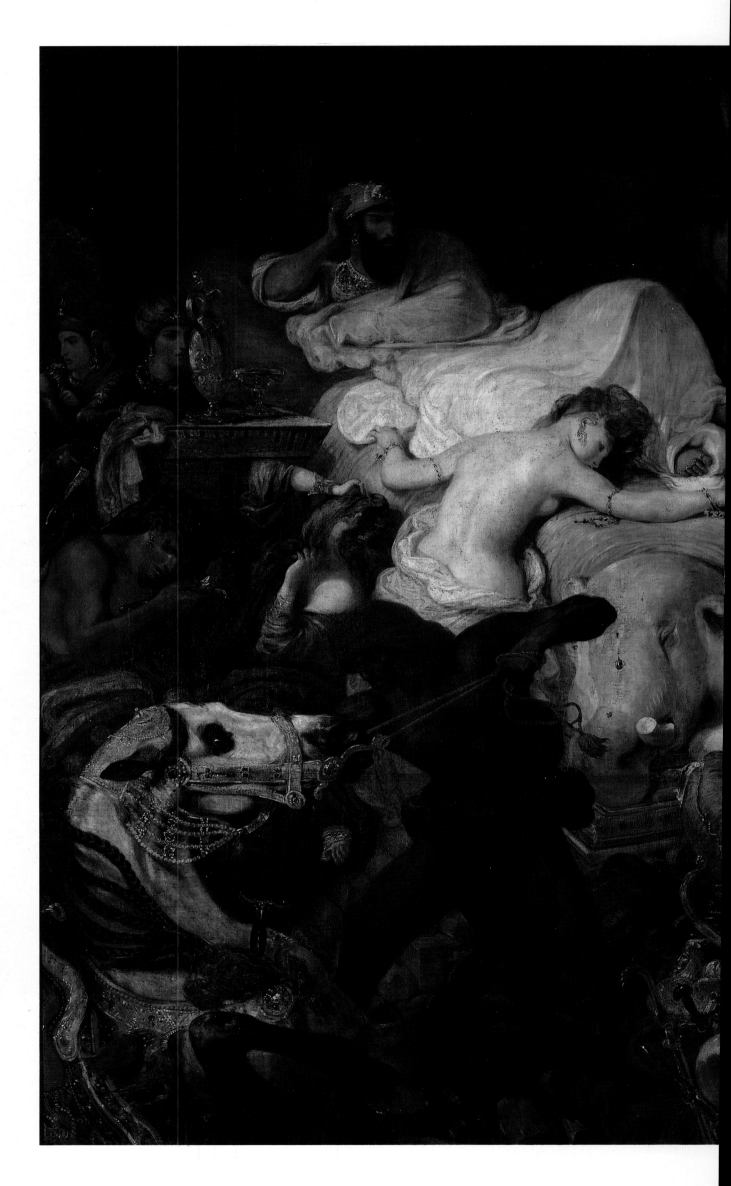

Eugène Delacroix
The death of Sardanapalus
Oil on canvas
Paris, Louvre

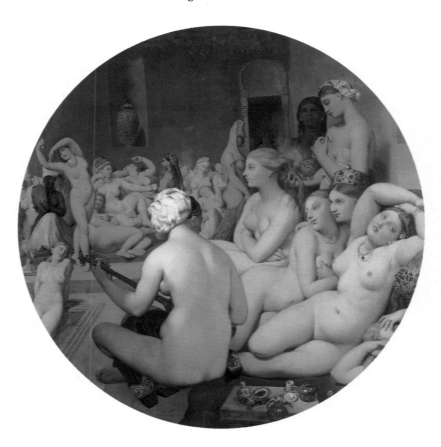

150　　**Monsieur Ingres**

After praising the merits of Delacroix it is customary to contrast his work with the glacial perfection of Ingres, casting these two artists as the representatives of the conflict between Romanticism and Neo-Classicism. This seductive but inaccurate summary goes back to 1824, when Delacroix exhibited his *Massacre at Chios* at the Salon, while Ingres, who was then living in Florence, submitted the *Vow of Louis XIII*. Immediately the advocates of the Académie who were hostile to Delacroix turned Ingres into their standard bearer, hailing his work as a triumph. From then on Ingres, without ever seeking to be, became the leading figure of the opponents of Romanticism.

This involved quickly forgetting all the reproaches Neo-Classicism had leveled at Ingres over the previous twenty years. Ingres, who had been criticized by David's pupils as early as 1806, was classical only in appearance. Even a cursory deeper examination of his work very quickly reveals that the painter hardly cared about perspective, the colors in his work are violent and modeling almost non-existent. Line articulates and governs his composition. David's metaphysics relating to the oath are totally alien to Ingres. In short, Ingres was almost as far removed from David as he was from Delacroix; he followed a different path which, though it did not found a school, influenced Puvis de Chavannes and Degas. Ingres returned to France in 1824 after the success of the *Vow of Louis XIII* and spent ten years there, until the lukewarm reception accorded to the *Martyrdom of St. Symphorian*. Annoyed by this reaction,

he decided to give up exhibiting at the Salon and applied for the post of director of the Villa Médicis (French school) in Rome. When he returned to France for a second time in 1841, however, he was greeted by King Louis-Philippe in person. From then until his death in 1867 his reputation remained high, and official and private commissions sanctioned his position at the forefront of 19th-century painting.

But what in fact is Ingres's style? Where does the originality of his work lie? Essentially it resides in the preeminence of line over color, which does not mean, as might be hastily inferred, that the drawing is correct, or that color is neglected. But it is primarily line that structures his compositions. Controlling other aspects, it extends anatomy to impossible proportions, in a manner reminiscent of Parmigianino in the *Madonna with the long neck*, and even more of the sinuous shapes in Botticelli's *Birth of Venus*.

Thus Ingres's style is first of all suppleness of line, a sort of affected elegance, a certain idea of perfection, in fact, which he tried to achieve by divestment and rejecting spatial illusionism. It is a cerebral art which looks ahead beyond Impressionism to the simplifying experiments of the Pointillists and the Cubists, making Ingres not so much the belated conservative figure as which he is all too often portrayed, as an innovator primarily preoccupied with form. And it was that pure, ideal form that he sought in the work of Raphael and the Greeks when he cited them as the only examples worthy of being studied by pupils in his studio.

Ingres
The Turkish bath
Canvas on wood
Paris, Louvre

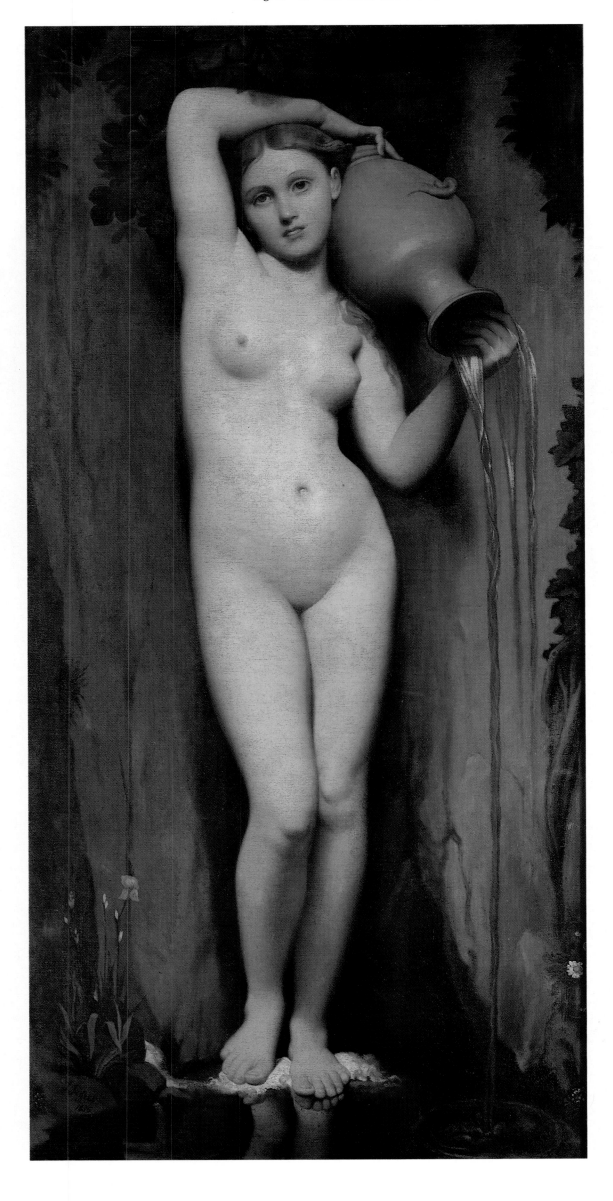

"Art consists primarily of taking nature as a model, and copying it scrupulously, though at the same time choosing its noble aspects. Ugliness is an accident and not one of the features of nature."

Ingres, quoted by Théophile Silvestre
Histoire des artistes vivants

Ingres
The source
Oil on canvas
Paris, Musée d'Orsay

152

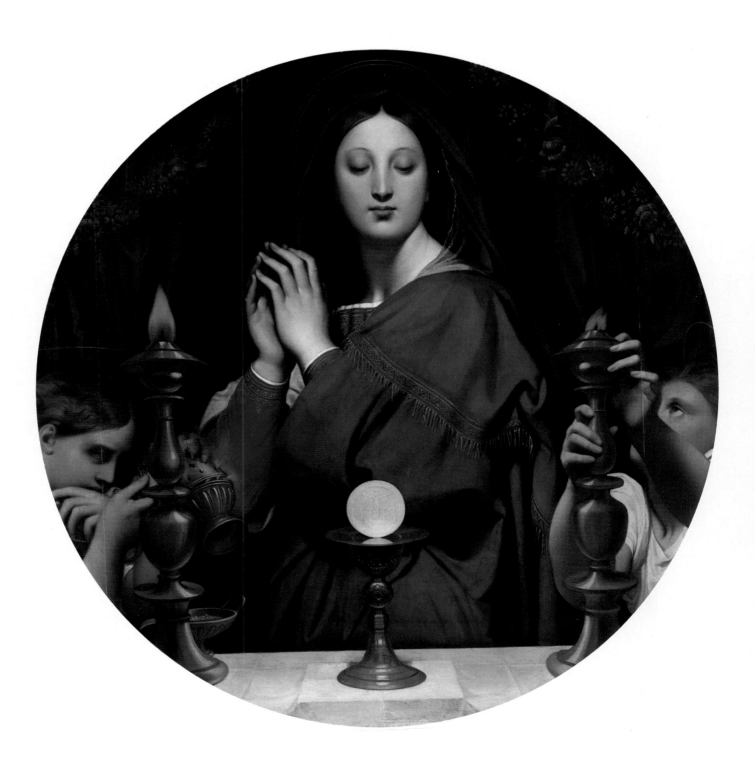

This was an unfortunate formula, and Baudelaire remembered it with biting irony in his account of the 1846 Salon, writing: "In a certain sense Monsieur Ingres draws better than Raphael, the popular king of graphic artists. Raphael decorated huge walls; but he would not have made such a good portrait of your mother or your friend or your mistress It is fair to say that if Monsieur Ingres, devoid of imagination when it comes to drawing, cannot create pictures, large-format ones at least, his portraits are almost pictures, that is they are private poems." Returning to the theme in 1855 he added, "So what is Monsieur Ingres looking for, what does he dream of? What has he come into this world to tell us? What new appendix is he contributing to the gospel of painting? I am inclined to believe that his ideal is of a sort composed half of good health and half of tranquillity, indifference almost, something similar to the antique ideal to which he has added the oddities and minutiae of modern art Monsieur Ingres's drawing is that of a methodical man. He believes that nature must be corrected, amended; that skilful, pleasant trickery, perpetrated with a view to pleasing the eye, is not only a right but a duty."

Baudelaire's annihilation of Ingres, for that is what it amounted to, finished with these words: "Carried away by his unhealthy preoccupation with style, the painter often suppresses the model or reduces him or her to virtual invisibility, hoping by this means to enhance the value of the outline, to such an extent that his figures look like very correct cut-out patterns, inflated with a soft, inanimate substance that is alien to the human organism."

Ingres
Virgin with the Host
Oil on canvas
Paris, Musée d'Orsay

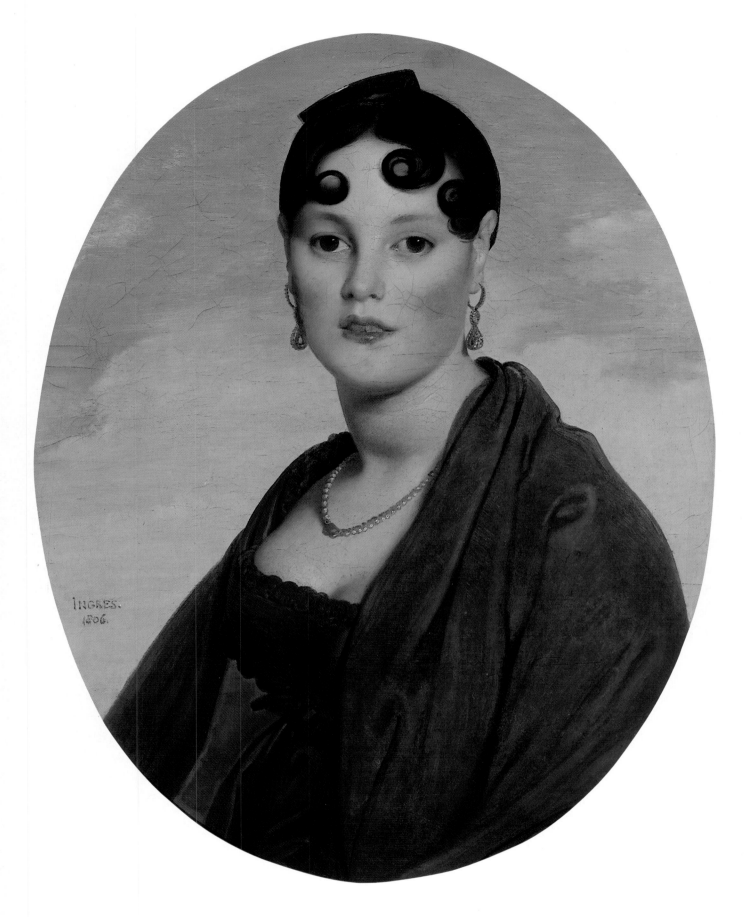

153

*"Everybody is stiff,
constrained and dressed
up in M. Ingres's work:
... the women from
antiquity are
uncomfortable in their
tunics, the modern women
in their bodices, and the
naked figures in their
skins."*

Théophile Silvestre
Histoire des artistes vivants

Ingres
La Belle Zélie
(Portrait of Mme Aymon)
Oil on canvas
Rouen, Musée des Beaux-Arts

154 *Space and light*

Ingres emphasized the figure; Turner preferred landscape. The former used line to structure his paintings, while the latter chose light and color. And whereas one paid particular attention to delineating his forms with meticulous care, the other did away with boundaries and opened the door to abstraction.

Turner was born in London in 1775 and trained as a topographical painter; he soon moved away from the careful study of detail to devote himself to the study of atmosphere and the play of light. In his early period he was influenced by Poussin and Lorrain, but he developed his own autonomous style from 1820, with an ever greater role being assigned to the imaginary.

Occupying a pivotal position between the 18th-century esthetics of the sublime, Romanticism and Impressionism, Turner is the epitome of the artist who cannot be categorized. Though he became a member of the Royal Academy in 1802 he had to wait for the end of the Napoleonic Wars really to discover the Continent. His journey to Italy in 1819 had a crucial impact on the development of his approach to light. In the end his work, which was pushing the concept of the dematerialization of space to the limit, upset the public, who turned away from it after 1830. Though isolated, Turner still continued actively to paint, leaving an estate of 19,000 drawings and over 200 canvases on his death. Ruskin was an ardent advocate of his work, but he was not rediscovered until 1870, when an exhibition of his bequest was held. Monet, Pissarro and Sisley, who had withdrawn to London to escape the advancing Prussian army, went into raptures over these visionary canvases which made light the central element of painting. Form dissolving in a vibration of colors struck them as the very thing they had spent ten years in search of.

Nonetheless, it is perhaps going too far to talk of abstraction in connection with his work, just as it is in the case of the Impressionists, firstly because the concept of abstraction was foreign to Turner and his period, and secondly because, despite his obvious wish to break free from the obsession with drawing and Realist exact reproduction, Turner's work still continued to depict nature. If he used extreme solutions to do so, this in no way detracts from the fact that Turner always remained a landscape painter, closer to Lorrain than to Klee or Kandinsky.

Joseph Mallord Turner
Unfinished landscape
Oil on canvas
Paris, Louvre

Joseph Mallord Turner

155

"On a visit to the
National Gallery [Monet
and Pissarro] were very
struck by the works of
Turner. This spell-binding
painter, visionary yet
naturalistic, alternately
seeking the unreal in the
real and the real in the
unreal, inevitably
stimulated them to try to
achieve more vibrant color
than the subtly graduated
shades of gray used by
Corot and Boudin, or the
rich but heavy impasto of
Courbet."

Arsène Alexandre
Claude Monet

Joseph Mallord Turner
View thought to be of the Val d'Aosta
Watercolor
London, Christie's

156

Edgar Degas
Dancer with bouquet, bowing
Pastel
Paris, Musée d'Orsay

158 *A revelation*

"The greatest fault at the present time," Constable wrote in 1802, "is *bravura*, the desire to outdo truth." John Constable, who was born in East Bergholt in Suffolk in 1776, upset the received ideas of painting of his day by opening up new avenues, less flamboyantly than Turner but with just as profound an effect.

Like his fellow-countryman Constable started his painting career under the influence of French and Dutch landscape artists. But his rejection of the sublime and his indifference toward the idealization of his subject set him apart from those who inspired him, and represent the main interest of his work. At the beginning of the 19th century, when everyone was aspiring toward sublimeness or historical painting, Constable swam against the tide, devoting himself to his native area.

His *Haywain*, which was exhibited at the 1824 Paris Salon, struck Delacroix because of its simplicity and truth. Without excessive effects (though his sense of the picturesque may appear a little heavy to us today through having been so much copied) this ordinary scene broke with the great Neo-Classical set pieces. Truth and simplicity were the words that sprang to mind, and that was what Constable had set out to achieve: to look at the world with new eyes, without prescriptions or prejudice; to paint what he saw without reconstructing reality according to preconceived ideas – in short to rediscover the pleasure of confronting his subject with humility.

For in the course of the centuries painting had become extraordinarily vocal, narrative and pretentious. Constable very quietly broke with that tradition. That is where he differed from Gainsborough, though Gainsborough is the painter to whom he was closest.

Constable had no direct followers in England, but he influenced the French Realist movement, and more particularly the Barbizon School, which drew inspiration from his ideas which breathed fresh life into the practice of painting "from nature"; this was to become all-important with the Impressionists.

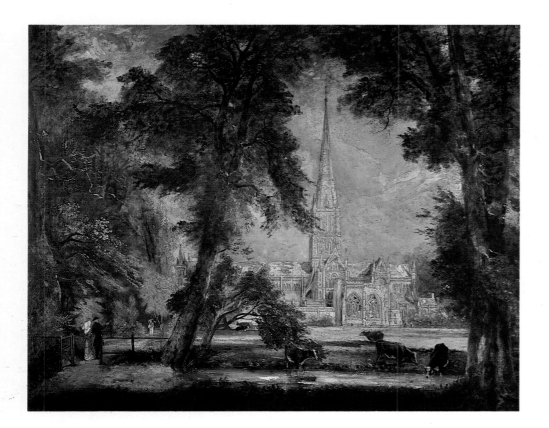

John Constable
*Salisbury Cathedral from
the bishop's garden*
Oil on canvas
São Paulo, Museo de Arte

John Constable
View of Hampstead Heath
Oil on canvas
Paris, Louvre

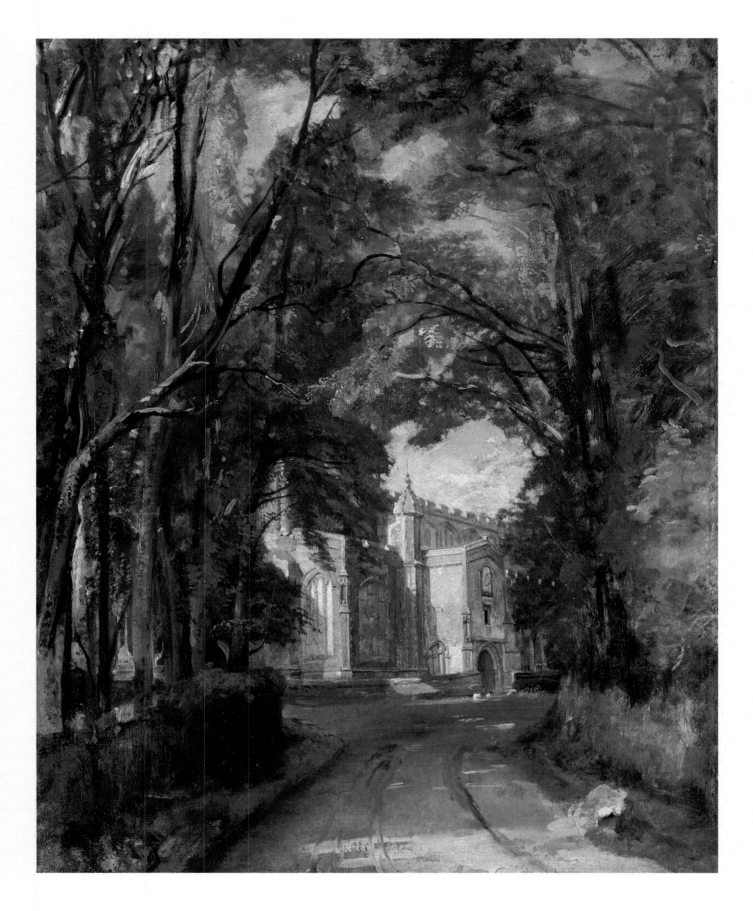

159

"The watercolors and paintings of Turner and Constable as well as the work of Old Crome certainly had an influence on us."

Pissarro

John Constable
East Bergholt church
Oil on canvas
London, Christie's

Work and the times

Millet, who originally came from the Cotentin peninsula, settled at Barbizon in 1849. He had started his career by painting portraits and mythological scenes, through which he acquired great skill in conveying the human body. Though he was close to the Naturalists, he did not initially go along with the ideas of the Barbizon painters who followed Diaz and Rousseau in devoting themselves entirely to landscape.

His great subject was the peasantry. While the country was beginning to feel the first effects of the upheaval caused by the Industrial Revolution, and the countryside was beginning to empty and the towns to fill with uprooted people who would swell the ranks of the incipient proletariat, Millet set out to celebrate a timeless humanity in the peasantry, living at one with nature and respecting the rhythm it imposed on life. Their gestures are slow, their attitudes noble. Every moment is a ritual. And these powerfully constructed pictures, completely attuned to their subject matter, celebrate the peaceful union of man and nature.

Millet's peasants are faceless heroes, far removed from the frolicsome shepherds of the rustic imaginings of the 18th century. They are as strong as rock, eternal statues, untouched by sentiment and triviality. Neither the women in *The Gleaners* nor the couple in *The Angelus* have any claim to a personal history: they are types, incarnating the thousand-year-old peasantry tilling the French soil. It is easy to understand why

Millet, both because of his synthetist treatment of color and form and his allegorical approach to his subject, was so important to the Symbolists.

Thus his message is ideologically loaded. Though he was the heir of Constable, who deplored the idea that everything should be turned into something sublime, Millet was certainly not content just to observe. Nothing is more carefully thought out, more "contrived" than these scenes of rural toil. To see Millet as a revolutionary painter because he rejects Academic subjects involves conveniently forgetting Vermeer's *Milkmaid* – to see him as the bard of the humble and nameless would be to fail to recognize his total indifference toward the working-class world.

"It's painting by a democrat, one of those men who don't change their underwear" were the words used by Count de Nieuwerkerke to dismiss the Barbizon painters. For all that, ideologically speaking the content of their painting is reactionary. It displays a clear-cut rejection of modernity, movement and change. It is a hymn to immobility. Moreover, these peasants do not suffer in their work any more than an ox suffers when it pulls the plow, because it is in their nature to work and they are fed for that purpose. The huge success of Millet's paintings with the middle-class public is obviously bound up with this underlying ideology, reflecting a conservative view of society in which everyone would inevitably occupy an eternally immutable place.

Jean-François Millet
The church at Gréville
Oil on canvas
Paris, Louvre

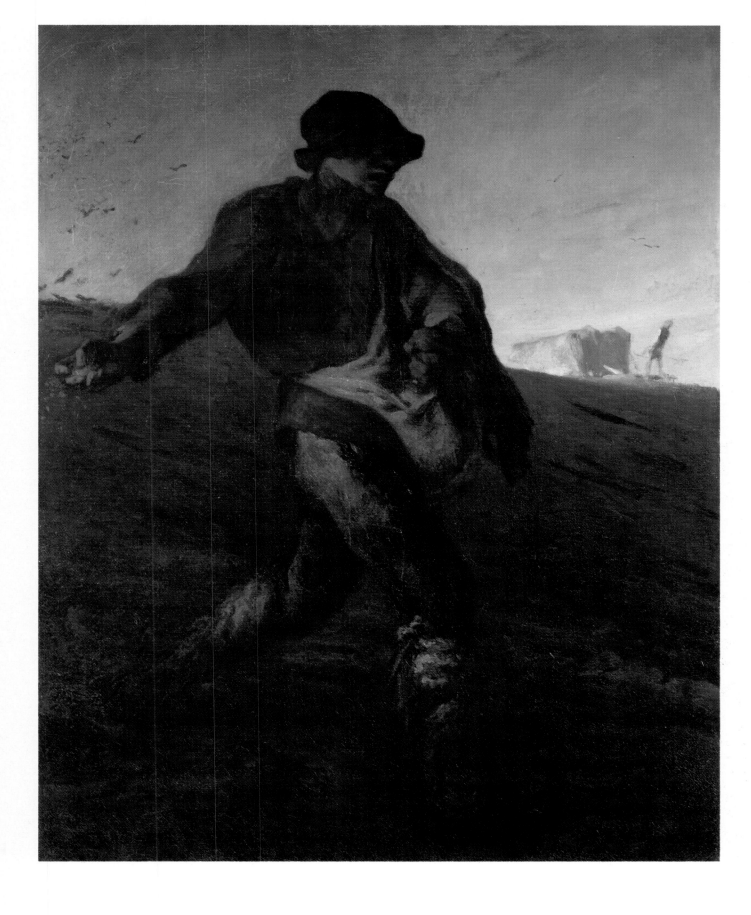

161

"Drama is enveloped in splendor. This is not something I invented, and the expression 'the call of the earth' has been around for a very long time."

Jean-François Millet

Jean-François Millet
The sower
Oil on canvas
Boston, Museum of Fine Arts

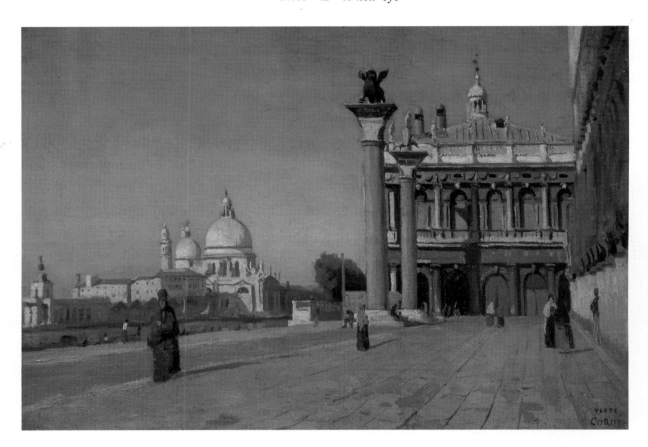

Humid light

Renoir compared Corot to Vermeer, not because they painted in the same way, but because both stood outside fashions and schools. Corot was generous, loyal, and to use Nadar's description, worthy: qualities that have only a remote connection with painting. Yet the power of attraction that his painting exerts must have something to do with the individual personality of the artist.

Corot was free: he was the meeting point for all the trends running through his century. He was brought up in a Neo-Classical atmosphere, was at his prime when Romantic tumult was at its height, and ended his days alongside the Impressionists. He painted the vaporous atmosphere of early morning in the Ile-de-France, light moist with mist, but could also convey the almost mineral light of Italian skies. Before Monet, his painting was already subject to the impression: "the first impression which moved us" as he put it himself. In spite of the vibration of the many details that animate his paintings, he took a synthetist view. To quote him again, he said that we must always envisage "the mass, the whole, what has caught our eye." We must grasp the spirit of the landscape, its soul, or rather the "impression" it leaves on ours. Thus in order to see a landscape we must see inside ourselves and give structure to what we see by placing

our impressions in hierarchical order. This is not just a mental exercise in the sense of being an intellectual operation, it also has a moral dimension. In order to paint harmony in nature we have first to test it within ourselves. But if there is morality in his painting, it is not in the least dogmatic or heavy. It is intimate and cannot be generalized, even if it has an inspirational value.

So we are dealing with example rather than dogma, the giving of evidence rather than of a message. It is necessary "to raise reality to the level of the soul one wants to instill into it," he said.

Putting into practice in his life what he advocated for his painting, Corot, an inveterate traveler, unashamedly always on the move, nonetheless always kept his door open to young painters. He gave advice to Pissarro, Sisley and Berthe Morisot, and lent a helping hand to Chintreuil and Daumier. His word was respected and his friendship valued. Not so much a master as a father figure, "he inspired fervent respect among the entire younger generation," according to Nadar. "Papa Corot," as he called himself in a letter to Berthe Morisot, never let success go to his head, in spite of the seal of approval given to his work at the World Exhibition in 1855, when the emperor bought one of his paintings.

Camille Corot
Morning in Venice
Oil on canvas
Moscow, Pushkin Museum

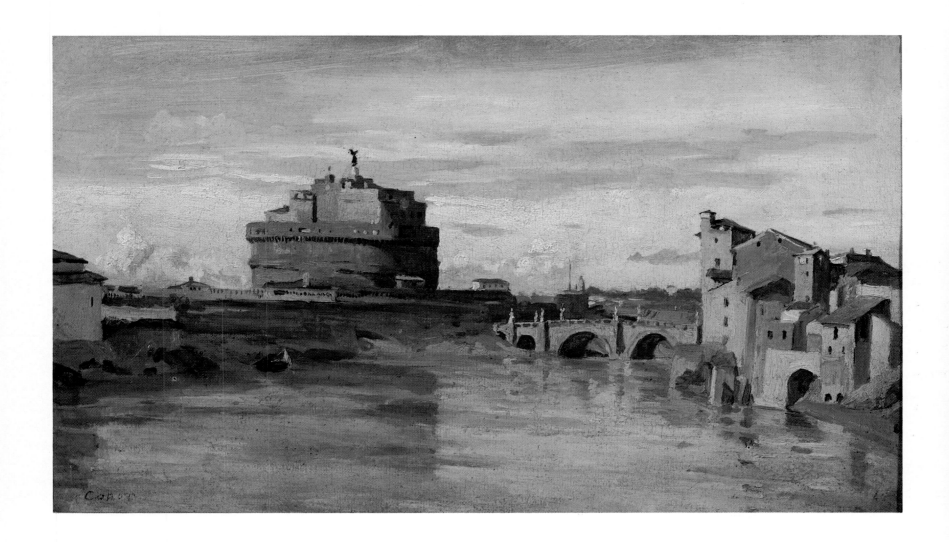

*"Corot with his great
tenderness defying
categorization Corot
like a marveling child, a
bird persistently singing
its little song above the
gray clouds, Corot, or art
in the form of a prayer."*

Michel Le Bris
Journal du romantisme
Skira, 1981

Camille Corot
The Tiber at Castel Sant' Angelo
Oil on canvas
Paris, Musée d'Orsay

Hoisting the flag of Realism

"The description Realist has been imposed on me just as the Romantic label was imposed on men in 1830," Courbet explained in the Catalog of his 1855 "exhibition and sale," adding further on: "Being capable of conveying the manners, ideas and appearance of my period as I see them, in short, creating living art, that is my objective."

Unlike Millet, Courbet had real political commitment. Unresponsive to Romanticism and hostile to academicism, Courbet reveled in scandal. He was robust and uncompromising in his approach, not interested in half measures. "In order to paint countryside," he proclaimed, "you have to know it. I know my countryside, and I paint it. This undergrowth belongs here, and the river is the River Loue. Go and have a look, you will see my picture."

The only allegory he painted, except for provocative pictures like *Venus and Psyche* (destroyed), *Sleep and the Source*, was the *Studio* subtitled *A real allegory of seven years of my artistic and moral life*. For he needed the robustness of reality, which he conveyed in thick, powerful material. Maupassant, who visited him in Etretat in 1869, described him with the same exacting Realism: "In a large bare room a fat, greasy, dirty man was using a kitchen knife to stick slabs of white onto a large bare canvas. From time to time he would go and press his face against the window and look at the storm. The sea came so near that it seemed to be beating the house which was enveloped in spray and noise. The salty water struck the panes like hail and ran down the walls in rivulets. On the mantelpiece a bottle of cider beside a half-full glass."

However, the founder of Realism did not exclude mystery and poetry from his compositions. *Roebuck cover at the stream of Plaisir-Fontaine* is redolent with calm melancholy, and we find it astonishing today that such a picture could have shocked the critics. The cause of shock in the case of *Burial at Ornans*, on the other hand, was quite clear: the people were ugly, so the picture was ugly. And as they were nothing but obscure villagers, the picture was further stigmatized as vulgar by Delacroix in person. Etymologically speaking he was right. And it is no doubt in this aspect that Realism differs most sharply from Romanticism. While Courbet can sometimes be reproached for enjoying provocation when it added nothing to his talent, in one thing at least he was sincere: he was not interested in the sublime. He preferred genuine ugliness to artificial beauty.

Courbet had read Fourier, and was the friend of Proudhon; he made a spectacular demonstration of his disdain for the established order by exhibiting his

Gustave Courbet
Burial at Ornans
Oil on canvas
Paris, Musée d'Orsay

works outside the 1855 and 1867 Salons in special pavilions. He was the president of the Fédération des Artistes during the Commune in 1871 and was responsible for the idea of toppling the Vendôme column; this earned him six months in prison. Two years later he took refuge in Switzerland to escape the threats of arrest that were hanging over him. His last works were landscapes of Lake Geneva seen from the castle of Chillon, a picturesque fortress from which you can see the Rhône tumbling into the lake surrounded by the snow-capped peaks of the Alps.

To Ingres, who rejected ugliness, Courbet gave a simple answer: nature is beautiful provided you look at it with sincerity and respect your subject. Breaking down the hierarchy of the genres, he taught subsequent generations how to be bold.

Gustave Courbet
Roebuck cover at the stream
of Plaisir-Fontaine
Oil on canvas
Paris, Musée d'Orsay

The invention of modernity

166

Impressionism was born twice, the first time in 1863 when the *Déjeuner sur l'herbe* was refused by the Salon, along with about 2,000 other canvases, and the second when Monet and his friends decided to exhibit their works themselves in an independent Salon in 1874. By that time Manet was famous, and had nothing to do with the second event.

Oddly enough, the man who initiated Impressionism never felt totally involved in his friends' experiments. The art critics, following the wrong scent, tried to cast him as the leader of the rebels when his painting *Olympia* caused a scandal in 1865. But Manet was not interested in such a role. Unlike Courbet, Manet, who came from a good, middle-class background, was ambitious for official recognition.

He had been a pupil of Thomas Couture until 1856 and felt close to the Italian and Spanish masters. *Olympia* was conceived as a homage to Titian's *Venus of Urbino*, Goya's *Maja desnuda* and Ingres's *Grande Odalisque*. It would have been hard to be more law-abiding and circumspect, more respectful of tradition. Moreover Manet did not see success as something that could take place outside the Salons. But to his great disappointment people were upset by his manner of painting.

Manet's modernity consisted firstly in putting Baudelaire's famous program into action by choosing his subjects from everyday life. *Olympia* is not a dream, she is a model posing for a painter. The picture takes us into the artist's studio. Courbet had already done the same thing, but in a style that was much too pedestrian to attract the esthetes. In Manet's work the vulgar was decked with a semblance of elegance. Is that in itself enough to explain why the picture marks the birth of modern painting? Of course it is not, for the novelty lies elsewhere.

The revolution is in the field of plasticity. In his important works of 1863 and 1865 Manet abjured everything which had until then constituted the value of a painting. He neglected perspective, and forgot relief. He rode roughshod over color harmony and disregarded *chiaroscuro*. As a result Olympia's flesh-tones are yellow, her forms are flat, and the black background is in brutal contrast to the light foreground colors.

Logically the result should have been dreadful, but this was not the adjective most frequently used to describe the hated work. People actually talked of indecency. They were unintentionally admitting that the composition had a certain evocative power. Taking the opposite path from the one usually adopted, Manet had achieved his objective by endowing an image that was technically unrealistic with credibility.

Edouard Manet
On the beach
Oil on canvas
Paris, Musée d'Orsay

167

Rochefort's Escape is an atypical work, reducing people to the dimensions of a dark blob. People are nonetheless a central element, but one that threatens to merge into the vast expanse of sea surrounding them. The attempt to integrate the human figure into landscape inaugurated in the Déjeuner sur l'herbe is here pushed to its limit, resolved in the abolition of both figure and landscape.

Edouard Manet
Rochefort's escape
Oil on canvas
Paris, Musée d'Orsay

The light of forms

168

"Manet did not copy nature at all," wrote George Jeanniot, and Jacques de Biez added: "It is undoubtedly the pool of light which strikes him first and immediately attracts him. But it is also through it that he sets out to declare his respect for drawing. His elegant line becomes lively and animated following light in its every flight of fancy." These two remarks are important because they emphasize everything that sets Manet apart from his Impressionist friends.

Manet rarely worked from nature. It was an exceptional event in his career that he spent the summer of 1874 at Argenteuil in Monet's company. His style temporarily wavered, giving a more supple treatment of line, noticeable in his *Blonde with bare breast* (1878) which echoes Renoir's *Woman's torso in the sun* painted two years earlier. But he missed the city, and still more the studio which provided him with the necessary sense of distance enabling him to compose his canvas in a serene frame of mind. Reality catches one's eye with a thousand details which the mind must then place in hierarchical order. "Cultivate your memory," Manet used to say, "for nature will never do more than provide you with information." Nature is a reservoir of forms, but it is up to the artist to organize them. It is not a question of copying, as Courbet suggested, nor of interpreting, like Monet, but of drawing inspiration.

Manet loved the city, and he loved success. He was saddened by critical hostility. One day he candidly confided to Degas, who used to make fun of him, that he wanted to be recognized and greeted in the street like all the great names of the Salon. Unlike Monet and Sisley, who lived in poverty for a very long time, Manet had a studio in Paris and friends in the literary world. He became the friend of Verlaine and Mallarmé and had been a friend of Baudelaire's: he cultivated refinement. He emphasized the importance of being concise, saying: "Conciseness in art is a necessity and a form of elegance. A concise man makes people think, a verbose man bores them." No needless words, no superfluous forms, no vulgar impasto such as typified the great Courbet, but a form which takes shape through the outline of its light.

After twenty years of failure, as he himself bitterly noted, official recognition finally came. Manet was awarded the Legion of Honor in 1882. But the syphilis which he had contracted in his youth was taking its toll, and by 1880 Manet already had great difficulty in moving. His left leg was amputated in April 1883, and he died three weeks later after terrible suffering.

Manet had never completely subscribed to his friends' beliefs, but he had been the soul of the group, its shining light. When he went, contacts between them became rarer. Everyone went off in their own personal direction. For all those men Manet's death also signaled the end of their youth.

Edouard Manet
Blonde with bare breast
Oil on canvas
Paris, Musée d'Orsay

"Poor Manet! He told me people were asking him for the price of The Balcony. He ingenuously said that I brought him luck."

Berthe Morisot

Edouard Manet
The balcony
Oil on canvas
Paris, Musée d'Orsay

170 **Reflections**

During his adolescence Monet, who had made Le Havre his adopted home, distinguished himself as a caricaturist. His initial training was with Boudin, who introduced him to out-of-door painting in 1858; he went to Paris the following year, enrolling at the Académie Suisse where he met Pissarro. When lots were drawn for military service, his number unfortunately came up and he was forced to go off and serve in Algeria. He fell ill and in 1862 was given permission to return to Le Havre, where he resumed his work with Boudin and Jongkind. That autumn saw him back in Paris, where he entered the Gleyre studio; he did not like it much, but met Renoir, Bazille and Sisley there.

At the 1863 Salon the group banded together enthusiastically to defend Manet's *Déjeuner sur l'herbe*. Up until then Monet had tended rather to be influenced by Courbet, Corot and the Barbizon landscape painters, but from that time on he became interested in the question of integrating the human figure into a landscape, painting a monumental *Déjeuner sur l'herbe* in obvious tribute to Manet, and furthering these experiments with *Women in the garden*, which was turned down by the Universal Exhibition of 1867.

But the real beginnings of Impressionism as a style came two years later, when Monet moved to near Chatou. As he was very short of money he had had to give up large formats and was painting views of the banks of the Seine, very rapidly and in a bold style, rediscovering the inspiration of his early days with Boudin. But the one or two still-lifes that he sold to Chatou shopkeepers were not enough to rectify a situation which he himself described as desperate. Working from nature, he needed a synthetist technique which would convey the reflections of light on water without having recourse to skilled studio procedures. "Here I am again stopped as usual for lack of colors," he wrote in 1869. And there was the further factor that it was a technical impossibility to mix some shades without them changing color. So there was a twofold problem: how to convey the impression of a color if you did not have that color available, and how to convey the different nuances of a single color without coarsening it by adding too much black or too much white. Monet overcame the difficulty by juxtaposing dabs of color, giving up drawing almost completely. Even before discovering Turner in London, Monet had opted for color at the expense of line. And it was due to that momentous choice that Impressionism came into being.

In *La Grenouillère* the instant is seized in its incompleteness. Monet had understood that the perfection of drawing fixes a scene. When the line becomes solid, truth goes. The instant is not complete in itself, it is a passage of time. It is fleeting and improbable; applying dabs of color made it possible to restore this fundamental incompleteness to it. And finally, to prevent the whole thing from collapsing completely into non-objectivity, Monet rescued his composition by emphasizing the contrasts. That is what we can learn from the reflections of August light on the waters of the Seine.

Eugène Boudin
The beach at Trouville
Oil on wood
Paris, Musée d'Orsay

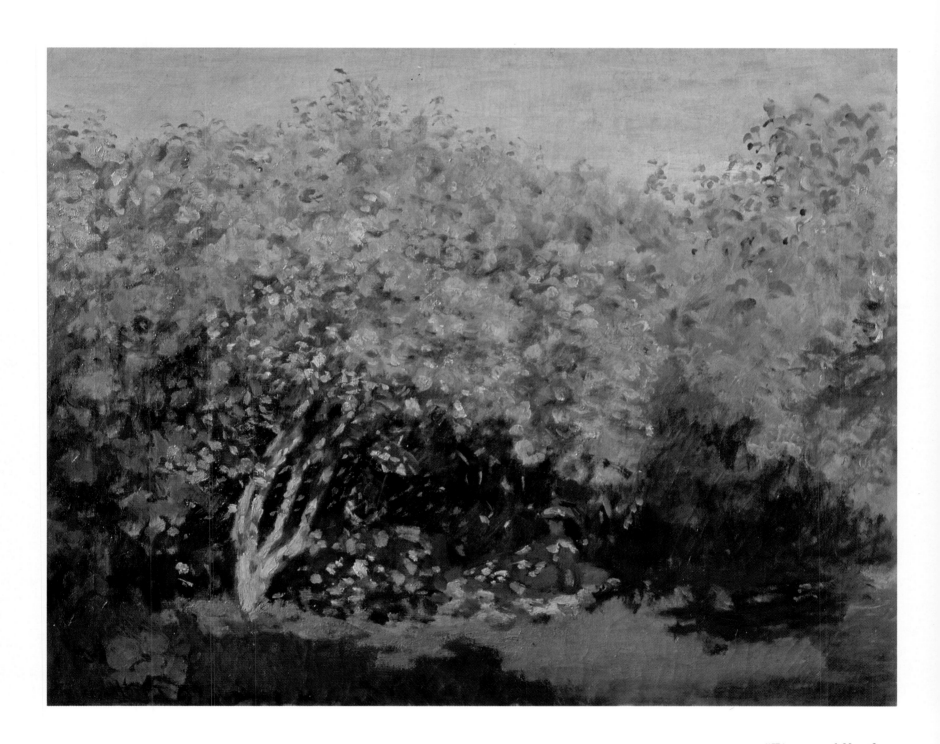

*"[Pissarro and Monet]
returned from London
more determined than ever
to paint only with the
colors of the prism and to
juxtapose on their
canvases all the tones that
their very subtle eye could
pick out in an impression
of nature."*

Georges Lecomte
Pissarro

Claude Monet
Lilacs in sunlight
Oil on canvas
Moscow, Pushkin Museum

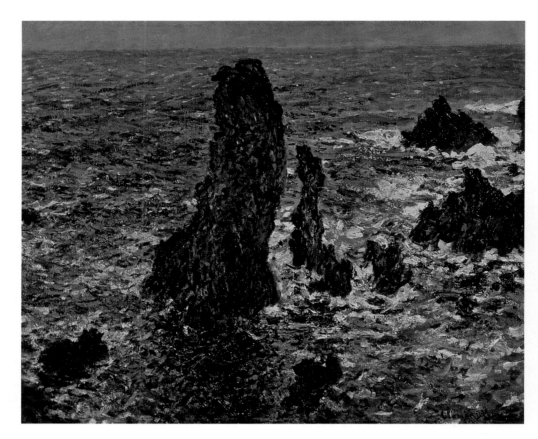

The laws governing the series

172

"After spending twenty-five years roaming along the banks of the Seine from Le Havre up to Paris, then back again from the Louvre river-front to the estuary," Arsène Alexandre wrote, "Monet suddenly found his chosen place – thinking of the further journeys he was to undertake as an untiring explorer of regions and colors we might almost call it his home port. It was Giverny." That was in 1883.

The fact of settling down was to have a considerable impact on Monet's approach to his work. Up until then he had been concerned to seize the light of the instant, as chance ordained, in the course of his excursions. Henceforth he would seek to convey the variety of light by repeated studies of the same theme at different times of day in order to show how light transforms reality, or rather to prove that the very principle of reality resides in the light that reveals it.

His sequences or series which began with *Haystacks* in 1889 continued with the *Poplars* in 1891, the *Views of Rouen cathedral* in 1894, the *Thames* (1904) and *Views of Venice* (1908). *Waterlilies*, the most famous series, which he embarked on at the end of the century, kept him busy until his death in 1926.

Producing series such as these involved a special approach to organizing his work. In Monet's own words, "No painter can work for more than half an hour on the same subject out of doors if he means to remain true to nature. When the subject changes, you must stop." So he worked on several canvases simultaneously, waiting for the conditions to be right to resume work on each of them.

This quest, founded less on the study of forms than the chromatic analysis of vision, ended in a dematerialization of the subject. It is as if light in the end were dissolving the form in order to restore it to us in all the brilliance of pure color. Henceforth color had no message other than itself, to such an extent that we may justifiably wonder if the nature which so obsessed Monet was still there as a representational object. This amounts to asking the thorny question of where the boundary between abstraction and figurative representation lies. Was Monet still depicting nature in the *Waterlilies*? He was, but with the freedom of a painter who has acquired a vocabulary of his own after sixty years as a practising artist. In any case, this debate between art historians never touched Monet. What the artist puts on his canvas is a synthesis, the transcription of the moment of a vision. As for the part played in that vision by the intrinsic qualities of the object or by the arbitrary reconstruction imposed on it by the painter, in the final analysis it matters very little. "You are not an artist if you do not carry your painting in your head before you carry it out," he declared in 1920, "and if you are not sure of your craft and your composition Art ... is a spontaneous, yet sensitive transposition of nature."

Claude Monet
Rocks at Belle-Ile
Oil on canvas
Moscow, Pushkin Museum

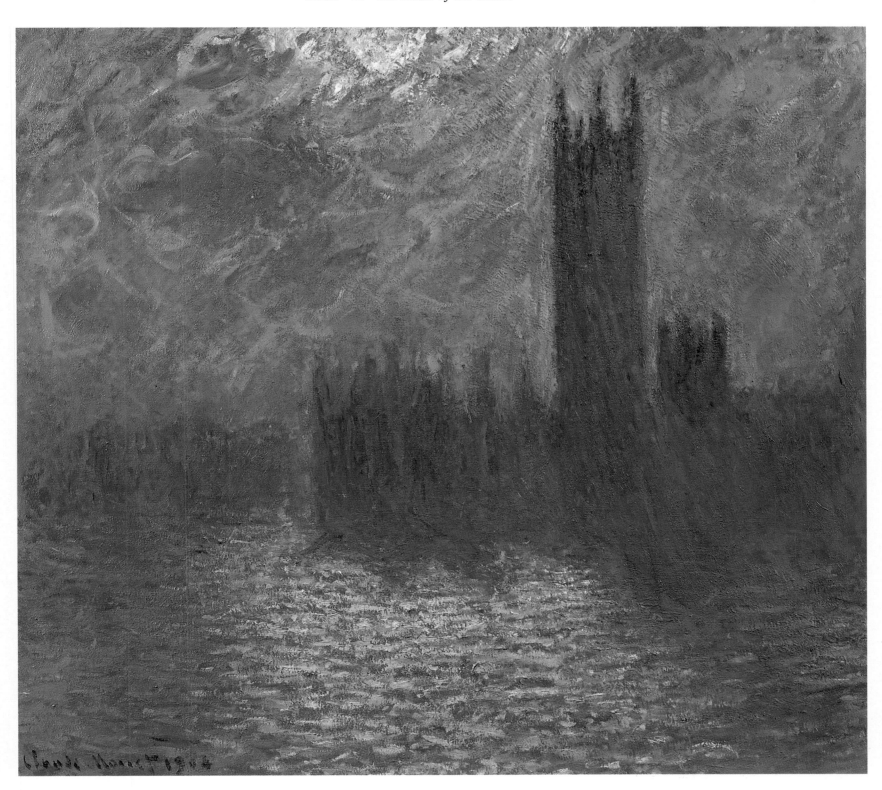

"*Monet very quickly
noticed that no color
really exists in nature,
that all colors are a
function of light and that
form itself is subject to
countless variations
strictly depending on the
relationship between color
and light on the one
hand, and the quality and
density of the air on the
other.*"

Pierre Francastel
*Histoire de la peinture
française*, vol. II
Editions Meddens, 1955

Claude Monet
London, the Houses of Parliament
Oil on canvas
Lille, Musée des Beaux-Arts

174 ***The poetry of the incomplete***

Sisley was of English origin, and Whistler American: each occupies a place on the sidelines of Impressionism. The work of Sisley, who died in poverty in 1899, remained unknown to the public. Writing about him Octave Mirbeau said that "he gave incompleteness a sometimes exquisite sense of poetry." As a disciple of Courbet, Daubigny and Corot, he devoted himself solely to landscape. His father's financial ruin and death in 1871 left him penniless.

Never having been slated by the critics, Sisley was always regarded as a second-rate painter. He was described as harmonious, subtle, sensitive and delicate – in short, a delightful creature painting pretty things which it would have been churlish to criticize. In actual fact he and his wife and their two children often did not know where their next meal was coming from. After wandering all over the Ile-de-France, staying at Argenteuil, Bougival, Pontoise, Auvers-sur-Oise and Louveciennes, he finally settled at Moret-sur-Loing in 1883.

That year his first one-man show at the Durand-Ruel gallery was a flop. Bitter and downhearted, Sisley decided not to take part in the final Impressionist exhibition in 1886. From that point on his painting moved away from the gray and blue tones of the previous decade. The color became brighter, the touch heavier and more dramatic, but without detracting from the realism of the representation and the judicious harmony of the composition.

So what was lacking in his painting? Scandal perhaps – or the special aura which a painter's death confers on his work. For as early as 1900 *Flood at Port-Marly* fetched the fabulous sum of 43,000 francs at a sale at the Hôtel Drouot. When it was painted in 1876 Sisley would not have been able to ask for more than thirty francs, the average price he then received from Drouot.

Whistler did not experience the same rebuffs. His time in Paris between 1855 and 1859 enabled him to meet the Realist painters and Manet. He established himself in London in 1859, introducing Impressionism there. However, the path he followed was later to bring him closer to the Symbolists. His work was defended in France by Mallarmé and Huysmans: like them he stuck to the principle of "art for art's sake," so marking a break with the Realism of his early days.

Oddly enough Whistler's approach was very close to Monet's, even though his paintings appear very different. His *Symphonies* and *Nocturnes* show that he thought of his works less as representing reality than as the visual equivalent of a piece of music. Color was handled like notes of music. Thus what was important was not how well it matched reality (its representational capacity) but its intrinsic esthetic intensity (its evocative capacity). With Whistler color became an autonomous value: abstraction was born of this discovery.

Alfred Sisley
Coast of Wales in the mist
Oil on canvas
Rouen, Musée des Beaux-Arts

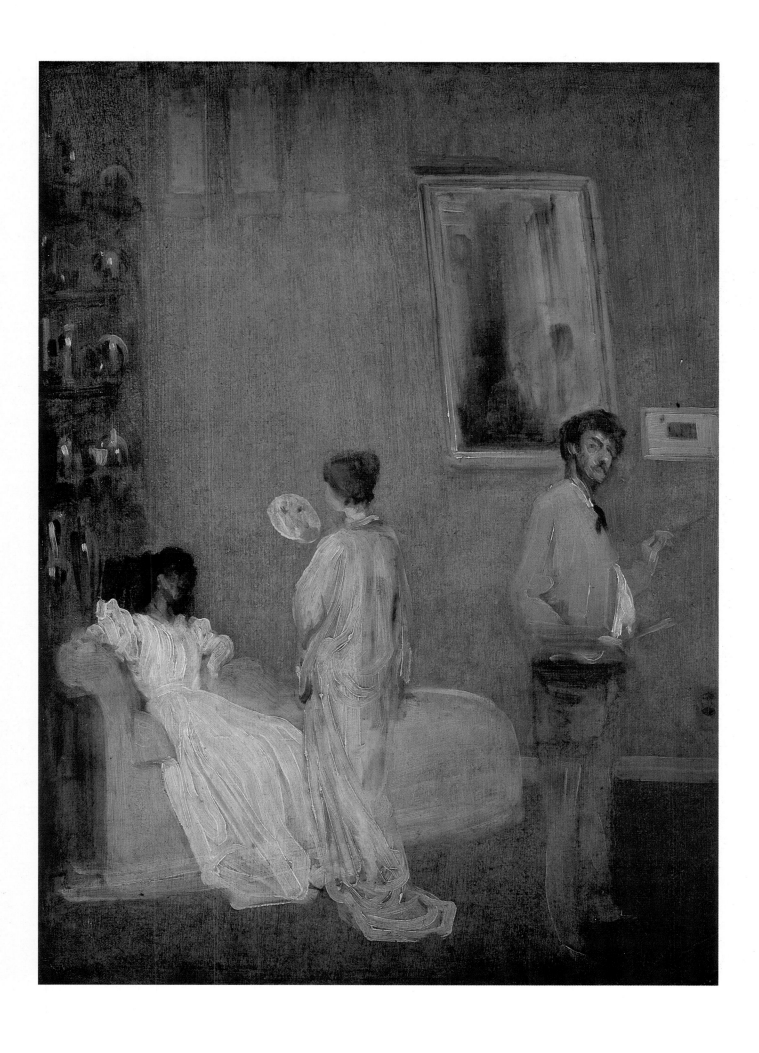

James Abbott McNeill Whistler
The artist's studio
Oil on canvas
Minneapolis, Minneapolis Society of Fine Arts

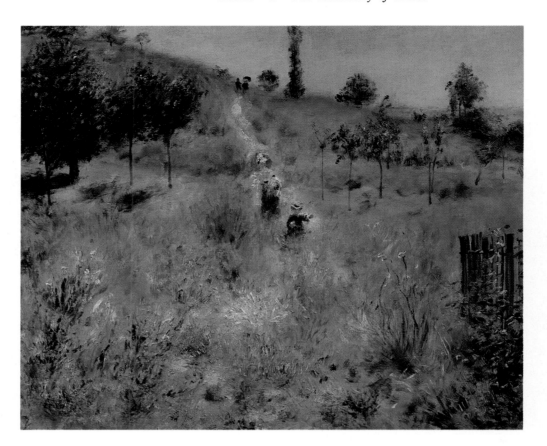

176 *The enchantresses*

Renoir combined within him ardor and prudence, caution and passion. Starting off as a modest apprentice he hoped painting would bring him everything: happiness, fame and fortune; but he had no systematic approach, no theory, no doctrine. Even at the darkest times he always made good temper his bulwark. Even so, if his naivety was not calculated, nor was it completely innocent. He might well have yielded to the academic approach if he had enjoyed painting frozen nudes of the type lining the walls of the official Salons, but their impersonal perfection bored him. Despite his admiration for Raphael, he loved life too well to sacrifice it to the classic ideal. He was more in sympathy with Rubens.

Having met Monet and Sisley at the Gleyre studio in 1862, he went to Fontainebleau and along the banks of the Seine with them. On Diaz's advice he lightened his palette. Painting *La Grenouillère* along with Monet, he invented Impressionism with him in the summer of 1869. From then on his canvases were structured by color, though they differed from those of his friend in their greater chromatic richness. Contrast was less accentuated, the touch more supple and fluid.

The landscapes Renoir painted between 1872 and 1885 enabled him to go more deeply into the discoveries he had made at La Grenouillère. *Path in the woods* (1874), *Road climbing through long grass* (1876-1878) and even more *English pear tree* (1885) show that he had succeeded in dispensing with drawing more quickly than Monet. These landscapes, real symphonies in green, were far and away the boldest produced by the group, as Monet realised later. But Renoir took fright. Having been accepted for the 1879 Salon he stopped taking part in the Impressionist exhibitions, returning temporarily to compositions more based on drawing. This was the period of his "harsh manner."

In parallel with his landscapes Renoir devoted himself to studying Parisian life and – even more – Parisian women. He liked women, loving the grace of their full bodies. And studying the human figure gave light back a structure which landscape made too improbable. "He was the painter of free life, letting the imagination of his youth wander through it," Gustave Geoffroy wrote. In the nude or the group he found a psychological dimension not offered by landscape.

After 1880, with the advent of success, Renoir moved away from scenes from popular life. His biographer Georges Rivière explained: "From that time on the painter was hardly ever to be seen working at the Moulin, Bougival or the Place Pigalle." But he did not forget women – they became his only theme. To be sure, they were no longer the small-time prostitutes of Montmartre: he painted a personal ideal, a sort of mythical, intimate woman, opulent and generous. He had found the miraculous incarnation of this ideal in the person of Gabrielle, the young cousin of his wife Aline, who was his model for over twenty years.

Pierre-Auguste Renoir
Road climbing through long grass
Oil on canvas
Paris, Musée d'Orsay

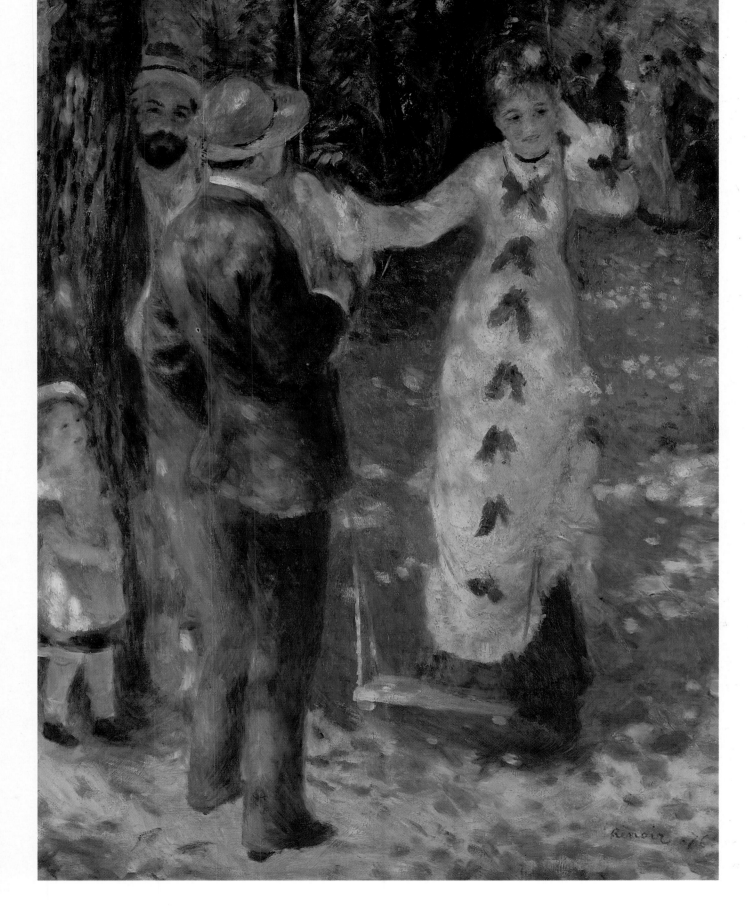

177

"[Renoir's women] show
the relaxed abandon
appropriate to young
women who have eaten
and are enjoying
themselves in the company
of young men, but above
all they show a niceness
and mischievous charm
which only he could
impart to the feminine
world."

Théodore Duret
Renoir

Pierre-Auguste Renoir
The swing
Oil on canvas
Paris, Musée d'Orsay

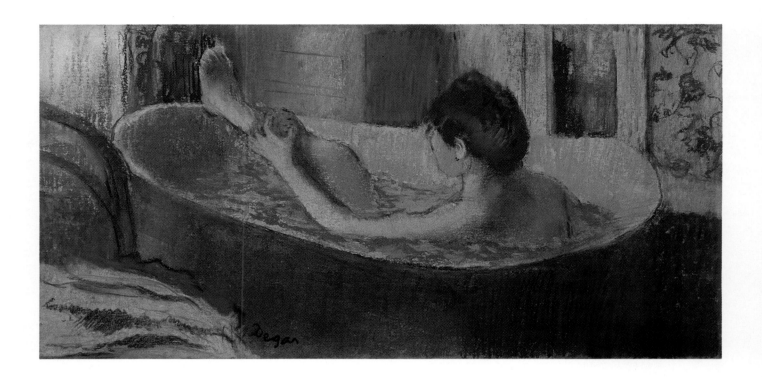

178 ***Movement captured in an instant***

Degas, another great interpreter of the female body, had originally been influenced by Ingres, and his youthful works show an original combination of Neo-Classicism and Realism. Nature bored him in the extreme, and mythology did not hold his interest for long. Unlike his Impressionist friends, whom he met daily at the Guerbois, he did not believe either that "truth" had to be seized by painting from nature. He wanted to "bewitch truth, give it the appearance of madness." Painting according to him was "a product of the imagination."

This is why Degas felt he was really at work only when he was in his studio. "For years he shut himself away there from morning to night, refusing to open the door even to his closest friends," George Moore wrote. Like Manet he distrusted "the tyranny exerted by nature." When the artist paints from nature it points him in a thousand different directions; it does not select. It is neither true nor false, beginning to exist only when the eye recomposes it. Without nature the imaginary world would have nothing to draw on, but without the power of thought nature would remain for ever inscrutable.

What Degas liked best about modern life was its most manufactured, artificial aspect: the theater. As the city was already an artificial universe in itself, the theater seemed like an artifice within an artifice. Adding yet another artifice by painting the theater was a paradox which did not trouble Degas in the least. For he thought that if he progressively refined reality it would gain in strength. Only by this means, he believed, could one

get to the very essence of the truth of life: movement.

Of course movement can be perceived only in relation to a fixed point of reference. In Degas's work this was the function of the original settings he used for his *Dancers* or his *Women in the bath*. By using planes that are close together and contrasted, he intensifies the action without needing to dramatize it. He seizes the fleetingness of the moment in a dancer bending her knee, the yawn of a woman ironing, or the hand of a woman combing her hair.

The gaze he directs toward women betrays a sensuality that dare not let itself go; desire restrained by the mind. Degas made a profession of distancing himself. He was obsessed with being lucid, with not idealizing his beliefs. "I show them without their coquetry, like animals cleaning themselves," he said of *Women in the bath*. It was true – and it was false. For his protestations of objectivity do not stand up in the face of the obvious presence of repressed desire. The bodies he contorts as they wash and dress fascinate him.

Like a latter-day Pygmalion he could not bear to part with his creations. He was as jealous of his works as of a mistress, reluctant to give them up, sometimes going so far as to denigrate them so that they would not be bought. "When he came to see us," Durand-Ruel recounted, "we had to keep an eye on him so that he did not walk off with anything." Resentful, embittered and almost blind, Degas ended his days sadly, surrounded by a fabulous collection which he could no longer enjoy, like a legendary misanthropist, an object of adulation to some, unknown to the public at large.

Edgar Degas
Woman in her bath sponging her leg
Pastel on monotype
Paris, Musée d'Orsay

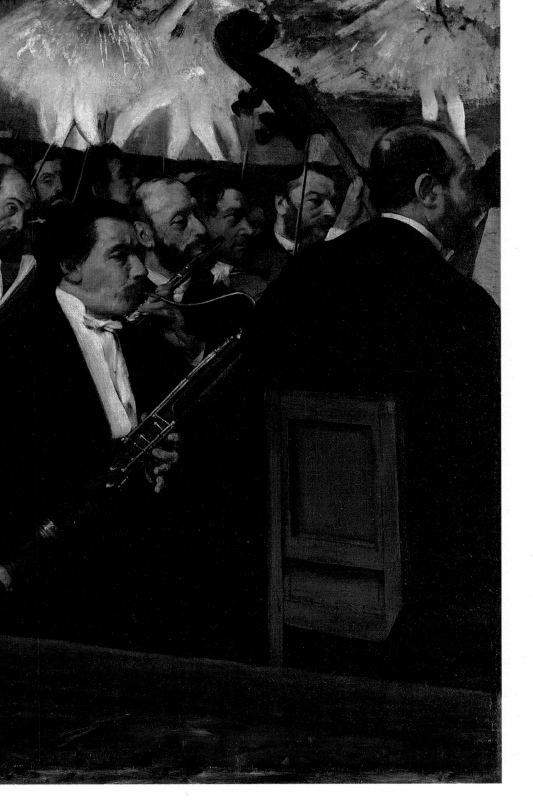

179

*"I saw Degas in his
perturbation of mind and
implacable self-criticism
trying every procedure,
pursuing form with angry
rigor, and heaping
experiment on experiment
throughout a long, furious
career."*

Paul Valéry
Cahiers, vol. II
Gallimard, 1974

Edgar Degas
*Musicians in the orchestra
(or The Opera orchestra)*
Oil on canvas
Paris, Musée d'Orsay

180 **No time to spare**

Toulouse-Lautrec was inspired by the Impressionists, by Degas in particular. His work reveals the same skill in creating a framework and in lighting, the same synthetist, rapid, hatched style, and the same subject matter borrowing from the world of the night and the theater. Another source of influence was the Japanese print – their widespread availability in Europe in the 1860s had already had a crucial influence on Manet. Toulouse-Lautrec drew inspiration from them for his posters, taking up the ideas of a two-dimensional space defined by line and colors distributed in masses.

Born to a life of wealth and idleness, Toulouse-Lautrec was a descendant of the Counts of Toulouse. After two riding accidents had crippled him for life, he turned away from the society life which should by rights have been his to devote himself to drawing and painting. He spent some time in Bonnat's studio in 1882, then in Cormon's between 1883 and 1886, meeting Van Gogh and Emile Bernard. His distorted figure soon became a familiar sight in Montmartre. As a regular customer at the Mirliton, the Chat noir and the Moulin-Rouge, he painted the artists there and created around 300 posters for their shows. Jane Avril, Yvette Guilbert, La Goulue and Aristide Bruant were his favorites, but there were also all the nameless figures from the brothels, the booths of the Foire du Trône and the countless cabarets on Montmartre. Toulouse-Lautrec worked quickly. As with Van Gogh, it might have been thought that some sort of premonition of his early death prompted this elliptical style. Fixing the outlines of his model with a vigorous brushstroke, he organized his canvas on the basis of wide, unpainted spaces which he counterbalanced with touches of garish color. Turpentine enabled him to add the richness of subtly transparent glazes. This resulted in an extraordinarily synthetist whole, setting out in its deliberate incompleteness to convey the movement of life.

In the final decade of the 19th century his drawing became increasingly stylized. The use of hatching, adopted from Van Gogh and Degas, was replaced by bold, flat tints which would influence Matisse. Unfortunately alcoholism was wreaking havoc on his weakened body. Two years after vainly attempting a cure, Toulouse-Lautrec went off to the Château of Malromé in the Gironde, which his mother had bought in 1883. His work was bequeathed to Albi museum and has been exhibited in Albi at the Palais de la Berbie since 1922.

Henri de Toulouse-Lautrec
Seule, 1896
Cardboard
Paris, Musée d'Orsay

181

"Models are always like dummies. These women are alive."

Toulouse-Lautrec

Henri de Toulouse-Lautrec
Yvette Guilbert
Cardboard
Moscow, Pushkin Museum

Space structured by color

Camille Pissarro was the most fervent of the Impressionists and the best teacher among them. Born in the West Indies in 1830 he settled in Paris in 1855 after traveling to Venezuela together with the Danish painter Fritz Melbye. Corot initiated him into *plein air* painting, and he attended the Académie Suisse, where he met Monet in 1859. His work was accepted that year in the Salon, but subsequently refused in 1861, 1863 and 1867.

Along with his friends Sisley, Monet and Renoir he invented Impressionism toward the end of the 1860s, always differing from them in his firmer touch and the way his compositions were solidly articulated by color. He was the first member of the group to eliminate blacks from his pictures and to go off and work from nature in the suburbs of Paris. Pissarro did not have a special area – urban landscapes inspired him just as much as the countryside. On the other hand he was not drawn to water, and group scenes are less common in his work than in that of his friends.

Pissarro was curious about everything, venturesome and generous, and of the Impressionists he was the one who kept coming up with new initiatives. Once he had managed to get on the right side of Cézanne, he persuaded him to give up his "macho" manner, helping him to discover the potential of a reflected use of color. Thanks to Pissarro, Cézanne learnt to "see" light in color and to balance his compositions.

During his stay in London in 1870 to escape the war, Pissarro made friends with Durand-Ruel, who became the Impressionists' dealer.

Paul Cézanne
The negro Scipion
Oil on canvas
Sao Paulo, Museo de Arte

Camille Pissarro
The shepherdess
(or Girl with a loaf of bread)
Oil on canvas
Paris, Musée d'Orsay

183

"Cézanne was completely alone, for a long time he had to work hard and endure rejection by the French and Russian critics; they stigmatized him as a charlatan and a mountebank, printing their condemnation in the popular press."

Casimir Malevitch

In 1874 Pissarro undertook to organize the first Impressionist exhibition; he was the only artist to take part in every exhibition subsequently held between 1876 and 1886. He also paid attention to young painters, launching Gauguin and according the neo-Impressionist theories of Seurat and Signac an enthusiastic welcome – he adopted their Divisionism (Pointillism) between 1886 and 1890, though it led to a rift with his former friends.

However, poverty dogged his footsteps for a long time. Between 1874 and 1880, when the Impressionist battle was at its height and a critic described his painting as the "scrapings from his palette smoothly spread over a dirty canvas," Pissarro wrote: "What I am suffering now is terrible, even worse because I am young, enthusiastic and full of ardor, convinced as I am that I have no future." But he was generous in his suffering. His socialism was not just a pretence – Pissarro loved his fellow men. According to Adolphe Tabarant, his biographer, he was "a delightful man, ... so profoundly humane that an act of injustice

Paul Cézanne
Self-portrait
Oil on canvas
Moscow, Pushkin Museum

184

affecting someone else angered him just as much as a personal offence. It was impossible to approach him without being won over by the patriarchal majesty of his face, where there was never any trace of hardness or hauteur."

His painting reflected his nature: solid but not off-putting, sensitive but not mawkish, and always open to new ideas without ever losing its coherence and serenity. It took the radiance of such a powerful personality to unlock Cézanne from the predicament where the excesses of his darkly-flamboyant approach had landed him.

Cézanne had joined him in Auvers-sur-Oise in 1872. "We were always together," Pissarro later recounted, "but one thing is certain, we both preserved the only thing that matters, the capacity to feel." But it was through him that Cézanne discovered all that could be extracted from constructing by means of masses of color, and a little later on from geometricizing forms. This led Cézanne to break with Impressionism in 1877. Adopting the opposite approach from Monet, who moved toward the dilution of form in color, he realised that the selfsame color could enable him to restore all its density to form. It was an enormous step for someone who was an unqualified admirer of Goya's "black paintings." As he continued to be the butt of the critics,

Cézanne decided to live in retirement in Aix. In spite of the friendship of a few people, he continued to be "the most reviled artist" of his time. His childhood friend Zola even used him as the wretched hero of his book, *L'Oeuvre*, depicting him as a failed painter who ends up committing suicide in front of his uncompleted work. Cézanne answered simply by observing that "you cannot expect a man who knows nothing about it to say sensible things about the art of painting." And all contact between the two men ceased.

The death of his father in 1886 gave him financial independence, and he was finally able to devote himself entirely to his work. Cézanne wanted to use the "capacity to feel" Pissarro had talked of as just a point of departure. More of an architect than a poet, he was not so much anxious to express the world he saw as to reconstruct it without the help of chiaroscuro or traditional perspective: to make line spring out of color, give space depth by means of color – with him, everything came from color and was resumed in color. "The more color is in harmony," he wrote, "the more the drawing stands out. When color is at its richest, form is at its fullest."

In his search for harmony Cézanne returned to one of Manet's youthful preoccupations, expressed in

Paul Cézanne
Landscape near Aix,
Mont Ste-Victoire
Oil on canvas
Moscow, Pushkin Museum

185

Déjeuner sur l'herbe: how to integrate the human figure into landscape? Or to put it another way how to reconcile the moving architecture of a body into the immobile architecture of nature? In setting out to "treat everything in nature using the cylinder, sphere and cone" Cézanne overcame a first difficulty. In his work the human form no longer differed from any other form. Turned into geometry or a monument, it did not dissolve into the background as in Monet's work, but opened onto it. The other difficulty was how to convey movement.

Degas worked like a photographer, grasping it in a moment of time which implicitly referred to a before and an after, but Cézanne, anticipating Cubism, set out to put onto canvas the sum total of instants by multiplying the points of view, as if the same scene were being observed several times from several different standpoints.

After winning belated acclaim with his first one-man show at Vollard's in 1895, Cézanne died on 22 October 1906.

Paul Cézanne
Woman in blue
Oil on canvas
St Petersburg, Hermitage

Conveying line by color

The aim of Seurat's Divisionism, which was perfected during the summer of 1885, was to take the Impressionists' researches beyond the realm of simple subjective sensation and give this style of painting a scientific justification. In the prevailing Positivism of the late 19th century Divisionism (or Pointillism), inspired by Chevreul's and Maxwell's discoveries about light and color, was based on the theory of optic mixing.

Seurat, who came from a middle-class background, enrolled at the Ecole des Beaux-Arts in Paris in 1878. At first sight nothing about the nineteen-year-old youth would seem to have predestined him to overturn established traditions. He admired Ingres, was attracted by Millet and worked with Puvis de Chavannes on decorating Lyons museum. But the demon of science was at work in his methodical mind. He could not be satisfied with the discipline of making correct copies after Renaissance masters. This was not because their vision did not match his, the point of view of the Impressionists, but because it no longer corresponded with the teachings of science regarding optical phenomena. Seurat saw his dreams with a "mathematical" eye.

His first important work, *Bathing at Asnières*, was turned down by the 1884 Salon and exhibited at the first Salon des Indépendants organized by Odilon Redon and his friends. The Impressionists really did not recognize themselves in this cold, cerebral painting, closer to the formal purity of Puvis de Chavannes than to the colored lyricism of Renoir. Monet, Renoir and Sisley made a public display of their disapprobation by refusing to take part in the eighth and final Impressionist exhibition in 1886 beside Seurat.

He exhibited *Sunday afternoon on the island of the Grande Jatte* there – it provoked a fine scandal and put him on the map once and for all. This scene, apparently so calm and simple, was in fact the result of an enormous amount of preparation work. For Seurat, who had come to painting by way of drawing, still thought that composition was balanced by line, and with this in mind produced countless rough studies and sketches. But it was his intention to convey line by means of color, and to convey color by touch.

His premature death in 1891 at the age of only thirty-two brought the development of the movement to a halt. Only his friend Paul Signac remained more or less faithful to the technique, but Seurat's work made an impression on Matisse as a young man, inspired the Fauves and had some influence on the Cubists and Futurists.

Georges Seurat
Bathing at Asnières
Oil on canvas
London, Tate Gallery

"The great puritans of art are a curious study. They seem to be divided into two groups, those who renounce a rich, early sensuality, like Poussin and Milton, and those who hope, like Malherbe and Seurat, to purify art by giving it the logic and finality of an intellectual theorem."

Kenneth Clark
The Nude

Georges Seurat
*French Cancan
(or Le chahut), study*
Oil on canvas
Former Brame and Lorenceau Collection
London, Courtauld Institute

Haunting undulations

Van Gogh committed suicide on 27 July 1890. He was thirty-seven years old. He left 800 pictures behind him, none of which had ever attracted a purchaser (this should not surprise anyone, given how short his career as a painter was).

Everything that can be said about his madness, his genius and his suffering has been said. He was the son of a pastor, and would have liked to become one himself. He set off to preach to the miners, but his excessive ardor frightened them and he was sent packing. He tried to get into the theological college in Amsterdam, but failed. Then he failed again in another attempt to

enrol at the Protestant college in Brussels. Religion did not want him, the people did not want him, so he took refuge in painting.

His first style was realistic and somber. He admired Millet and painted peasants, but without resorting to the idealization of his master. The creatures he painted with a heavy, coarse touch are almost caricatures. He thought he was "evoking manual work and suggesting that these peasants had earned the right to what they eat through honest toil." His work was naive, full of good intentions and (understandably?) failed to attract attention.

After five years of unrewarding work Van Gogh joined his brother Theo in Paris. He discovered Impressionism in the year of the group's final exhibition (without Monet or Renoir), met Toulouse-Lautrec, Pissarro, Degas, Seurat and Gauguin. Père Tanguy agreed to exhibit his work in his shop for artist's materials along with that of Monet in 1887. He went through a pointillist phase, then converted to Gauguin's cloisonnism before adopting his own style, lying halfway between the two schools.

Pure, strongly contrasting colors, drawing emphasized by impasto, a hatched, undulating touch: these are the characteristics of a style which need no longer be described, anticipating Fauvism and Expressionism. Van Gogh went off to Arles in 1888 because he could no longer bear the grayness of Paris, and at first thought he would like it there. He continued to paint prolifically: "I am functioning like a painting engine," he wrote. He told his brother: "Let me tell you that I am in the middle of a complicated calculation

Vincent Van Gogh
Women of Arles
Oil on canvas
St Petersburg, Hermitage

Vincent Van Gogh
Landscape at Auvers after rain
Oil on canvas
Moscow, Pushkin Museum

"Oh well! Really, the only thing we can make talk is our pictures."

Van Gogh
Letter he was carrying the day he committed suicide

which results in me churning out canvases quickly one after the other, but they have been worked out a long time beforehand. So there, when people say something's been too quickly produced, you'll be able to tell them that they've looked at it too quickly."

Van Gogh was locked away after the unfortunate episode of the severed ear in December 1888, returning to Doctor Gachet's house in Auvers-sur-Oise at the begin-

ning of 1890. The works of his final period are certainly the most accomplished. The fact that it is possible to detect the signs of his advancing illness is one aspect, but the main thing is that we can see that the artist had by then acquired a total mastery of his language. Van Gogh did not commit suicide because he was frightened he could not paint, but because he could not express himself in any way other than through painting.

Vincent Van Gogh
Eugène Boch, a Belgian painter
Oil on canvas
Paris, Musée d'Orsay

"The truth is primitive art"

"What matters to me," Gauguin said, "is what is happening today and what is going to open the course of the 20th century." Gauguin was revolutionary in the sense that he called for "a frank and reasoned return to principle. And that return is the necessary effect of symbolism in poetry and art." Thus it is quite clear that Gauguin was as far removed from Impressionism as from Seurat's Divisionism. He reproached Impressionism with serving nature rather than exploiting it, for "nature degrades the artist in allowing him to worship it." He reproached Divisionism with trying to replace symbol and myth with calculation, extending the misdeeds of the Positivist illusion even into the field of art. For Gauguin mastery of the world meant not material, but spiritual mastery: "The truth is pure cerebral art, it is primitive art – more knowing than any other – it is Egypt."

From 1871 to 1883 Gauguin worked as an exchange broker, starting to paint as an amateur. Pissarro and Degas admired his work, and he was invited to take part in the fourth Impressionist exhibition in 1879; then in 1883 he joined Pissarro in Rouen after handing in his notice to his employer. His wife left him, taking the children and going back to live with her family in Copenhagen. Free of family commitments, but on cool terms with Pissarro because of a disagreement over Pointillism, he embarked on a series of journeys to Brittany (Pont-Aven), Martinique and Panama (1887), back again to Brittany with Emile Bernard, and then to Arles (1888), where he joined his friend Van Gogh.

After spending a few months teaching painting at the Académie Vitti in Montmartre, he got a favorable answer from the Ministry of Public Education and Fine Arts to his request to go on a mission, and embarked for Tahiti in April 1891. Two years later he returned to France, his mind full of Polynesian tales, recounting his experiences in *Noa Noa*, published by the *Revue blanche* in 1897. An exhibition of his paintings at the Durand-Ruel gallery was a flop and the subsequent sale at Drouot's a total fiasco. Abandoned by his mistress as well, in July 1895 Gauguin set off again from Marseilles heading for Tahiti – the last time he set foot on European soil.

During the seven months that followed his output was prolific. Relating less to everyday life and inspired more by Polynesian mythology, it demonstrated Gauguin's development from the simple exoticism of the early work toward real reflection on the artistic and religious function of symbols. At the same time his fight against colonialism continued in the columns of *Guêpes* and *Sourire*, two satirical newspapers which he was responsible for editing and publishing. Forced into exile on the Marquesas Islands by the authorities in 1901, he continued to urge the natives to rebel. But syphilis was by now making rapid inroads on his health, and he had to give up painting a year later. His final months were devoted to writing his memoirs. He died on 8 May 1903, in utter deprivation, while in Paris his work was already inspiring a new generation of artists.

Paul Gauguin
Breton peasant girls
Oil on canvas
Munich, Staatsgalerie Moderner Kunst

"It seems to me that Gauguin thought that the artist should seek out symbol, myth, enlarge things in life to the point of myth. Whereas Van Gogh thought that it was necessary to know how to destroy myth where it relates to the most down-to-earth things in life. In which I think he was only too bloody right."

Antonin Artaud
Van Gogh, le suicidé de la société
Gallimard

Paul Gauguin
Landscape with peacocks
Oil on canvas
Moscow, Pushkin Museum

192

Gustave Moreau
Salome
Watercolor on paper
Former Brame and Lorenceau Collection

193

"There is always the same pale coloring, the same fresco-like look, the painting is always angular and hard; ... and yet ... that painter has talent."

J.-K. Huysmans
Salon de 1879
L'Art moderne
Charpentier, 1883

194

A moment of eternity

"I have tried to be ever more sober, ever simpler," Puvis de Chavannes said. Though an admirer of Delacroix, he aspired to stark simplicity, reposeful colors and balanced compositions. When he then came to be regarded as an official painter, decorator by appointment of the pretentious, wedding-cake architecture of the Second Empire and the staircases and galleries of the Third Republic, he had to go through a long period in purgatory from which he is only just emerging today.

Aiming for simplicity in art is always a dangerous gamble, especially if it is not offset by a wildly eventful life giving people something to write about. But Puvis de Chavannes's passage through life was smooth, like his work. Even his colors seem to be drowned in a veil of mist. His painting is a tender, hieratic dream.

In a period that indulged in the pleasure of excess and accumulation (see the Garnier Opera) with *nouveau-riche* vulgarity, Puvis de Chavannes put his faith in sobriety, and it is amazing that the State valued his work so highly. His compositions are very far removed from those of someone like Bouguereau, which appeal to the eye by using easy effects, and belong rather to the tradition of the great pre-Renaissance fresco artists. In Puvis de Chavannes's work there is something of the primitive power of a Giotto or a Fra Angelico. His allegories are neither flesh-and-blood creatures nor easy stereotypes. The women he paints are found only on the staircases of museums, but nonetheless they live, in mythological space and time: they are unreal without being artificial.

Naturalistic painters could not bear his ethereal manner, but the Symbolists and Mallarmé on the other hand recognized him as one of their own. And Gauguin paid tribute to his work by alluding to *Hope*, exhibited at the 1872 Salon, in one of his last canvases, dated 1901. It was not so much an act of homage as a bequest. Gauguin had recognized in Puvis the mark of the art which "proceeds from the mind and uses nature," and in the abstract, uniform light of his pictures saw the expression of a "pure, cerebral art".

Pierre Puvis de Chavannes
Marseilles, gateway to the Orient
Mural painting
Marseilles, Musée des Beaux-Arts (Palais Longchamp)

195

"The only way to achieve real success easily in the noble genres is to treat one's subject with rigorous modesty, with that spirit of self-denial which can force the hand to work in a simplifying, summary way Puvis de Chavannes is short-sighted through abstraction: he must have spent a long time in reflection before painting and finding his way He has managed ... to paint his dream, and in short to produce work which is imitated and which will endure: he has found a style."

Odilon Redon
A soi-même
José Corti, 1961

Pierre Puvis de Chavannes
At the fountain
Oil on canvas
Reims, Musée St-Denis

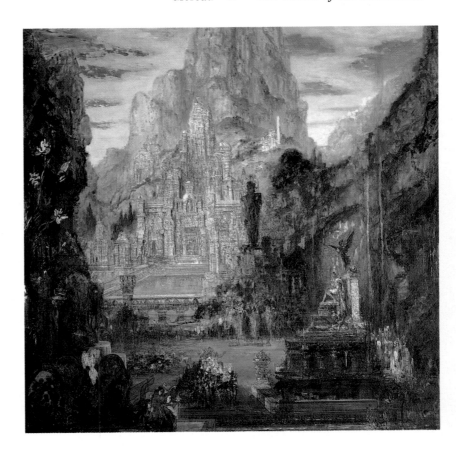

The beautiful inertia of myths

196

Like Puvis de Chavannes, Moreau evolved in a world of myths. But whereas Puvis's vision was based on an ideal of harmony and concord, it was a quite different story in the mystical, sensual world of Moreau. In Puvis's work myth was derived from an idea, and was abstract. Myth in Moreau, on the other hand, is more inclined to suggest horror and fear, though it does not degenerate into chaos. For if his myth is a stranger to peace, it is always depicted with majestic hieratism. The very silence, as in *Orpheus at the tomb of Eurydice*, is "a silence of death," as Moreau himself put it.

Oedipus and the Sphynx, exhibited at the 1864 Salon, and *Thracian girl carrying the head of Orpheus* made Moreau famous, but he soon abandoned his official career for good. Some critics accused him of archaicism, and from 1867 he submitted work to the Salon increasingly rarely, giving up exhibiting there altogether from 1880. Success did not really matter to him, and as he did not have to sell his work to live, he kept most of his output in his Paris home, which became the musée Gustave-Moreau after his death, through a bequest to the State.

His style of working, which had been classical and detailed in his early work, freed itself after 1870 of the formal constraints of drawing and line, deploying rich, costly colors, with violent contrasts between golds, purple reds and blues, in a highly charged sensual atmosphere, redolent with contained violence and a phantasmagoric, yet intimate Orient. For in Moreau's work myth is often clothed in an aura of mystery and fantasy. It is a sort of inert and terrible power, an apparition whose meaning cannot be understood, bereft of any didactic virtue. Writing about him in *Jean Santeuil* Marcel Proust said: "You could have known Gustave Moreau's life in detail, chatted with him about art, life and death, dined with him every evening, all to no avail: you would be no further forward in trying to penetrate the mystery of the origin and significance [of his paintings], which he himself really knows no better and which are brought to him as precious gifts, like strange women from the sea, in the tides of inspiration that break over him. Anything he might tell you about them would relate only to the circumstances in which they were invented … but not to the mysterious similarity that unites them, the essence of which, though it is bonded to his mind since it alone brings forth such work, and only such work comes to his mind and sets it free, [is] nonetheless unknown to him."

Accepting a teaching post at the Ecole des Beaux-Arts in Paris in 1892, Moreau attracted young artists such as Matisse, Marquet and Rouault to his studio – Rouault of all his pupils was his most faithful heir. The power of his imagination also inspired the Surrealists. "The discovery of the musée Gustave-Moreau," André Breton wrote, "… had a permanent effect on conditioning my way of loving. Beauty, love, that is where they were revealed to me in a few faces, a few women's poses."

Gustave Moreau
Triumph of Alexander the Great
Oil, watercolor and Indian ink on canvas
Paris, Musée Gustave-Moreau

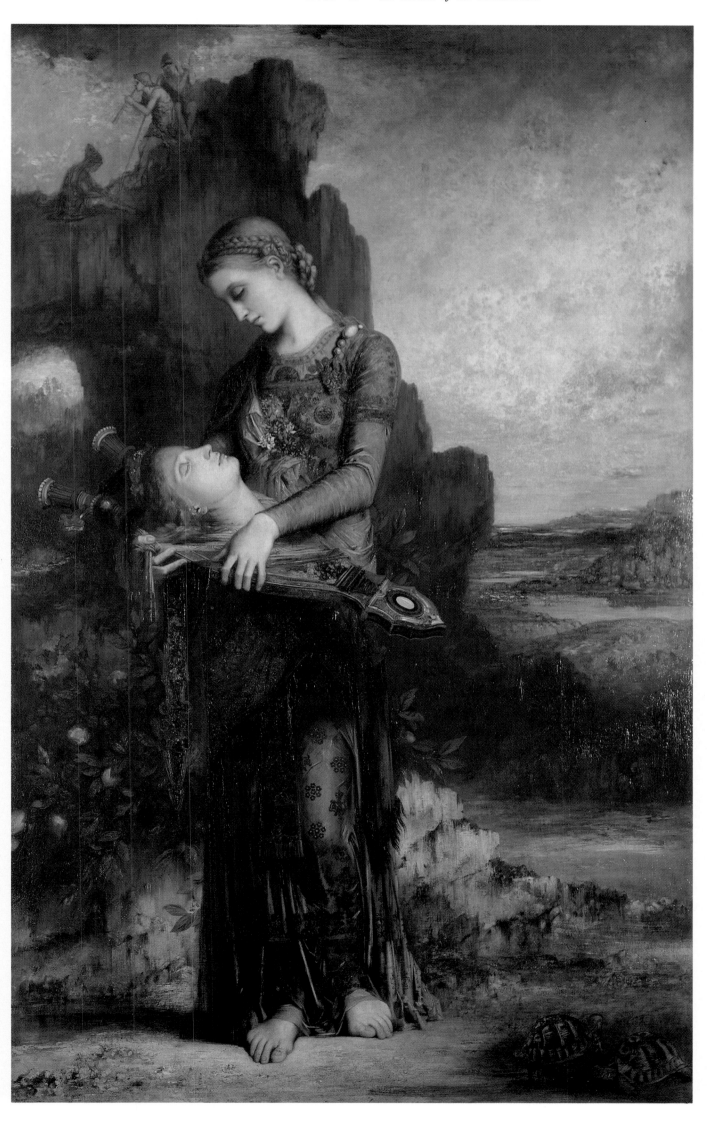

197

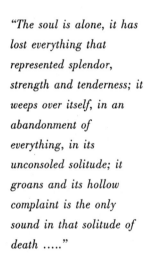

"The soul is alone, it has lost everything that represented splendor, strength and tenderness; it weeps over itself, in an abandonment of everything, in its unconsoled solitude; it groans and its hollow complaint is the only sound in that solitude of death"

Gustave Moreau

Gustave Moreau
Orpheus
Oil on wood
Paris, Musée d'Orsay

The colors of the unconscious

Odilon Redon, whose work carries on from Moreau's, was Huysmans' favorite artist. A precursor of Symbolism, Redon devoted himself to the world of dream and to fantastic visions welling up from the depths of the unconscious, but used the visible world to give them form. "I made an art that corresponded with my own ideas," he wrote. "I made it with my eyes open to the wonders of the visible world and, whatever people may have said, with a constant concern to obey the laws of the natural world and of life …. I believe I yielded docilely to secret laws which have led me to fashion as best I could and in accordance with my dream things in which I have invested my whole self." Thus it is not nature that is being rejected – moreover Redon was passionately interested in the microscopic universe revealed to him by the botanist Clavaud – but the ambition, which was the Impressionists' ambition, to convey a sensation without being concerned with anything other than nature itself, and never with what might be taking place in the mind of the person perceiving it. "An entirely legitimate way of painting," he explained, "when it applies mainly to representing external things in the open air. [But] I do not believe that everything beating away behind the forehead of a man who is listening to his own thoughts and composing himself, I do not believe that *thought* taken for what it is in itself has much to gain from this obstinate determination to consider only what is happening outside our houses …. On the contrary, the future belongs to the subjective world." This was a premonitory statement, and an extremely modern one, which attracted posthumous support from the Surrealists, who saw Redon as the apostle of "docile submission to the arrival of the unconscious."

For Redon nature, which he studied in the forest of Fontainebleau, Brittany and at Peyrelebade, his property in the Landes, constituted a repertory of forms. He drew on it for material to "make the invisible visible" and convey fantasy in images. For a long time he stuck stubbornly to using only black, but after 1891 his work exploded in a symphony of colors that dazzled Bonnard, Matisse and Denis, and probably inspired Debussy, whose music in some respects was a transposition in sound of this iridescent, poetic world. "If an artist's art is the song of his life," Redon wrote, "a solemn or sad melody, I must have struck a light-hearted note with color."

Odilon Redon
The red boat
Oil on wood
Paris, Musée d'Orsay

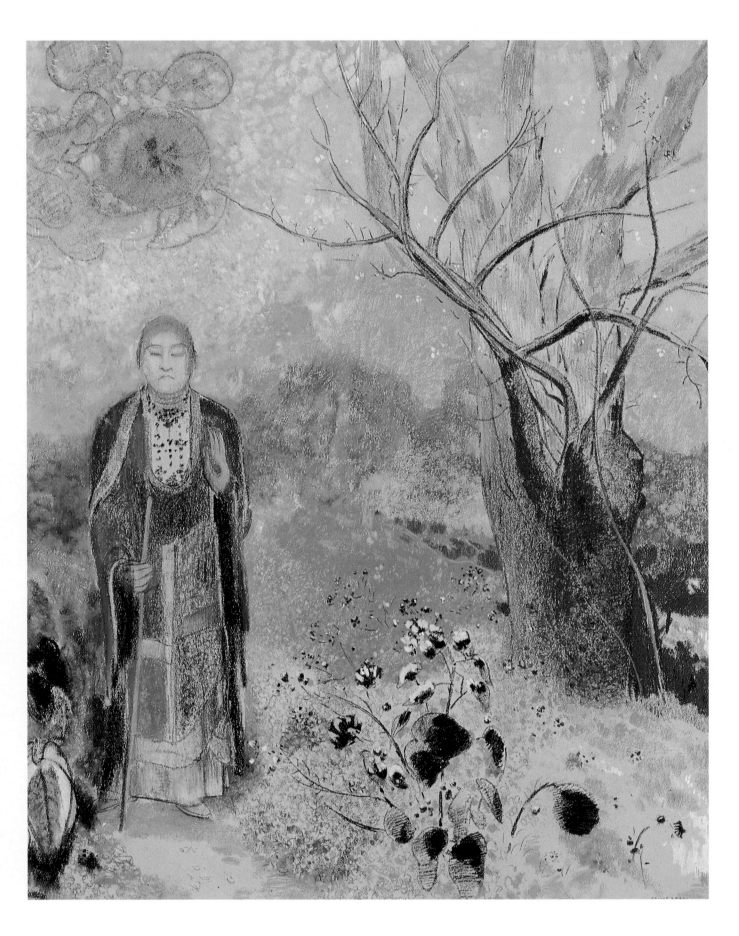

"I abhor those who roll the word 'nature' in their mouths, without having a trace of it in their hearts."

Odilon Redon
A soi-même
José Corti, 1961

Odilon Redon
The Buddha
Pastel on brown paper
Paris, Musée d'Orsay

200 ***Precious symbols***

The end of the 19th century was marked by the eclecticism then prevailing being challenged throughout Europe. There was a desire to break free from the styles of the past, but also a determination to restore esthetic coherence and formal unity to the work of art; this "modern art," also known as "Art nouveau," was embodied in Austria by the Vienna Secession movement.

Based on esthetic principles that were vague enough to deter no-one, the Secession was above all a call by the young for creative freedom. Its program could have been summed up as bringing art into life in order to restore life to art.

Klimt, who was one of its founders in 1897, became the president and main moving spirit the following year. Having taken part in decorating the theater, museum and university of Vienna, he had developed a style borrowing techniques and materials from the applied arts; the impact of this style was beginning to be felt in the rest of Europe. Loyal to the philosophy of the movement, he rejected any distinction between "great art" and the "minor arts." The same desire for unification had led him to reject

illusionistic perspective, which made an artificial distinction between the subject of a painting and decoration by creating a two-dimensional space into which the figure slotted like a piece from a jigsaw puzzle.

The stylization of forms in Klimt's work, which sometimes verges on abstraction (in that any and every form becomes a plastic sign), goes hand in hand with the development of a more or less hermetic symbolism, with woman as its central figure, alternately concealed and revealed (betrayed) by the juxtaposed planes surrounding her, at the heart of which "her face is set like a stone in a tangle of precious materials."

Refined forms, invasive arabesques, saturated colors: everything in this art is dedicated to beauty and its fundamental ambiguity. Klimt's work, a sublimated exaltation of instinct, a stylized expression of desire, set out to transform the world into a work of art by the use of symbol: an extreme position which by its intense estheticism distances art from the world rather than bringing them nearer together, as the Vienna Secession had intended when it first started.

Gustav Klimt
The kiss
Oil on canvas
Vienna, Österreichische Galerie

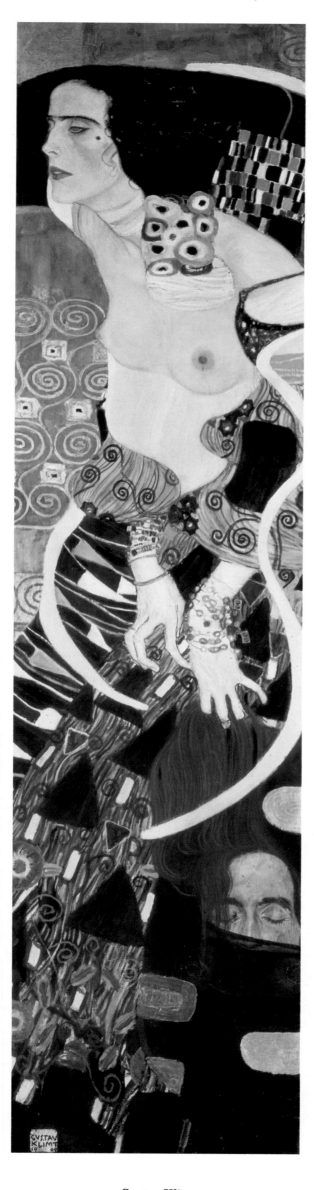

*"In Klimt [women]
frequently incarnate Eros,
the harbinger of death.
The central theme is
man's blameworthiness
and his expectation of
being punished by woman,
which amounts to saying,
in abstract terms, that
instinct subjugates
principle. His Judith, his
Salome pronounce death
sentences and carry them
out."*

Werner Hofmann
*"La mort dans la peinture
autrichienne"
Vienne, 1880-1938:
l'Apocalypse joyeuse*
Exhibition catalog

201

Gustav Klimt
*Salome
(or Judith II)*
Oil on canvas
Venice, Museum of Modern Art

202 *Under Gauguin's influence*

With the Nabis (Hebrew for prophets) the second Symbolist generation emerged, taking over from Moreau and Redon. Bonnard, Vuillard, Sérusier, Denis and Vallotton followed Gauguin in rejecting Divisionism and Impressionism. Like him they aimed to rediscover the "sacred character" of art. It was a vague ambition which would have had scarcely any impact if it had not been conveyed in plastic terms in accordance with the minimalist definition of painting penned by Maurice Denis: "A painting, before being a battle-horse, a naked woman or any sort of anecdote, is essentially a flat surface covered by colors arranged in a certain order."

Like the Vienna Secession artists the Nabis were associated with the Art Nouveau movement, extending their activities to wallpapers and mural decorations, so demonstrating that they no longer intended to confine their activities to painting only on canvas. Thus Vuillard painted his *Public Gardens* for the dining-room of Alexandre Natanson, the director of the *Revue blanche*.

The Nabis wanted "walls, walls to decorate." Like Vuillard, they wanted to get art out of museums and take it into life – and they were partly successful. But from 1900 Vuillard, after pushing the stylization of forms and chromatic simplification a very long way (*In bed*, 1891), reverted to a naturalistic vision, while at the same time preserving the Synthetist tendency of his early work.

Paul Sérusier
Solitude, landscape at Huelgoat
Oil on canvas
Rennes, Musée des Beaux-Arts et d'Archéologie

Edouard Vuillard
Public gardens (Nannies –
The conversation – The red sunshade)
Size paint on canvas
Paris, Musée d'Orsay

Sérusier, more of a mystic than his friends, was responsible for giving the group its name; he discovered his style thanks to the advice of Gauguin, whom he met in 1888 at Pont-Aven and accompanied the following year to Le Pouldu. Displaying a radical break with the Realism of his early work (*Breton weaver*, 1887), the *Talisman*, virtually painted on Gauguin's instructions, was a revelation to Sérusier and his friends at the Académie Julian. Subsequently attracted by theosophy, Sérusier moved away from the primary preoccupations of the group to venture onto the shifting ground of mystical quest, basing his research on the application of the golden number, which Father Didier Lenz had revealed to him at convent of Beuvron, and seeking his subjects in the imaginary medieval times of a Brittany transfigured by legend.

Paul Sérusier
Incantation
Oil on canvas
Paris, private collection

204 *Melting into color*

In spite of the formalist statements in the Nabis' program, Bonnard belatedly recognized that "art [could] never dispense with nature." After a Nabi period, characterized by the use of neutral colors arranged as flat tints and of motifs from printed materials (*Woman in check dress* [1891] and *Child eating lunch*), when his style was very close to Vuillard's (*Public gardens*), Bonnard took an interest in scenes from Parisian life, so moving back toward Pissarro, who had influenced his early work.

After 1900 intimate scenes took over from other subjects. Liberated from the tyranny of the line, Bonnard gave free rein to his extraordinary gifts as a colorist, no doubt spurred on by the example of his friend Redon. The canvases he produced then, dominated by harmonies of yellows, pinks and blues, afford a lyrical vision of nature – a vision that without forgetting the lessons of Impressionism seems to want to integrate the subjective dimension so dear to Redon.

This extreme conception in which everything is structured round color, leading to a complete dissolution of drawing, ultimately frightened Bonnard himself and he went through a period of doubt between 1914 and 1922. Like Renoir, who had experienced his harsh period, he felt obliged to go back to a more graphic structure, hoping to restore greater formal rigor to his paintings by this means. Once the crisis had passed, color again gained the upper hand, and from then on it was color that gave his compositions their plastic coherence.

In a parallel development, as if afraid that too strong a resemblance with the reality inspiring him might disturb the dialog between the colors, Bonnard muddied the waters by blurring the outlines so as to leave only a very restricted number of figurative indicators on the canvas. "Saturated with light to the very last nook and cranny," André Fermigier wrote, "his canvases, especially the landscapes, become a sort of humming, droning surface ... where the forms and the planes are abruptly confused, and the oddities of the drawing and the composition are accentuated with truly Expressionist vehemence. The nudes, still-lifes and even the portraits stand out with remarkable power against backgrounds that are striped with splashes of color and rapid brushstrokes where it becomes impossible to recognize any element of a real decor."

Pierre Bonnard
Nude in the bathtub
(or Nude in the bath)
Oil on canvas
Paris, Musée d'Art moderne de la ville de Paris

205

"The intimate and natural evolution of Pierre Bonnard's work is today culminating in a blossoming into the freedom and boldness that typified Cézanne, Renoir or Van Gogh."

Tériade
Verve no. 3
Paris, 1938

Pierre Bonnard
Conversation at Arcachon
Oil on canvas
Paris, Musée du Petit Palais

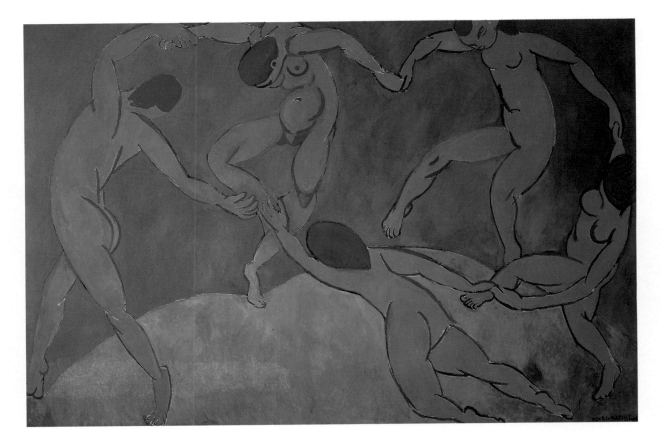

Color and simplification

206

Matisse had his first one-man show at Vollard's in 1904. The following year his works were exhibited in the autumn Salon along with those of Vlaminck and Derain, earning the room where they were hanging the name the "cage aux fauves" [cage of wild animals]. He had been a pupil of Moreau, who opened his eyes to the importance of color, was then affected by Cézanne, and temporarily influenced by Signac. The discovery of Gauguin's work finally prompted him to simplify forms and make more extensive use of flat tints of color. As he was drawn to light-filled atmospheres, he traveled to Morocco and Tahiti, and lived mostly on the French Riviera.

In the processes of simplification that ultimately ended after the Second World War in cut-out gouaches, it is possible to recognize the famous desire for stylization beloved of Gustav Klimt. But Matisse's purpose was noticeably different from that of the master of the Vienna Secession. Matisse refined to the point of suppressing the anecdotal. Moreover, Klimt's ambition of transforming the visible world by means of art was completely alien to him. Matisse managed his canvas as a purely plastic problem, with no social or political pretensions. At the very most, and then only in the final years of his life, it is possible to detect the signs of a spiritual reinterpretation of his esthetic options based on formal simplicity, the apprehension of color as pure light, and delight in painting. "In creating these cut-out, colored papers," he said, "I feel that I am moving happily in the direction of what is to come. I do not believe I have ever been so balanced as when making these cut-out papers. But I know that it will be a long time before people realise the extent to which what I am doing today is in tune with the future."

Matisse's crucial contribution to painting – in this he went beyond the legacy of Fauvism, which was simply typified by a strident use of color – was to resolve "the very old dichotomy between drawing and color," as Harry Bellet emphasizes. Speaking in October 1951 Matisse explained: "Instead of drawing the outline and putting color into it, the one modifying the other, I draw directly in color which is all the more measured because it is not transposed. This simplification guarantees a precision in the coming together of the two methods which are thus turned into one …. It is not a point of departure, it is a culmination."

Henri Matisse
The dance
Oil on canvas
St Petersburg, Hermitage

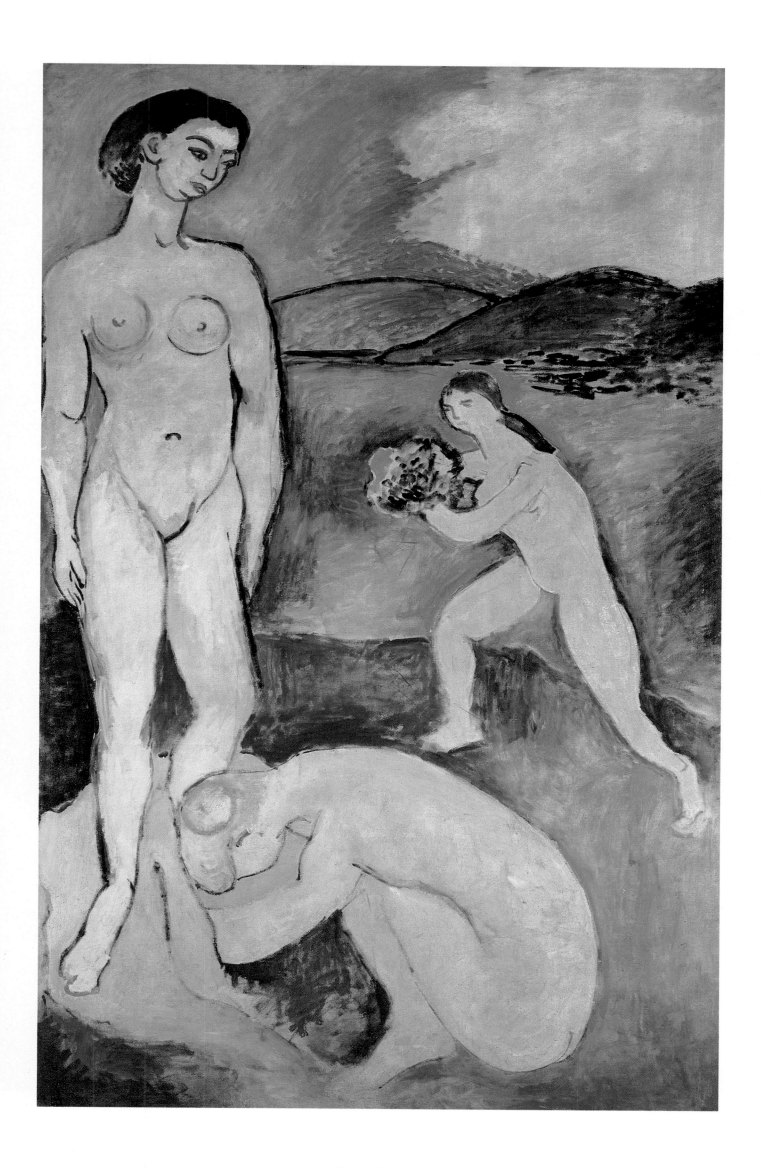

207

Henri Matisse
Luxe
Oil on canvas
Paris, Musée national d'Art moderne
Georges Pompidou

208

Henri Matisse
La desserte rouge
Oil on canvas
St Petersburg, Hermitage

209

"*Resolving the very old
dichotomy between
drawing and color which,
since the traditional
opposition between
Florence and Venice, ...
had forced artists to favor
one of the two elements at
the expense of the other,
Matisse, armed with a
pair of scissors, cut
directly into color, like a
sculptor cutting into
marble.*"

Harry Bellet
*Catalog of the exhibition
"L'oeuvre ultime, de Cézanne
à Dubuffet"*
Fondation Maeght, 1989

"Derain was a young man then; he admired Matisse tremendously, he went with them to the country, to Collioure, to Perpignan, and they all had a marvelous time."

Gertrude Stein
The Autobiography of Alice B. Toklas
Gallimard, 1934

210

The intoxication of pure colors

The intoxication was violent, but short-lived. Derain's Fauve period was confined within the narrow framework of the years 1905 to 1907. A friend of Matisse and Vlaminck, whom he had met at the Académie Carrière around 1900, at the beginning of the century he oscillated between the influence of Toulouse-Lautrec and that of Gauguin, whose two Paris exhibitions in 1904 and 1906 had delighted the new generation of painters. Given a contract by Vollard in 1905, he set out in Monet's footsteps so to speak on a journey to London, where he painted several views of the Thames and of Westminster, often regarded as the culmination of Fauvism.

But from 1908, perhaps because of the example of Braque and Picasso, who were then inventing Cubism, he abruptly abandoned his first manner of painting and turned to Cézanne. Brusquely reversing the relationship of line and color, he toned down his palette, reverting to firmly drawn compositions in which volume took precedence over color. All his subsequent attitudes betrayed a powerful need to return to Classicism, and after the First World War a violent rejection of Dadaism, Surrealism and Abstraction.

Thus the intoxication seems to have been a sort of accident, a youthful deviation in the career of this sober man, anxious about everything and worried about order. Pierre Francastel wrote about him in these terms: "In their work [that of Derain, Vlaminck and Friesz] violence gave a momentary illusion of strength. They were never able to go beyond the stage of youthful rebellion, they were incapable of setting up a discipline or elaborating a system. Basically, prolonging one of the least innovative aspects of Impressionism, they did no more than clothe a traditional figurative schema in bright colors and broad strokes Some of them remained stuck in that manner, while others transformed their method of working, turning to still more traditional techniques."

This is a harsh comment, but it is fair. Fauvism, which can be interpreted as the French branch of the Expressionist movement then developing in Germany, was not able to preserve a united front when faced with the rapid development of Cubism. The huge impact of Cézanne was no doubt crucial at that point. In the final analysis, once the time of pure rebellion was over, the Fauvists may simply have lacked someone of Cézanne's stature to serve as a point of reference and encourage them to "think" their painting through.

André Derain
Lighthouse at Collioure
Oil on canvas
Paris, Musée d'Art moderne de la ville de Paris

"Derain started painting landscapes highlighting the outlines of the trees in red; he had an individual way of perceiving space which he first revealed in a landscape where you could see a cart climbing a slope on a road lined with trees highlighted in red. People were beginning to take notice of the work he submitted to the Salon des Indépendants."

Gertrude Stein
The Autobiography of Alice B. Toklas
Gallimard, 1934

André Derain
Portrait of Mme Paul Guillaume
Oil on canvas
Paris, Musée de l'Orangerie

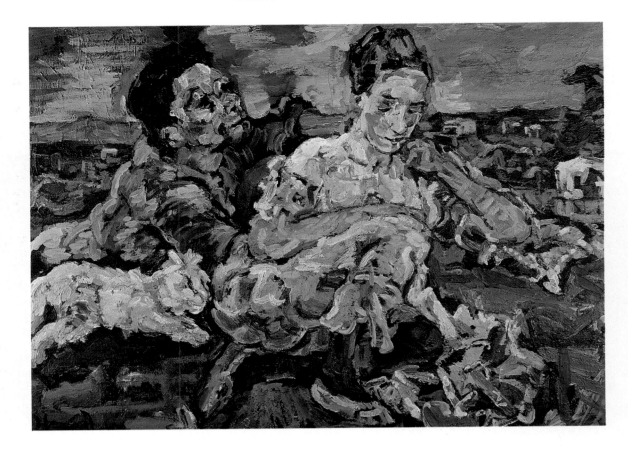

212 *Tragic color*

While Braque and Picasso were inventing Cubism in France around 1907, painting seemed to be following a completely different path in Austria, Germany and the Scandinavian countries. Expressionism, a term used to cover the various manifestations of an art that rejected both Classicism and Impressionism, was rooted in the anti-rationalist current running through painting from Grünewald to Van Gogh by way of Goya in the dark style of his final period.

The Expressionists, grouped together in "Die Brücke" (The bridge) in Dresden in 1905 with Kirchner as its leading figure, and in Munich in 1911 gathered round Kandinsky, who founded "Der Blaue Reiter" (The blue rider), saw themselves as following in the wake of Romanticism, Moreau, Redon and the Fauves. Among the elements defining the movement were a rejection of the urban world described as an image of inhumanity; the aspiration toward a spiritual fusion with nature; the rejection of rules and principles; the exaltation of subjectivity and individualism; introspection; caricature; the anguished expression of the world's conscience; violence; and tragic derision.

The Norwegian Munch, whose 1893 lithography *The scream* (or *The cry*) was a premonitory forerunner of the Expressionists' quest for an "original cry," was associated with the Berlin Secession and may in some respects be seen as the godfather of the "Die Brücke"

artists. His compositions, which combine line and color in an original way, develop an oppressive sense of rhythm based on a reiteration of the line which seems barely able to contain a color which is asking for nothing better than to explode on the canvas. A feeling of extreme tension emanates from them, conveying in plastic terms the anguish experienced by the painter, who suffered from serious nervous problems until at least 1908.

The Austrian painter Kokoschka was a great admirer of Munch; he too gravitated round the Secession and the "Die Brücke" group, as well as taking part in the "Der Blaue Reiter" exhibition in 1912. He was Expressionist in the violence of his touch and his use of color, but he did not push social criticism as far as his friends, preferring to go more deeply into the psychology of his subjects. In fact, as Günter Metken wrote, "what does not concern his ego is a matter of indifference to him: political parties and esthetic groupings alike. Everything and everyone causes him suffering: suffering is his link with the world." The suffering did not preclude humor, however, as when he wrote to Alfred Kubin, then very taken up with occultism: "Unfortunately I have just died today and will not be on the earth tomorrow. I am sorry that on account of this I will miss your visit which is an honor. With my very best wishes, dear friend. Yours deceased, O. Kokoschka."

Oskar Kokoschka
Lovers with cat
Oil on canvas
Zurich, Kunsthaus

Edvard Munch
White night
Moscow, Pushkin Museum

214 ***Les Demoiselles and after ...***

"*Les Demoiselles d'Avignon*, how that name riles me! It was Salmon who invented it. You know of course that it was called the *Bordel d'Avignon* [Avignon brothel] originally. Do you know why? Avignon has always been a name familiar to me, a name associated with my life. I lived a stone's throw away from the Calle d'Avignon. That's where I bought my paper, my watercolor paints. Then as you know Max's grandmother [Max Jacob] originally came from Avignon. We used to tell loads of jokes about that picture. One of the women was Max's grandmother. The other was Fernande, another was Marie Laurencin, all in an Avignon brothel." That is Picasso's account of the picture which critics see as marking the birth of modern art.

Yet the picture, not first exhibited until 1916, was met with indifference by the public and disconcerted the painter's friends. The break with the two preceding periods, the blue and the pink, was too radical. "It took the clear-sightedness and eyes of poets, Aragon and Breton, to understand the *Demoiselles d'Avignon*, the *Guitars* of 1926 and the *Crucifixion* in their day," wrote Dominique Bozo.

The evolution, already foreshadowed in the work of other artists such as Bonnard or Matisse, relates to a transfer from the primacy of the subject to the primacy of form. "The importance of abstraction and the role of the outlines is increased," Philippe Thiébaut explained. "The painter goes from the rounding of bodies and drapes inherited from the forms of autumn 1906 to an angular geometricization. This change can be attributed to the shock Picasso must have experienced at the Salon des Indépendants of 1907 where Matisse exhibited *Nu bleu, souvenir of Biskra* and Derain the *Bathers* which readopted Cézanne's constructivism ... and it was also in Matisse's studio that Picasso had been able to see negro sculptures."

Thus Picasso's total novelty consisted in being the first to attempt a synthesis between the quest for stylization that typified the start of the century with Art Nouveau, Cézanne's geometricization and the rediscovery of African and Oceanic primitive art.

Without going into the difficult question of the role of Cubism in the advent of Abstraction, it is impossible to deny the impact on all 20th-century artists of the experimental research carried out by Braque and Picasso; between 1907 and 1914 together they radically reformulated the question of the problem of the relationship between art and reality. It was no longer the choice of techniques or styles that was being debated, but the very idea of representation.

Nonetheless, unlike others after him who have concluded that art is dead, Picasso, completely absorbed in the joy of painting, never foreswore the subject. "It's nonsense to do away with the subject," he protested. "It's impossible. It's as if you were to say, 'Behave as if I wasn't here' Obviously if a warrior has no helmet, no horse and no head he's a lot easier to paint. But in that case, as far as I'm concerned, he's of no interest whatsoever. In that case he might as well be a man using the underground. What interests me in the warrior is the warrior."

And what interested him in painting was painting.

Pablo Picasso
Mother and child
Oil on canvas
Paris, Musée Picasso, hôtel Salé

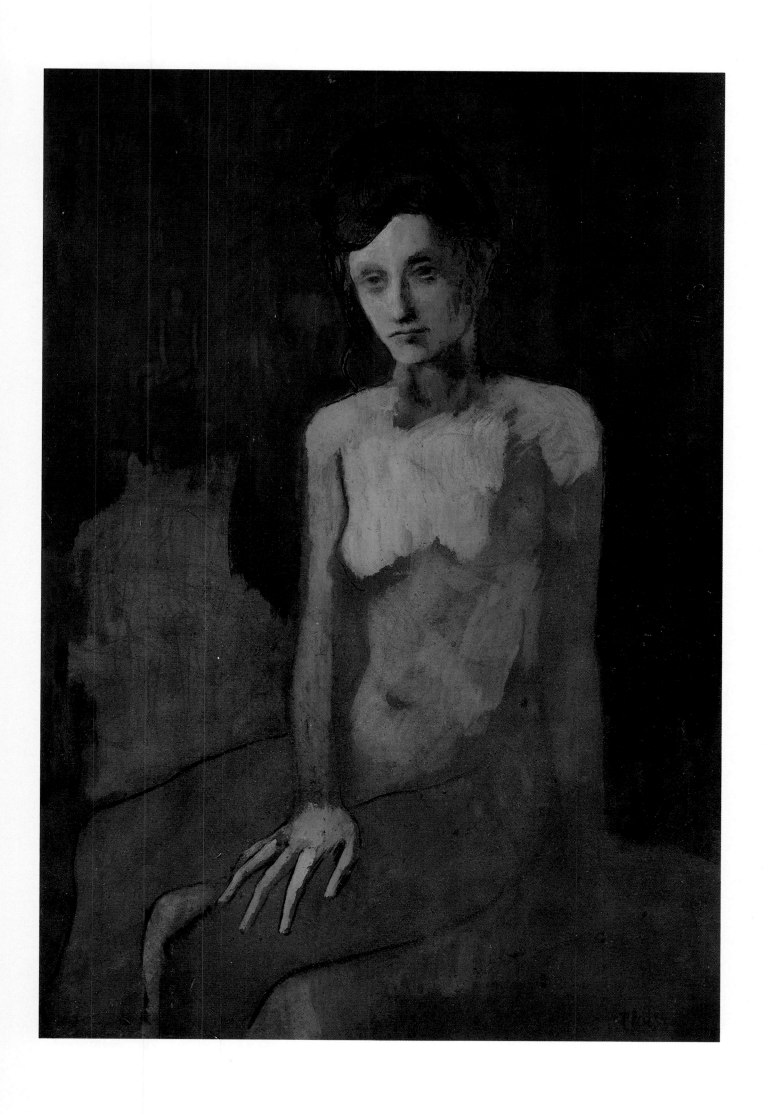

Pablo Picasso
Seated nude
Oil on hardboard
Paris, Musée Picasso, hôtel Salé

216

"Cubism is neither the seed of a new art nor its germination: it represents a stage in the development of original pictural forms. Once realised these forms have a right to an independent existence. If Cubism at present is still in a primitive state, a new form of Cubism should come into being later. Attempts have been made to explain Cubism through mathematics, geometry, psycho-analysis etc. All that is just so much verbiage. Cubism has plastic objectives which are sufficient unto themselves. We define them as means of expressing all that our reason and our eyes perceive within the confines of the possibilities covered by drawing and color."

Picasso

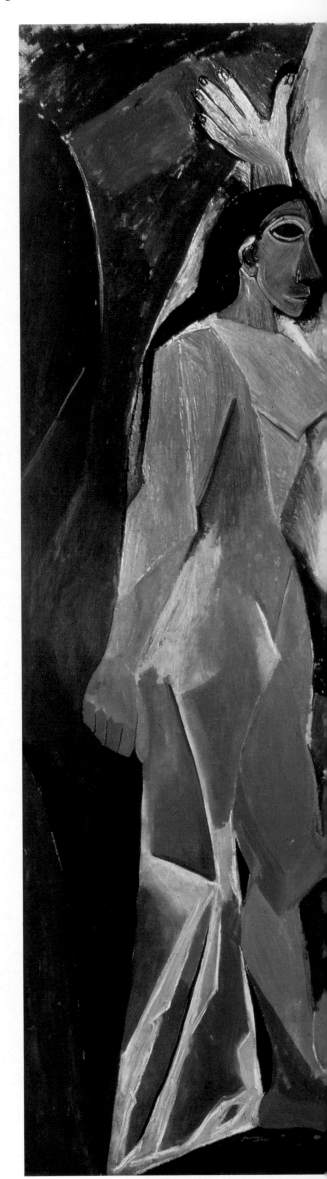

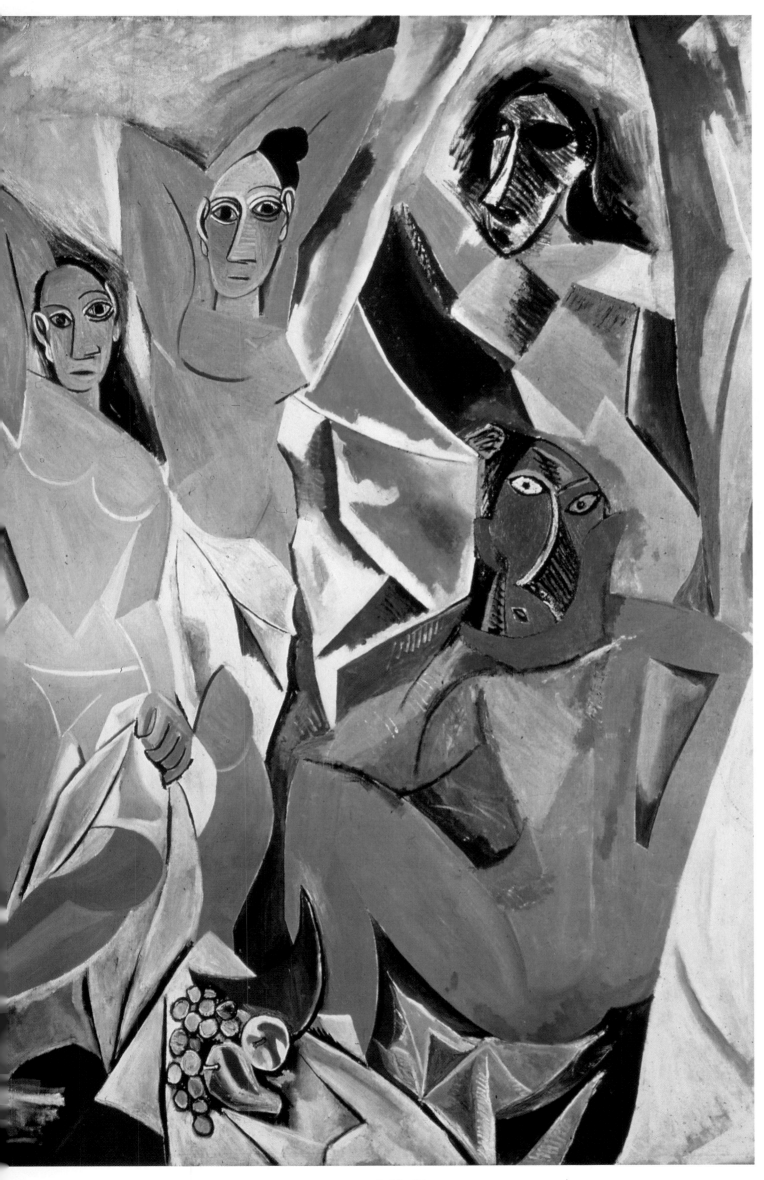

Pablo Picasso
Les Demoiselles d'Avignon
Oil on canvas
New York, Museum of Modern Art

218